Timothy Hilton
was born in 1941. He was educated at
Aston Technical College, Birmingham, Balliol College,
Oxford, and the Courtauld Institute of Art, where he
subsequently taught. He is also the author of *The
Pre-Raphaelites,* published in the *World of Art.*

WORLD OF ART

This famous series
provides the widest available
range of illustrated books on art in all its aspects.
If you would like to receive a complete list
of titles in print please write to:
THAMES AND HUDSON
30 Bloomsbury Street, London WC1B 3QP
In the United States please write to:
THAMES AND HUDSON INC.
500 Fifth Avenue, New York, New York 10110

Printed in Singapore

PICASSO

TIMOTHY HILTON

with 207 illustrations, 30 in color

THAMES AND HUDSON

© 1975 Thames and Hudson Ltd, London

Published in the United States of America in 1985 by
Thames and Hudson Inc., 500 Fifth Avenue,
New York, New York 10110
Reprinted 1996

Library of Congress Catalog Card Number 87-50464
ISBN 0-500-20144-7

Printed and bound in Singapore

Contents

To Fanny

Preface

THIS BOOK IS DESIGNED as a short critical introduction to the work of the twentieth century's most significant artist. It is not a biography, and I have made no attempt to describe the whole of Picasso's enormous œuvre, excluding most of the work of the last twenty years from my discussion. However, my selection of works to represent Picasso is not at all original; most writers on Picasso choose the same two or three hundred paintings out of thousands, whatever they may feel about their relative merits. I believe that there is room for more discussion about the nature of these familiar works. It is clear that every generation will have its own view of Picasso, but the critical assessment of his achievement and his place in modern art has now been static for some time. This may simply be because his art was superseded long before his death. It is now a quarter of a century since the last major paintings that were influenced by him or took note of his example, the Abstract Expressionist paintings of the late 1940s. Since then, neither painting nor art criticism has paid much attention to Picasso. However, during this time the basis of Picasso studies has been laid. I am thinking in particular of the devoted scholarship of Douglas Cooper, John Golding, Roland Penrose, Robert Rosenblum and William S. Rubin. I hope to have shown throughout the text how much I – and every other writer about Picasso – owe to their work. I have also tried to indicate where I have allowed myself to differ from their opinions. For the fact is that Picasso presents a whole arena for disagreement. He is so important to the art of our century that making decisions about him involves decisions about modern art as a whole, and attention to very high standards of achievement. I believe that we trivialize Picasso if we do not think of him in this way, and yet I am very well aware that writers about art should feel modest beside the great paintings of their own time.

7

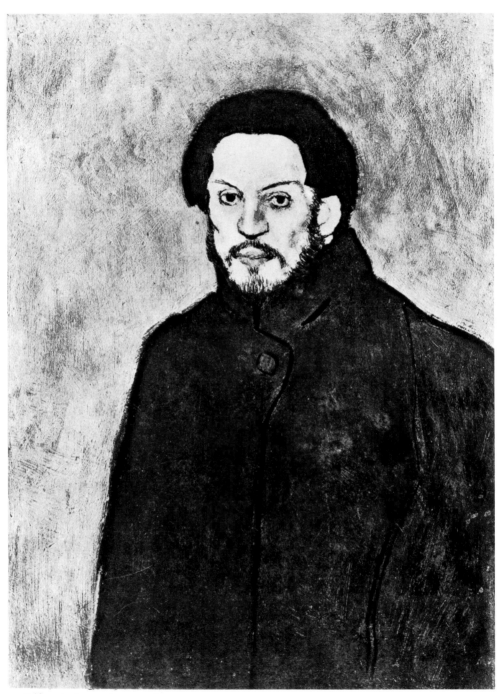

1 *Self-portrait* 1901 (see p. 22)

1 Early paintings and the blue and rose periods

PABLO RUIZ PICASSO was born in 1881 in Málaga, a town built on an ancient Phoenician site, below the Sierra Nevada on the Andalusian coast of Spain. Across the Mediterranean can be seen the Atlas Mountains, in Africa. Picasso's father, José Ruiz Blasco, was an artist of moderate talent who earned his living as a museum curator and teacher. Successive appointments took him and his family first to Corunna and then, in 1895, to Barcelona. His son's blazingly apparent ability when a child had immediate support, and was nurtured by parental pride. There was never any question that he would be an artist. A conceivably apocryphal story relates how Picasso's father, amazed at his expertise, presented him with his own palette and brushes, vowing himself to paint no more. Picasso's juvenilia, generally rapidly made, are indeed remarkable. Unlike most other work of the gifted young, academically precocious or carefully considerate of an admired teacher, they are swift, vivid, and eclectic. Their confidence is almost unnerving. One immediately begins to make comparisons with artists of the very highest rank. Before certain of the childhood works – a Rembrandtesque portrait sketch, a casual Monet – one might well feel in the presence of a major artist whose identity one could not begin to surmise.

3

Neither his father nor the Academy he briefly attended had anything to teach him, and the only encouragement he needed was the widening of his interests. This kind of stimulus was initially provided by the intellectual and bohemian atmosphere of Barcelona. Not only was there a lively artistic scene, as we can sense by looking at the little magazines of the time, *Pel i Ploma* and *Catalunya Artística*; separatist Catalan politics guaranteed the competitive interest of a provincial capital in the culture of Paris and London, not Madrid. Picasso frequented the café which was the centre of a tight-knit and

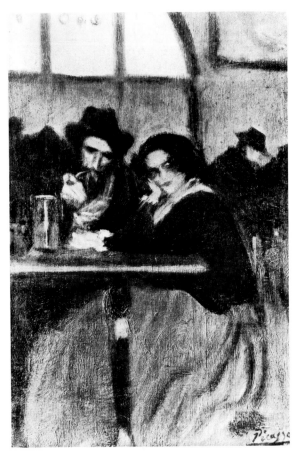

2 *Interior of the Quatre Gats* 1899–1900

ambitious artistic circle, the Quatre Gats, a rendezvous consciously modelled on the Parisian Latin Quarter, and advertised as 'a Gothic tavern for those in love with the North'. There Picasso met the older painter Isidro Nonell, whom he may have admired, and intellectual leaders such as Ramón Casas, who had antiquarian interests in El Greco (who was not a well-known artist at the time) and medieval Catalan art. Casas also knew Paris; he was personally acquainted with Steinlen and Toulouse-Lautrec. Picasso designed a menu card for the Quatre Gats, and painted an interior which is quintessentially a café-society picture. Darkly lit, it is dominated by the bravura of the red dress of an independent woman who sits at a rough table with a pipe-smoking man of ideas, a modern painting by an *habitué* on the wall behind them.

Many people of that temper made the trip from Barcelona to Paris. Picasso was just nineteen when he set out for the North, accompanied by Carlos Casagemas, another young painter. They were welcomed by Spaniards who had already settled into the artistic colony in Montmartre. But they were there for hardly more than a month before returning to Spain. Picasso was back in Paris soon enough, however, in the spring of 1901, this time for a much longer stay. He saw as much painting as he could, in the Louvre, in dealers' galleries, in other artists' studios. He painted a great deal himself, and began that process, crucial in all young artists, of relating his own work to the avant-garde of the day. It is important to recognize that this period of adjustment, for Picasso, was protracted.

IN THE FIRST YEAR of the twentieth century both the quality and the diversity of art to be seen in Paris was enormous. The whole of the modern tradition since Manet seemed to be assembled there. Picasso had ample opportunity to consider at first hand, not through reproduction and hearsay as in Barcelona, some forty years of avant-garde art. Impressionist painters such as Monet, Renoir, Pissarro, were still alive, and variously active. So were Gauguin, Cézanne, Degas and Toulouse-Lautrec. Within the Universal Exhibition of 1900, an 'Exposition Centenale' showed many paintings by Manet and a general anthology of the Impressionists. Rodin had a pavilion to himself. Elsewhere in Paris there was a large Seurat exhibition. Van Gogh and Gauguin could be seen at Ambroise Vollard's gallery. No single style predominated in the art of the day, and there was no consensus of informed opinion. On one major point, however, we may be reasonably sure that there was agreement. *Plein air* Impressionism, with its screening of perception, its wide and fair luminosity, mundane and candid iconography, rapidity of facture and love of the fugitive, was no longer acceptable. The reaction against this type of Impressionism had begun as far back as the mid 1880s, when Renoir turned to his classical style, declaring that he had 'wrung Impressionism dry', and Pissarro allied himself with younger men, the Neo-Impressionists Seurat and Signac. In the last fifteen years of the century, the transitory aspects of the older style were rejected by all the exponents of new art. This applied to Symbolists, Neo-Impressionists and Post-Impressionists alike.

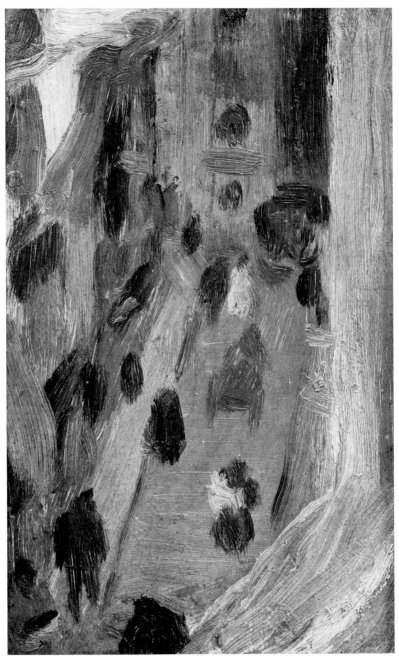

3 *Calle Riera de San Juan, Barcelona* 1900

Picasso's relationship to this state of mind is an interesting one. He was too young by a decade and more to have personally experienced the shift of sensibility which led away from Impressionism. Furthermore, he had no partiality for the theoretical and even dogmatic nature of some of the work involved. Very soon, his adoption of a monochromatic Symbolist mode would replay some aspects of that movement. But he was not initially concerned, as the Symbolists were, to replace Impressionism by a more 'meaningful' art whose address to the spectator suggested or avowed significant purport. And at no time did he wish to develop, like Seurat and his group, a scientific and logical art. He had no intentions, no *parti pris*. The capital was full of alternatives, not in themselves particularly important, but which he obviously felt like trying out; they would not take up much time.

So much of Picasso's earliest painting looks like other work of the day, or has a consideration of other work frankly built into it, that some commentators misleadingly represent him as subject to a plethora of influences. In the Barcelona period they find Pre-Raphaelitism, Nonell, Steinlen and El Greco guiding his hand, and in Paris they add to this list Carrière, Munch, all the Post-Impressionist masters and much besides. Certainly, Picasso had a curious and alert interest in all these people, as was noticed by the critic Félicien Fagus at the time of Picasso's first exhibition at the Vollard Gallery in 1901: 'One can easily perceive many a probable influence apart from that of his own great ancestry: Delacroix, Manet, Monet, Van Gogh, Pissarro, Toulouse-Lautrec, Degas, Forain, Rops, perhaps others . . . each one a passing phase, taking flight again as soon as caught. It is evident that his passionate surge forward has not left him the leisure to forge for himself a personal style; his personality exists in this passion, this juvenile impetuous spontaneity (they say that he is not yet twenty and covers as many as three canvases a day).'

This was perceptive. But to speak so firmly of influences, as we can now see, ignores the exceptional ability of the young Picasso, much else that we know of his artistic character, and above all the nature of the works themselves. When we see a *cloisonniste* portrait, with the heavy black outline introduced by Gauguin and his followers; or are reminded of Anquetin, Bernard, Laval; or notice that a motif closely follows a Munch, or that a little group of racecourse pictures almost mockingly outpaint some works by Ker-Xavier Roussel, then we

4

13

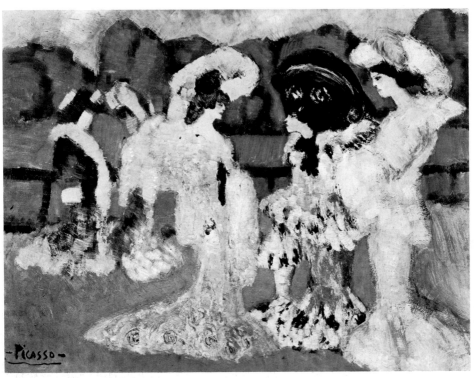

4 *The Races* 1901

must realize that the lively experience of being in Paris meant that
Picasso quite often painted pictures in much the same way that one
goes through a mixed exhibition, with catholic interest, looking first
at this, then at that. These paintings are not important in themselves,
and their aesthetic status is not an issue. Those who wish to speak
of pastiche will no doubt do so. Meanwhile it is enough to say
that the deep influences on Picasso's art, when the example is
magisterial and the response majestic, do not occur during his
apprenticeship but later in his career: and then our concern will not be
with the superficial ways in which one artist affects another, but with
the whole evolution of the modern tradition, where successive styles
are absorbed and developed, not imitated.

14

If Picasso's stylistic alignments at this stage were not fixed, the personal and social attitude which lay behind his art, and which his art often exhibited, was quite definite. He was clearly and provocatively anti-bourgeois. There was nothing novel in this, of course. Furthermore, the young Spaniard could hardly be expected to understand the many extra-pictorial subtleties – things to do with class, dress, urban life – which were certainly exploited by Parisian artists and their commentators since Baudelaire and Manet. Picasso never really had a social eye. The nature of his subject matter was a kind of declaration, and one that brought him closer to painters of an older generation for whom he felt real appreciation for both artistic and social reasons: at first Toulouse-Lautrec, the legendary debauchee of Montmartre, and a little later (with deeper significance) tragic exiles

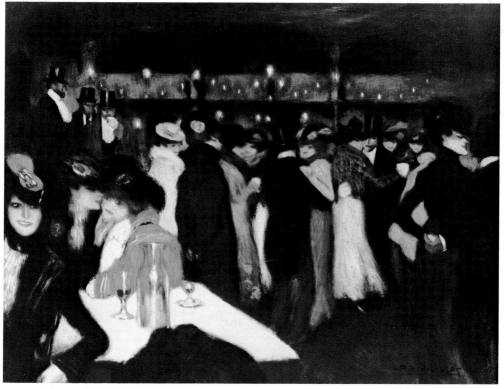

5 *The Moulin de la Galette* 1900

and outsiders like Gauguin and Van Gogh. As one would expect, therefore, Picasso had no interest in the tranquil domesticity of painters like Bonnard and Vuillard; how could he know, or care about, French family life anyway?

Picasso produced a number of works in 1901 which represent the cafés and night life of Montmartre. They are full of prostitutes and their madams, *demi-mondaine* entertainers, absinthe drinkers. But there is not a great deal of social observation. The characters seem to be there as some kind of assertion about the type of picture that is being made. In the *Moulin de la Galette* we are first of all put in mind of a social downgrading of Manet's *Tuileries*, one of the first modern paintings to represent contemporary life without comment and without inherited notions; and then we think of the precedent as mediated by Renoir, who painted the same café, and by Toulouse-

6 *Old Woman* 1901

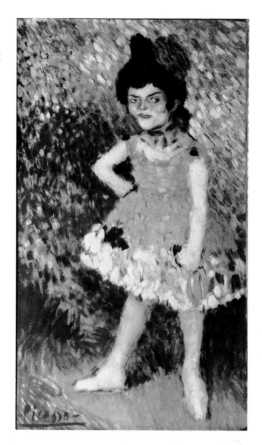

7 *Dwarf Dancer* 1901

Lautrec, who had recently made low-life subjects such as this the
staple of a new and daring art. But these were three artists of great
sophistication, of a Parisian sophistication which Picasso does not
share. The extent of his indebtedness to Toulouse-Lautrec can be
exaggerated. The formal and pictorial connections do not amount to
very much; the common subject matter should not conceal the quite
un-Lautrecian violence of some of the paintings of the 'cabaret
period', nor the eagerness and faltering tone of certain others. Unlike
Lautrec, Picasso has no interest in designing the picture by an elegant
line, no wish to copy the way that bold arabesques and silhouettes
make play with spatial equilibrium but are controlled by refinement.
Very little is drawn in these paintings. The application is rough,
sometimes frenzied, occasionally as if the brush had been held fist-
like. The colours are hot and vehement. Quite often they are put

7 down in separated half-inch dabs. In *Dwarf Dancer*, a hideous subject
(which may well have Spanish forebears, in Velázquez and Goya),
6 and in the cackling *Old Woman*, as also in the *Harlot with a Hand on her
Shoulder*, there are whole areas where the paintmarks are differentiated by tessellation into contrasting colours.

 What kind of paintings are these? They have individuality, but of
what sort? They are awkward when considered within the sophisticated urban tradition (they are, incidentally, the last significant
pictures of that type). They are not pastiche, and they are not directly
emulative of any particular model. We are sometimes told, however,
that the divided brushstrokes relate to Neo-Impressionist (or Pointillist) techniques, and furthermore that the paintings are 'an anticipation of Fauvism'. Neither interpretation can be admitted. Neo-Impressionist brushstrokes are even across the whole canvas, are
uniformly separated, and are not directional. Picasso's, on the other
hand, are irregular in size and dramatically highlight different parts of
the paintings. And, while the colour schemes of the spots in a Neo-Impressionist painting indicate recessional space as well as the natural
delineation of objects, some of Picasso's arbitrary and rushing flurries
function almost as curtains, concealing space elsewhere implied by
their aggressive holding to the picture surface. Furthermore, these
passages are quite often independent and partial, in that they do not
knit into the whole management of the painting. This is the opposite
of Neo-Impressionist methods and aims; for Neo-Impressionism
aimed at a stable and hieratic composition and a carefully worked-out
harmony based on the contrasting hues of colour opposites. There is
no temperamental or technical equivalent in Picasso's paintings. The
vague argument that paintings of the cabaret period have to do with
Fauvism is based only on the fact that they are often highly coloured.
But Fauvism was to liberate colour by its flatly applied, non-denotative use in areas rather than in passages, thus demoting local
colour. In these paintings of 1901, on the contrary, Picasso's colour
orchestration seems to be struggling out of chiaroscuro, and when the
colour is least notational it seems wanton, and is sometimes nasty. It
has not the disembodied autonomy we associate with Fauvism, or
with any good twentieth-century colour painting: it is more
reminiscent of German Expressionism, as it happens. Picasso was
never really an innovative colourist in his career, and certainly was
not so at this time. But his colour is always personally significant, and

18

since it is never allowed independence can often seem illustrative of other concerns, or problems.

Picasso's relative lack of interest in colour as such, and the highly expressive but ultimately unmanaged way in which it is used in the cabaret paintings, is one reason why we feel in this first group of independent pictures that the lavish disclosure of energy is paradoxically somewhat stifled. There is a parallel to be drawn, though it is not at all an exact one: the social aggressiveness and wilful disregard for fine taste is reminiscent of what Cézanne, employing a deliberately coarse expression, called his *couillarde* manner of the late 1860s and early 1870s. That painting, also figurative, was abrupt, brutally sensual, made from rough and impulsive motives with unpleasant colour and trowelled brushwork. Cézanne made this into a personal manner, together with the thickly Provençal peasant speech and oaths which he brought out to offend the suave Manet (whose *Olympia* Cézanne repainted *à la couillarde* in no spirit of homage); and he as deliberately courted rejection by the Salon with paintings like *The Murder*, *The Rape*, *The Strangled Woman*, and the six-foot-high painting of a deformed dwarf sitting on what seems possibly a *chaise percée*. There is in common a rejection of accepted pictorial fluency, though this is less marked in Picasso, and there is some kind of testing of personal thew against painting's agreed limits. In art since Cézanne there have been times when a need is felt by an innovative artist for a crude fracturing, with congested force or cracking disruption, to see what sort of weight the structure of painting can take. It is not suggested that Picasso was in this situation now; but since in his immediate tradition that sort of dislocation was most readily done through figure painting – and in particular through anti-erotic violence done to the nude, as we see in Cézanne – we may say that both the crudeness and revolutionary character of Picasso's *Les Demoiselles d'Avignon* had some preparation during the cabaret period.

Picasso was never really an artist of the boulevards. The painting of modern life and observed subjects soon began to disappear from his art. *The Flower Seller* is perhaps the last time for years that we have a sense of a specific time, place and social milieu, just as *The Blue Room*, with its respectful tribute to Degas and its talismanic collection of reproductions on the wall, seems like an end to his youthful enthusiasms. That painting in fact represents Picasso's own studio on

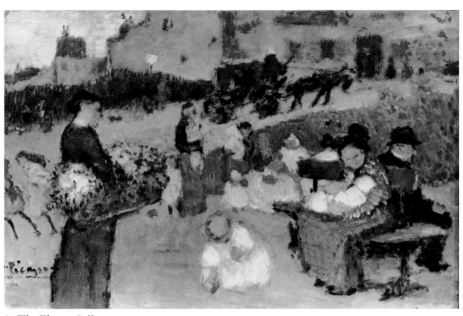

8 *The Flower Seller* 1901

9 *The Blue Room* 1901

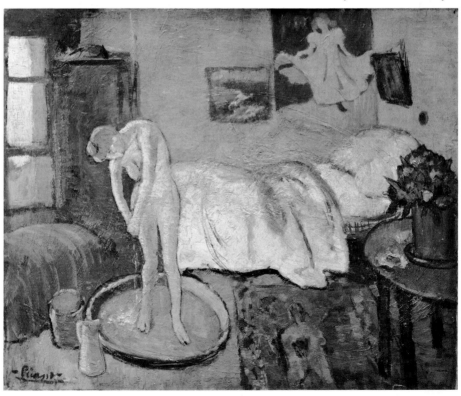

the Boulevard de Clichy. But henceforth all such images are generalized, and painted in a deliberately unworldly colour. Picasso's painting before this time was vivacious and changeable. It now becomes sombre and repetitious. Where previously the paintings continually surprised by their alertness, they are now recognized by their preoccupations. No still-lifes are painted, and observation is subdued by thematic reiteration. The themes are unrelievedly woeful: blindness, alienation, poverty and despair. At the same time Picasso's imagination evolves a cast, a number of recognizable characters. Here he follows certain painters of the previous generation in the accumulation of a figurative repertoire, a *dramatis personae*, figures who appear and reappear, are extended and repeated in a way that belongs to and signals that artist alone. Degas's dancers, Gauguin's Polynesians, Lautrec's Montmartre *demi-monde* are examples. Picasso's dolorous company is less specific than these, is invented, and evidently has some symbolic import. They are beggars, madmen, blind people, lonely couples and forlorn mothers. They meet with bowed heads, sit in deserted cafés, share frugal meals. Single figures are crouched, the women pulling shawls closer around their shoulders; and couples cling together in hopeless companionship. Their attitudes bespeak lives beyond lamentation. They do not look directly at each other; they point rather than speak. They are naked, or in rags, or in generalized quasi-medieval clothing. All of the paintings, until 1904, are in blue.

Picasso's time was largely taken up with work, but his social life was full nonetheless. He was surrounded by Spanish friends, in particular Jaime Sabartés, who was later to become his secretary and biographer. His French was improving rapidly. The exhibition at Vollard's increased his circle of acquaintances. He began a close friendship with Max Jacob, the son of a Jewish tailor from Brittany, a brilliant and witty poet and art critic who lived on his talents, doing odd jobs and pieces of writing. His nervous jesting, and a liking for buskined tomfoolery, which Picasso shared, overlaid a sensitive and melancholy disposition, steeped in the aesthetic and lapidary poetry of the Symbolist heritage. Through Jacob, Picasso became more aware of the writings of Baudelaire, Rimbaud, Verlaine and Mallarmé. As the winter of 1901 approached, and the blue period began, however, there seems no doubt that he was in depressed spirits, and there are indications that he was looking for a more

personal and intimate style. He was soon to leave Paris, despite the atmosphere and the old and new friends, and return to Barcelona.

Before going back to Spain he painted a particularly revealing portrait of himself, the first of the major self-portraits. Like all the important self-portraits it combines intense self-awareness with a quite complex shelter of masks and disguises. In the later works Picasso could be both flippant and profound, either alternately or – at first sight – simultaneously. This painting, however, is personally the more transparent by reason of his unbashful attitude towards his novitiate. It might be retitled *Portrait of the Artist as Van Gogh*, for the derivation is so frank as to amount to some sort of identification. Like the late tragic portraits of Van Gogh that Picasso would have seen at Vollard's, the painting is basically frontal but turned slightly towards the left, and employs exactly the same powerful and compact single outline against a very shallow background. Picasso does not use Van Gogh's rhythmic brushstrokes (and perhaps could not have), but he boldly follows the late self-portraits in excluding all extraneous matter and such typic attributes as palette and brushes. We recognize the active painterly concision which rivets attention by the force with which it displays the power of the artist's own self-examination: it shows the aestheticism of modernism in its autobiographical phase. This is not quite negated by the fact that Picasso does not paint with the power of Van Gogh or Gauguin, and that, barely twenty years old, he makes himself look older and as if he had suffered much more. The picture is significantly reminiscent of those self-portraits and mutual portraits which used to circulate at the end of the 1880s among Van Gogh's and Gauguin's friends, often – pathetically – inscribed '*à son copain . . .*'. The young Picasso, tactfully but also proudly, announces a half-reverential camaraderie with the artists who had preceded him, who were close to him though not personally known. He never painted Braque, or any other living artist, with serious intent. And if Picasso paints himself more gaunt with suffering than is warranted, there is this to recall: that the lives of many artists in Paris were heroic and martyred to an extent that we, conscious of the hardship as a familiar part of the mythology, too little respect. But this was real and immediate to Picasso, as to any ambitious artist of his own age. What guarantee could he have that his life would not be like Gauguin's, Cézanne's, Van Gogh's, whose sacramental activity as artists was attended by poverty, illness, public scorn and unhappy death?

The self-portrait of 1901 was sensitive to the communal position of advanced artists. That is part of its meaning. Yet the blue period style, it would be idle to deny, was determined by highly personal factors. The fact that Picasso chose to paint most of the work of this type in relative seclusion, in Barcelona, away from the stimulus of the artistic capital, suggests this. So too does the enclosed and static nature of the work itself. Most reasons given for the onset of paintings entirely in blue are by their nature extremely conjectural, and some are simplistic. Only one personal reason can be entertained. In 1901, Picasso experienced the blow of the death by suicide of his friend Casagemas, a fellow-artist and his first companion to Paris. In love, Casagemas shot himself because of his impotence. The effect on Picasso, as has plausibly been argued, was brutal and long-lasting. It certainly has much to do with *La Vie* (*Life*), and with other blue-period paintings. Those who seek psychological motivations for the blue period will not be able to prove its origin in this event; but they may at least feel that one reason why the period did not end until 1903 was that for two years Picasso was unable to make a good painting that would function as a convincing memorial to his friend.

Outside events are always more likely to conclude an artistic period than to inaugurate one: whatever impact the death of Casagemas had on Picasso, this would not in itself have effected a stylistic change. Other influences should be adduced. There was the general *fin-de-siècle* interest in melancholy in intellectual Paris, and in Barcelona too. Picasso would be the more aware of this as he read more of the literature that Max Jacob showed him. Sabartés later recalled how it was common in their circle to feel that 'sincerity . . . could not be found apart from sorrow'. Blue had literary associations with decadence, and was thought of by some as the most 'spiritual' colour. There were advantageous technical characteristics. Lighting becomes eerie when blue is modelled tonally. Picasso was aware of the effects that had been produced by El Greco, for one, with such means. He would also have known that this was a Symbolist procedure. Those artists used blue, and the associated tones of green, to produce a reverberatingly submarine quality when suggesting, as they so often did, the vast secrecy and nonlocality of the sea; and they also used a pervasive blue when there was no naturalistic reason for doing so.

In any case, it is more significant that the paintings are monochromatic than that they are blue. Monochrome approaches the ultimate

in the restriction of a painter's palette. It is composed of the tonal degrees of only one colour, or of a very few colours in close harmony, as in this case are blue and green. Old-master grisaille paintings are monochromatic, no doubt, but they are also classically constructed by chiaroscuro. Only after the *peinture claire* of Impressionism, with its negation of chiaroscuro method, does monochrome really become a modern concern. Henceforth it is either naturalistic, or symbolic, or (at a later date) literal; these distinctions may correspond very roughly with the degree of radicalism with which monochrome is consciously adopted. Naturalistic monochrome may be seen in Monet's foggy paintings of the Thames, which as it happens are contemporaneous with Picasso's blue period, or (as the titles announce) in such paintings as Whistler's *Arrangement in Silver and White*. Symbolist monochrome, which would have been closest to Picasso's own experience and concerns, is in painters like Carrière and, one should add, in the widespread practice of relief sculpture at just this time. These Symbolist artists also employed chiaroscuro; in the sculpture it was, of course, unavoidable. (The best Symbolists were usually the colourists, and that quality immediately led them out of the style.) Literal monochrome, when the paint and the painting are equally autonomous, belongs properly to abstraction; Malevich's *White on White* of 1918 was the instigator. Clearly, we must associate Picasso with the Symbolist camp here. But his place in a succession of monochrome attitudes does not at all mean that he was part of some developing or purposive movement, for there is no such thing as a monochrome tradition in that sense. The blue period is certainly cautious: it could even be argued that it was backward-looking. As suggested above, there are ways in which it repeated the move after Impressionism into hieratic, significant, and sometimes archaizing styles effected years before by advanced artists in the 1880s. Furthermore, decisive changes in pictorial colour, of vastly greater historical importance than the mere temporary assumption of a monochromatic mode, occurred during this period; and Picasso had nothing to do with them. These were not at all to do with the restriction of the palette – in which colour is still modulated by value – but with a restriction of modelling and perspective so that light is generated by flat colour rather than reflected in artificially moulded volume. This revolution, for such it was, made between Van Gogh and Matisse in precisely the years between the beginnings of Picasso's

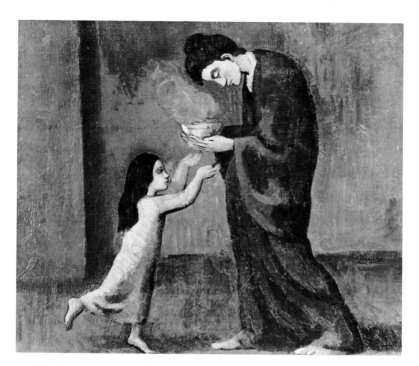

10 *The Soup* 1902

interest in art and the invention of Cubism, did not significantly affect himself. He missed it all. As we shall see, this fact is profoundly significant to the art of the twentieth century, even to our own day. Meanwhile, we should bear in mind that when Matisse came to paint a monochrome picture, in the *Red Studio* of 1911, he did so as a result of an attitude formed by previous experience quite the opposite of Picasso's.

One of the first of the blue-period pictures, known as *Soup* (1902), 10 combines the themes of religion and poverty which will be common during the next three years. In what one must suppose to be a deliberately unsophisticated manner, Picasso paints in profile against a flat background a child who is receiving, or perhaps giving, a bowl of soup. In contrast to the lively movement of the child the other figure is bent over in an attitude almost of prayer or supplication. Their gestures, so little realistic and so reminiscent of religious painting, put one in mind of an Annunciation, and more particularly of the ritual of the Eucharist, though that in itself is not a particularly common

subject in art. The pat conjunction of a sanctified atmosphere with the democratic simplicity of soup is too neat, too obvious; but would the painting be improved if its ideational basis were murkier? There is certainly an obscure religious undertow throughout the blue period, as we see in the many mother-and-child pictures. These have convincingly been characterized as secularized maternities. Religious themes are implicit in *The Two Sisters* of 1902, and certain paintings such as *Evocation* are specifically religious. A social strain is perhaps inevitable in paintings that so much deal with destitution. Picasso's sympathy with the sufferings of the poor was doubtless real, but this is too easily exaggerated as being in itself an active component of the blue period style. Nonetheless, it would be wrong not to make a tentative association with a general late nineteenth-century current of socially conscious subjects with Symbolist overtones. Like Symbolism itself (which was not a movement but a phase), this ran through a surprisingly large and varied number of artists. We see it in

14
17

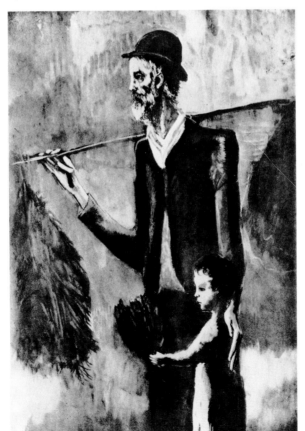

11 *The Mistletoe Seller* 1902–03

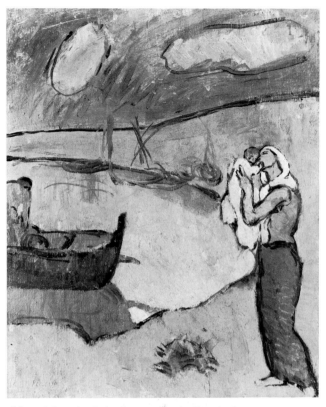

12 *The Fisherman's Goodbye* 1902

Millet, early Van Gogh, and late Munch; it is there even in Puvis de Chavannes' *The Poor Fisherman* and in the German Impressionist Max Liebermann; it is explicit in the relief sculptor Vincenzo Vela and in Constantin Meunier, and it is planned though never executed by Rodin. Compassionate rather than detached, and usually generalized, much of it deriving from late Pre-Raphaelite sources, this type of art is quite unlike the social observation of, for instance, Degas: there is a gulf between his laundresses and Picasso's. If Picasso's outcasts, beggars and occasional characters (like *The Mistletoe Seller*) remind 11 one a little of this social art, he still excludes what is common and maybe essential to the purport of all these artists: a feeling for the dignity of labour. Picasso's characters do not work and they do not have grievances, only the despair of felicity. In fact, Picasso is closest to the least forthright of this grouping, Puvis de Chavannes, who was to be quite important to him in a few years. Early in the blue period, his *Fisherman's Goodbye* owes something to Puvis. 12

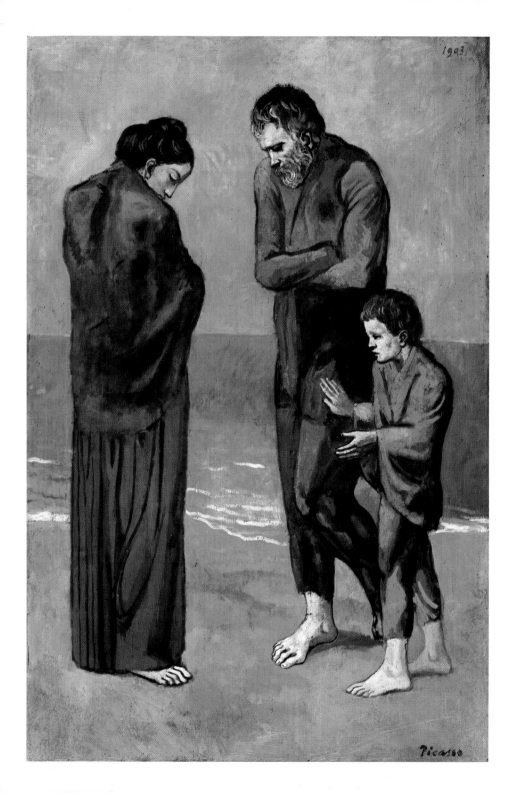

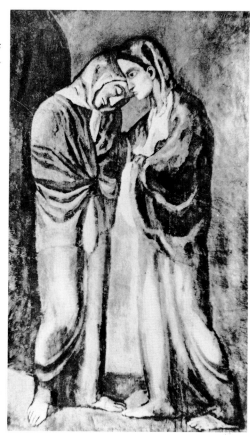

14 *The Two Sisters*
1902

A socially conscious art does not as a rule mix well with religious and sexual themes, for which Picasso had a vivid feeling at this time. His interest in prostitutes was intense. We know that in Paris he regularly visited the Saint-Lazare hospital for venereal diseases, drew there and patronized, as did the sick whores, a nearby café. His intention seems to have been to transmit this urban and sexual horror on to a loftier, timeless scale. In 1902 he wrote from Barcelona to Max Jacob: 'I am making a picture of this drawing I send you. It is a picture that I am making of a whore of Saint-Lazare and a nun.' This was *The Two Sisters*. Barefooted, robed, and in solid poses, these two women look a little like some rugged medieval sculpture. Judging from a preparatory drawing, they have exchanged sides in the painting. Indeed, they look much alike, their physical similarities therefore

29

< 13 *The Tragedy* 1903

belying their opposed natures. And so the painting is usually taken as some sort of meditation on the difference, or similarity, between sacred and profane love, between the spiritual and the sensual; and so on. It is reasonable to complain about this, on two grounds. Firstly, such biographical information as provided above tends sometimes to justify rather than explain what is not a particularly good painting. Secondly, there is a general difficulty about Symbolist art involved. In so far as it was an art of subject matter but opposed to Realism, Symbolism was necessarily dominated by the academic, or by the elicitation and display of personal beliefs or occult fantasies. Thus, a painting like *The Two Sisters* suffers rather from the abruptness with which, as Symbolist art, it reverses the address of previous significative painting: that is, it makes the mood, though intangible, transparent in a way that the meaning can never be. The contrast would be with the brilliant delicacy of *Les Saltimbanques*.

36

There is something wooden and *voulu* about *The Two Sisters*. Its rhythms are stolid; this is also true of many of the maternities and

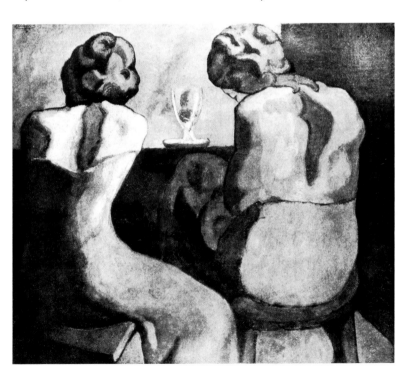

other paintings of the period. This is not only the case with the more sculptural figures. The enclosed shapes that Picasso derived from Gauguin are not aesthetically alive; they do not have the same function as they do in Gauguin, a continual binding of the movement of the painting. The more one looks at the 'ambitious' or 'important' blue period paintings, the more one feels that the relationship between outline and colour is uneasy. One comes to prefer pictures like the *Two Women at a Bar*. They are seen from behind, and the contrapuntal shapes of their heads and curving backs, and the stool on the right, are set against quite strongly contrasting light and dark areas. This kind of composition is much nearer to Gauguin, and is far preferable to the pompous set-pieces such as *The Tragedy*. Another type of blue period painting with real merit is the sort represented by the *Nude from the Back*, trenchantly drawn with a firm and rather thick black outline, and featuring a deeply sable *chevelure*; the point is that the blue inflection of the surface of the painting is more or less neutral, and in no way impedes the vivid nature of the line.

15

13

16

< 15 *Two Women at a Bar* 1902

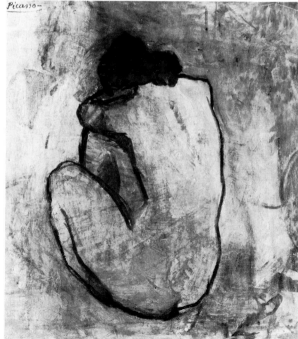

16 *Nude from the Back* 1902

Picasso returned to Paris in the early autumn of 1902 and shared a room with Jacob. They were extremely poor and often had to go hungry. Picasso's earlier success was not repeated, and he found that he was unable to sell his work. On the one occasion when he did so, he used the money to go back to Spain, where he remained for more than a year: a long time away from Paris for an artist at the beginning of his career. The suicide of Casagemas remained in Picasso's mind. Or, certain things to do with him – his character, the circumstances of his death, his art, their common nationality, age and friendship – came to occupy Picasso in a way that he wished to enlarge by generalization from those facts.

21 The painting *La Vie*, usually taken as the major work of the blue period, is not reducible to any single preoccupation; and yet the fate of Casagemas is central to it. Picasso himself both shunned and invited interpretation of the work: 'It wasn't I who gave the painting that title. . . . I certainly didn't intend to paint symbols; I simply painted images that rose in front of my eyes: it's for others to find a hidden meaning in them.'

Whether or not one is interested in 'hidden meanings' (which in modern art seldom justify the search), at least the identity of the protagonist is not in doubt. That his features are those of Casagemas has recently been shown by the publication of three rough paintings retained by the artist in his own collection, and never exhibited. Immediately posthumous portraits, they arouse an eerie suspicion that they were painted directly from the dead model. One is in lurid colours and shows a bullet wound in the temple. Another – for in 1901 we are at the very beginning of the blue period – depresses these colours into blue and green with a pallid ochre. In this small painting Casagemas is represented in his coffin. Two programmatic works

18 about the death soon followed, *The Mourners*, in which a group of
17 people are gathered around an open coffin, and *Evocation*, a very large and, one must add, totally improbable vertical composition. A lamentation over the corpse occupies the lower half of the painting. Above, Casagemas's soul is borne upwards by a white horse galloping into the sky past three stockinged but otherwise naked prostitutes. Both paintings have a sentinel-like woman with infant child to the right of the composition; this will reappear in *La Vie*. The real pictorial failure of *Evocation*, however serious its intentions, makes plain that Picasso at this stage had no facility in conceiving a large

17 *Evocation* 1901 >

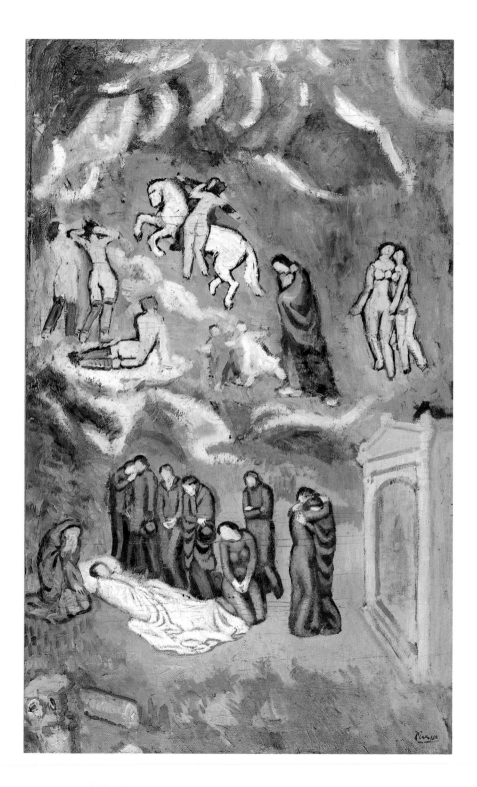

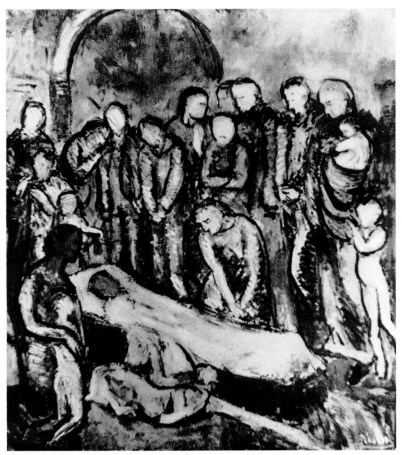

18 *The Mourners* 1901

figure painting of monumental import. Physically the most sizeable
work he had ever undertaken, it contains some twenty people and a
horse, between earth and heaven. Remarkably soon, at the end of
the rose period, he would be able to make a big painting that
independently absorbed the classical and academic French tradition;
but not yet. *Evocation* is derived from El Greco, a great artist who was
admired by Picasso and his Spanish friends, but at this date was
virtually ignored in Paris. It depends on such works as the *The Burial
of Count Orgaz* or the Toledo *Assumption of the Virgin*. Its unsureness
and lack of taste are in total contrast to that vivid sense of himself that
we noted in the self-portrait at just this time. Here, then, is the whole

problem of Symbolist art, poised as it was between the academic and the progressive. Picasso's acute respect for the Parisian avant-garde was not accompanied by any deep feeling for any of the post-Renaissance art which has a philosophical or eschatological scope. The intensely forlorn characters of the blue period, whose very significance is diminished by the want of such a sense, were better managed by concentration on one or two figures in a correspondingly intensified emotional aura; and there the example of El Greco was put to more potent use in an enclosed and singular composition such as that of *The Blind Guitarist*. 19

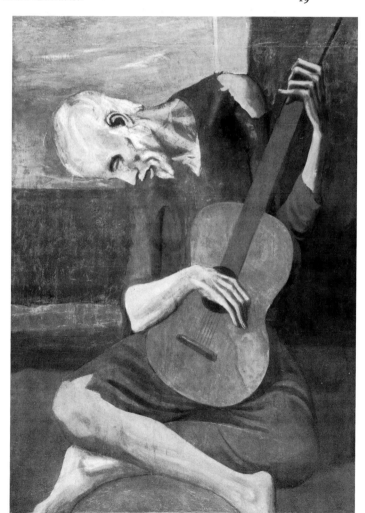

19 *The Blind Guitarist* 1903

This was the background to the attempt in 1903 to make a generalized commemorative tribute to Casagemas. Four preliminary
20 studies exist for *La Vie*. From them it can be seen that the conception of the painting changed markedly, and *pentimenti* on the canvas indicate that the picture itself was evolving in the course of painting, and that its present state represents a deliberate halting of that evolution. This interpretation accords with the nature of the work,
21 for *La Vie* (not Picasso's title, as he pointed out) is essentially a Symbolist cycle-of-life painting which makes dramatic how that cycle can be cut short. Cycle-of-life paintings were quite common at the turn of the century. They were often done as large-scale mural decorations, or have the feeling of fresco about them, and they play out the themes of birth, youth, maturity, death, rebirth. The best-known of them is Gauguin's *Whence come we? What are we? Where are we going?*, which is more personal and complicated than the somewhat ponderous ruminations on these themes which were produced by lesser artists like Toorop, Hodler and Segantini.

36

21 *La Vie* 1903 >

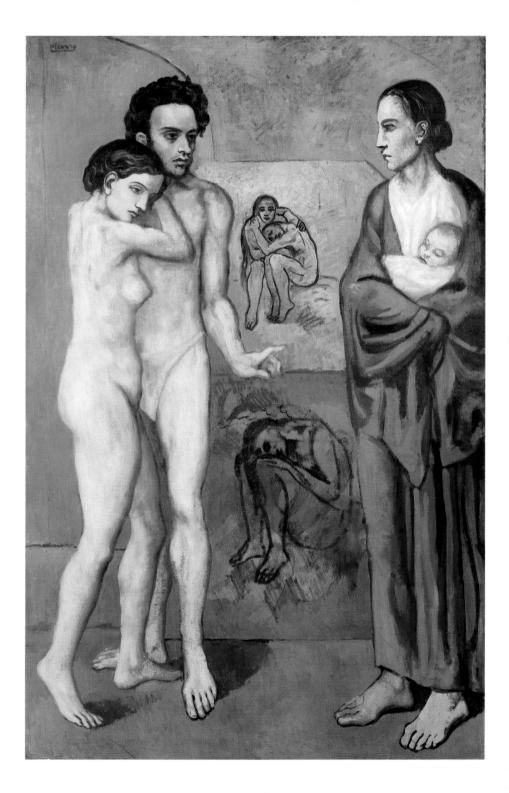

Paintings of this sort belonged on the whole to that kind of Northern Symbolist outlook which was admired in Barcelona. There was a strong enough feeling for them beyond Paris to have produced not only Munch's *Frieze of Life* but also the uncharacteristic *Evolution* by Mondrian as lately as 1911.

21, 14 *La Vie* is set in an artist's studio which has also, as in *The Two Sisters*, some vague suggestions of cloistered architecture. A naked girl clings woefully to the artist, who points silently towards the child carried by a heavily draped woman. The naked couple's posture, apart from the openness caused by the gesture towards the child, is similar to that 23 seen in *The Embrace*, which was painted in Barcelona at the same time and also depicts a naked couple. In that painting, however, the woman is pregnant. In *La Vie*, between the couple and the mother are two canvases, on which work has hardly begun although their subjects are outlined. In one, two seated figures look out hopelessly. In the other a figure that might be of either sex rests its head on drawn-up knees. The posture is unmistakably foetal. And so Casagemas's physical impotence is alluded to artistically, and in some sense equated with artistic impotence. The painting is about a career terminated just as it attains the vigour of youthful maturity.

 La Vie completes the blue period for the good reason that its stress is on the frustration of artistic promise as much as on the sympathetic depiction of irremediable afflictions in others. There had been no artists among Picasso's blue period characters, and one of the preparatory drawings shows that Picasso originally thought of himself in the central role of the painting. Since the painting is not cyclical but frozen, since it does not carry through the developing rhythms and intimations of regeneration which belong to all other paintings of its sort, there is a particularly strong feeling in it that what its creator can do is being withheld. How much fuller a picture, for instance, is *The Embrace*; humane, dignified and mature in a way that *La Vie* is not, and with an obvious emphasis on the potential rather than the stunted. This has a wider application: the blue period lasted for a long time, and the more it was extended, the fewer paintings were made, and the less Picasso developed as an artist. *La Vie* is a personal painting as much as it is a tribute to what is past, and its artistic significance has much to do with Picasso's now developed apprehension of his own route. It is not a breakthrough, but it marks a break.

'LA VIE' CONTAINS some recognition of the fact that the blue period had become an impasse; Picasso was at the same time looking for ways to free himself for an advance. He did so gently rather than abruptly. This in itself indicates how he was able now to let his art evolve through experience rather than be changed by a sudden new conviction. For the moment, the colour does not change, but there are many more watercolours and gouaches. Monochrome painting is as much the realm of fastidious as of bold artists, in that it can command a close reading of its facture and texture, displaying as much variety or delicacy of brushwork as the artist thinks proper, or can attain. Monet and Whistler are evidence enough of this. But in the blue period proper we are likely to find that the application is crude, that the paint is smeared on around drawing which hews out figures, that there are disagreeable transitions from matt surfaces to enamelled ones. In these new watercolours, though, there now appear the most subtle effects of all kinds, to such an extent that one of them, *The Brooding Woman*, appears almost as a showcase for textural niceties. 24 Equally, the drawing becomes much freer, sometimes with a suppleness that can spring into elongations, more often with a fine and wiry precision. This is so important, and so welcome, that on the occasion when drawing creates its own texture, in *The Frugal Meal*, 22

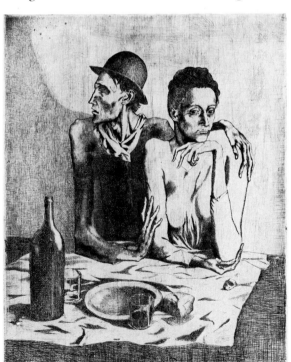

22 *The Frugal Meal* 1904

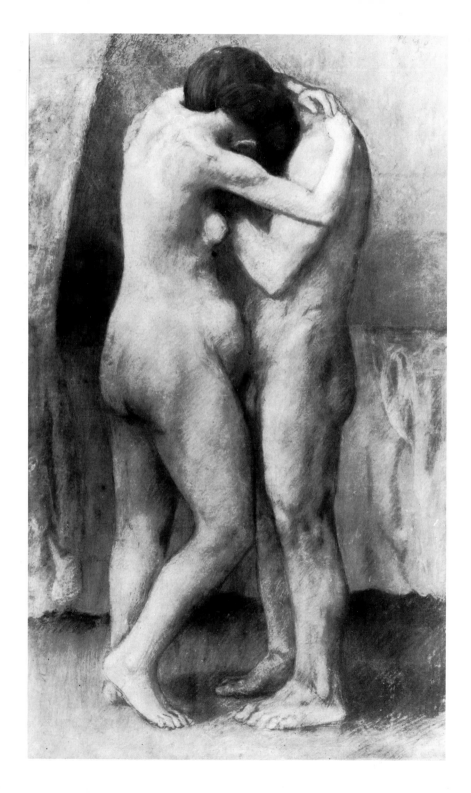

24 *Brooding Woman* 1904–05

we recognize a blue period masterpiece that paradoxically contains no blue at all.

The Frugal Meal is an etching, and was only Picasso's second attempt in the medium. He had done a small bullfight scene when in his teens, but nothing since. By reason of the fact that it is made in an edition and goes through a process apart from its initial execution, graphic work generally is technically and publicly conscious in a way that drawing is not. We see this here. It has been carefully worked to a completeness that has not been seen in Picasso's drawings beforehand. It is quite big, a foot and a half high, but not so big as to lose that essential characteristic of a drawing, that it is examined from about the same distance that one reads a book. Indeed, one is led to pore over its virtuosity. Weirdly long and tapering fingers, a motif picked up and repeated by the plucked-in chemise and scarf, are the expressive highlights within a taut outline that makes shoulders and elbows as gaunt as the faces of the *miséreux*. That outline is played against a

41

< 23 *The Embrace* 1903

repeated rectangle tilted at another plane, the tablecloth, and is balanced and completed by the roundnesses which at one point become the profile, from the plate to the glass and the bottle, rising to the crown of the hat, while from there the long arms shelter the fullness of the woman's breasts.

The source of this linear virtuosity – which has the effect of diverting attention from the subject of the drawing – is in Mannerism. Picasso's interest in that type of art was not confined to El Greco. He was also much taken with the School of Fontainebleau, as we can see from the famous sheet *Woman's Head with Studies of Hands*. The hands are of the same type that we see in the etching, and the whole is taken from a Primaticcio representation of Charity, made for the Galerie d'Ulysse at the Château de Fontainebleau. Picasso's response to Mannerism, however, was not simply a matter of picking up a motif here and there. It refined confidence in his draughtsmanly equipage, as he developed a line, whether with pencil or brush, that was as flowing and nimble as his circus characters. From *The Frugal Meal* onwards he develops slenderness out of emaciation, movement

25

25 *Woman's Head with Studies of Hands* 1904

26 *Salome* 1905

from immobility; and this easeful but trickily balanced manner, with an immense increase in poise, meant that (as suited his themes) he could paint or draw almost as a performance – again a Mannerist characteristic because it assumes appreciation of the knowing expertise in playing out what is already established as a norm. In this is Mannerism's pedantry, which can be crabbed or frivolous according to the type of sophistication it expects from its spectators, but which in an art of grace and display is always as courteous as curtsies before the ballet. Just as in Fontainebleau art, we now begin to see the turned postures, the costumes, elegances and mirrors, and their associated classical themes of allegory: *Vanitas*, the transience of human life, and *Impudicitia*, the effects of the sin of lust – there is much of that in the celebrated etching of the naked, dancing Salome.

26

Picasso had left Barcelona for the last time in April 1904, and on returning to Paris moved into the dilapidated building at the top of Rue Ravignan on the Butte de Montmartre, the home of so many

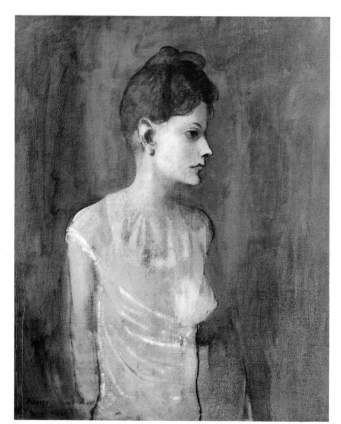

27 *Woman in a Chemise*
1905

artists and bohemians. Max Jacob christened it the Bateau Lavoir.
28 There Picasso met Fernande Olivier. She became his mistress and was
to live with him for the next six years. Her description of Picasso at
this time is worth quoting: he was 'small, black, thick-set, restless,
disquieting, with eyes dark, profound, piercing, strange, almost
staring. Awkward gestures, the hands of a woman, poorly dressed,
badly groomed. A thick lock of hair, black and shining, slashed across
his intelligent and obstinate forehead. Half bohemian, half workman
in his dress, his long hair brushed the collar of his worn-out jacket.'
Fernande Olivier's memoirs describe the gaiety with which they and
a group of largely Spanish friends put up with the hardships common
to many young artists – the unpaid rent, the shared meals, the
drawings hawked for next to nothing. After Picasso's return to Paris
it becomes more and more evident that some of these drawings, and
especially the gouaches, are of higher quality than the oil paintings.

28 *Meditation* 1904 >

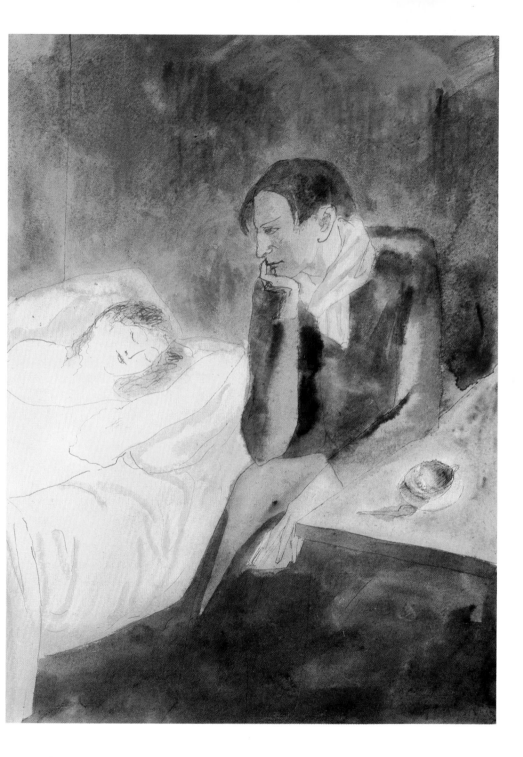

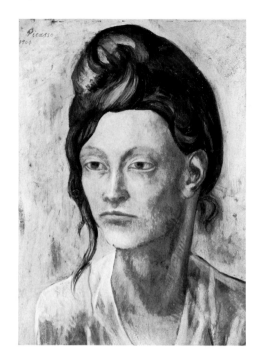

Woman with a Helmet of Hair 1904

29 Most noticeable is the work known as *Woman with a Helmet of Hair*, which has the essential characteristics of a tinted drawing. The invention of her features is a beautiful conception, as the gestation of a modern Venus must be: she is bold as Marianne, France's national symbol: tart-mouthed, sharp yet sensual, with a long neck and large eyes. The modulation into rose colours now begins, as the previously omnipresent blue warms into ashy lavender tones, greyed cinnabar, dawn pinks and a washed violet; all of them the more poignant in their emergence from blue because of their appearance of having faded from their parent primaries.

THE ROSE OR CIRCUS period is described too vaguely in some histories, which give the impression that it lasted until Cubism. On the contrary, it extended only from the latter part of 1904 to the summer of 1905, when Picasso went to Holland. There was not more than six or nine months' work in this particular style, and were it not that the
36 rose and the circus characters lead directly to the *Saltimbanques*, a major picture, we should probably consider this no more than a minor interlude in Picasso's career. After all, its very stylishness,

46

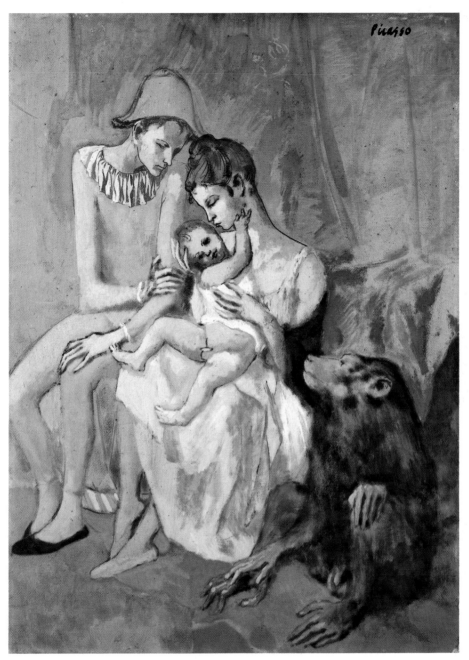

31 *The Acrobat's Family with a Monkey* 1905

Gertrude Stein recollected: 'At this time they all met once a week at the Cirque Medrano and there they felt very flattered because they could be intimate with the clowns, the jugglers, the horses and their riders.' Roland Penrose adds detail: 'There, behind the scenes and outside among the sideshows of the fair that traditionally occupies the whole boulevard during the winter, Picasso made friends with the harlequins, jugglers and strolling players. . . . With their families they camped beside the booths in which they performed under the warm glare of paraffin lamps. Their wives, their children, their trained pets, monkeys, goats and white ponies squatted among the props.'

The circus, and of course the Cirque Medrano itself, was already an established subject in French art, painted many times by Degas, Toulouse-Lautrec, Seurat and others. The new subject matter in Picasso's art was thus by no means an artistic invention. It was, rather, brilliantly seized on during this pause in Picasso's career. However many tumblers there in reality were in Montmartre, they are made unreal in the pictures. The aura of the style is particularized only by décor, neither rural nor urban, not of the palace yet not quite of the theatre, picked up by the characters and carried with them. Its transitory nature, even its evanescence as watercolour, suggests themes of alienation, of a vanished order whose relationship to the real world (the Cirque Medrano itself, for instance, sweaty and blaring) is lost. Whereas many of his predecessors showed *commedia dell'arte* characters such as these as urban tragedies (which in truth they were), Picasso nudges them away into a relationship with pastoral, at first rococo, then mysteriously nomadic: and the more he does so the more emphasis is laid on the painted factuality of the work itself, and the less it lingers among nostalgic connotations. Thus, quite early on in the rose period, an oil painting with a real location acquires, by comparison, quite a fierce edge. This is *At the Lapin Agile*. In the Montmartre café frequented by the artistic community is Picasso, looking grimly self-absorbed and dressed in a harlequin's costume. He does not look at his companion. Years later he identified her as Germaine Pichot.

29 The comparison above between *Woman with a Helmet of Hair* and a Venus was a relevant one, for the short-lived rose period was the last time for some twenty years that Picasso would recognizably concern himself with ideal beauty of a type deriving from post-Renaissance art. Its fine features, one can say without exaggeration, carry

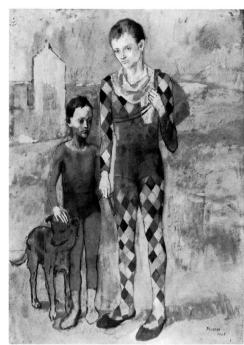

32 *Mother Combing her Hair* 1905 33 *Two Acrobats with a Dog* 1905

reminiscences of Florentine line. Such idealism has an importance in
the rose period. It is particularly demonstrated in the *Vanitas* painting
of the *Harlequin's Family*; and in that popular work *The Acrobat's
Family with a Monkey* there are references to a traditional Holy
Family. After all, one never encounters a child in that pose outside
Renaissance pictures. This might lead one to consider whether the
monkey has any attribual meanings (there is, for instance, a Dürer
Madonna and Child with Monkey, in which the animal represents lust,
greed, etc.); but this is plainly an otiose enquiry: works such as this,
with their avowed charm, have a playful attitude towards their
accomplishments. Equivocal attitudes to stylishness inevitably fol-
low. For instance, in high art as opposed to popular art, ideal beauty
and caricature have an intimate relationship, not as poles of an ideal
style but as linked concerns (as some of Leonardo's drawings, the first
true caricatures, make quite explicit). Caricature occasionally has a
purgative role in the early stages of modernism as an antidote to
cliché, a progressively weakened and confectioned repetition; and

51

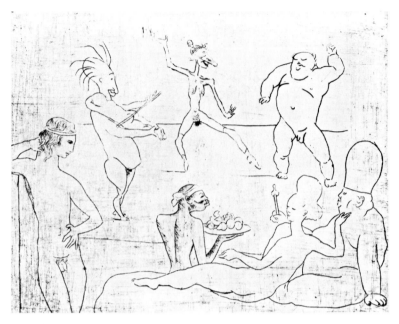

34 *The Dance* 1905

Picasso could not but have felt how near he was to cliché. (We shall
see how caricature has a specific role in the linear and ideal
involvements of the *Vollard Suite*.) In the rose period there needs to
be, at the least, a mannered wit to crisp the edges, and one finds this in
the slightly preposterous quotation in *The Acrobat's Family with a
Monkey*; and then caricature is startlingly evident when Picasso
34 suddenly jeers at his own circus characters, in *The Dance*, and
moreover goes to the trouble of making a drypoint engraving to do
so. This puzzling and unpleasant drawing seems to recede from the
classic to the Oriental to the bestial. It is sour and negative. If its
iconography has a meaning, it can only be, surely, in the bitter
assertion that the bestial is closer to splendour than we think. At the
least, the drawing makes plain that Picasso's temperament was not
33 content with the sentimentality of, say, *Two Acrobats with a Dog*.

35 Such facility in the pursuit of sentimentality was to be shunned. A
sense of seriousness, and of artistic effort, is transmitted by the *Young
Acrobat on a Ball*. A massive, broad-backed youth sits squarely on a die
watching an epicene little tumbler, arms in the air, balancing tiptoe
on a ball – again a motif that has a Renaissance ancestry. The rose

52

35 *Young Acrobat on a Ball* 1905 >

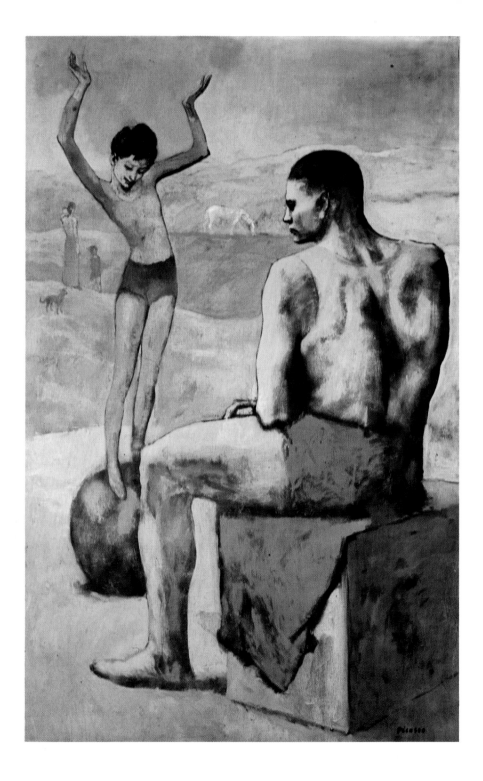

tones which predominate elsewhere are almost dried out in this picture into light and sandy tans and greys, and the varied brushing of the surface shows up how the paint has been worked. Picasso kept a hold on artistic reality even when his production elsewhere was affected and frivolous. We have seen that the experience of etching was important to Picasso; now, the medium kept him from too much lightness of touch. This produces a great difference in emotional tone

30, 32 between a gouache and a drypoint of the same subject; the *toilette* of the acrobat's wife. Etching also provided an occasion in the early months of 1905 for the deliberate preparation of an extensive

37 composition. This is *The Circus Family*, in which a number of characters are assembled. Some of them are performing domestic tasks; in the centre, others are practising balancing. In this was the

36 beginning of the large canvas of the *Saltimbanques*, a more ambitious painting than anything done in the previous months, and the largest picture Picasso had ever worked on.

The components can be quickly listed. There are six characters. Picasso, in an obvious self-portrait, wears a harlequin's costume, and holds the hand of a little girl carrying a basket of flowers. Next to them are the paunched and elderly jester, a familiar rose period character, and two young acrobats, one carrying a drum. Apart from this group at the other side of the painting is a solitary woman. She, unlike the others, is not a usual part of the rose period troupe. There is a preliminary study of her, as there are for other figures in the picture: the girl, for instance, who was originally with a dog. A gouache

38 study for the whole picture shows that it was originally conceived as more extensive horizontally, and was more particularized in social terms. The background was a racecourse rather than an untenanted landscape, and the self-portrait harlequin was first of all an older, ragged, top-hatted figure. These characters are not particularly unusual; we have seen them all in the work of the preceding months. The novel feature of the *Saltimbanques* is that, unlike any previous painting, it replies to the French classical tradition.

Perhaps as a consequence of the rose period – and how un-Spanish that is, how close to the French eighteenth-century ornamental style, for a young Andalusian who had only just mastered the French language – Picasso now came to consider French art in greater depth than before. For instance, the racecourse scene in the watercolour study is reminiscent of Degas, who had himself painted some

54

interesting pictures in the early 1860s which, right at the beginning of Impressionism, announce that between the academic and the avant-garde there was a *relationship*, not an uncrossable gulf. The relevant Degas picture here is of some Spartan youths exercising, naked, in a landscape vaguely similar to that of the *Saltimbanques* or the *Young Acrobat on a Ball*. This was a nineteenth-century theme, though not an avant-garde one; the title of a painting by Puvis de Chavannes sums it up: *Ludus pro Patria*. It is in Puvis that we shall find much of the larger significance of the Picasso painting. The decline of Puvis's reputation has meant that we sometimes forget how much respect he commanded, justly, at the turn of the century. All Symbolism was poised between academic and advanced art; and Picasso's relationship to Puvis is precisely to the point here. Puvis's big paintings – which were largely done as murals, even if they were *toiles maronflées*, on canvas glued to walls in French town halls – are beautifully replete with references to the French classical tradition since Poussin. He was much admired, this upholder of ancient values, by Van Gogh, Bernard, Gauguin. Picasso had derived one blue period picture from him. When he was featured at the Salon d'Automne in 1904, Picasso must have looked quite hard at him again to find out about his amplitude and his evocation of Arcadia – *le doux pays*. It is the approach towards Puvis's colours that makes plain that at this stage in Picasso's art what is loosely called 'rose' is more properly terracotta, tawny and plastery, and that he has come to paint in what are characteristically fresco colours. The disposition of the figures in the *Saltimbanques*, so much suggesting that the rose period has turned into mural art, has something of the posed and statuesque quality of academic painting. There are no lifted motifs (for Picasso at any age was more inventive than Puvis in the discovery of potent human images), but there is a continuity, one which carries the weight of centuries past.

Puvis's position between the academic tradition and large-scale new art had this great importance for Picasso: he was a mediator between a neo-classical and essentially public art and a later classicism, not necessarily attenuated, in which the epic mode is transformed into the pastoral. In the opening years of the century this was an important trend in Parisian art, and one has only to look at the current work of, for instance, Matisse and Derain to see how much their conception of the pastoral owes to Puvis. The *Saltimbanques* is where this reinterpretation of tradition emerges in Picasso, and so we find that we are

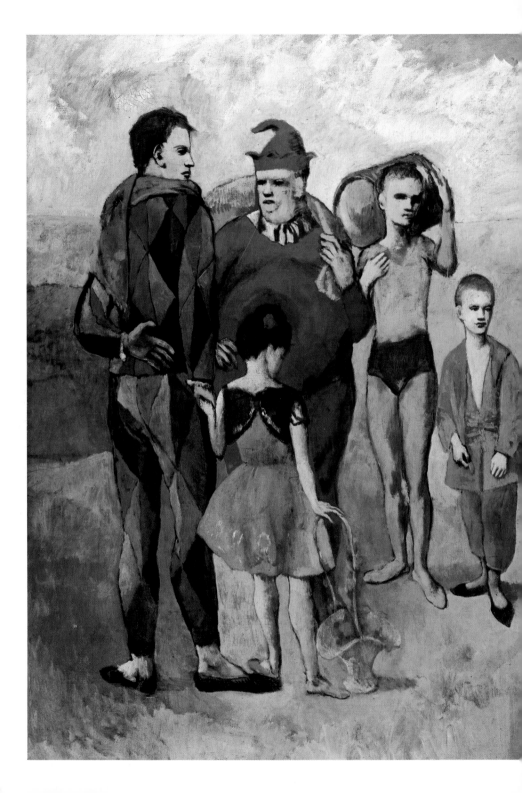

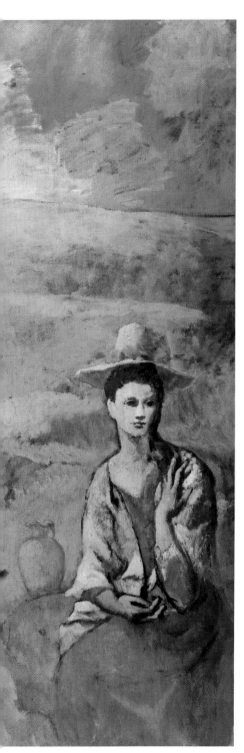

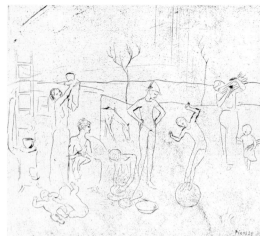

37 *The Circus Family* 1905

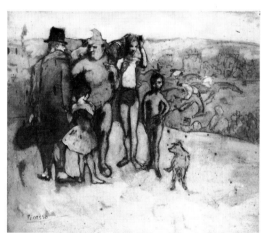

38 Study for the *Saltimbanques* 1905

36 *Saltimbanques* 1905

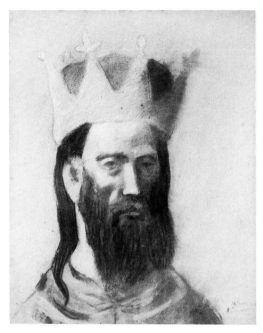

39 *The King* 1905

never far from references to *le doux pays*, and even to the first of all
pastoral metaphors, the ancient Egyptian idea developed by Hellenis-
tic culture of the king as shepherd of his people. There is a pastel of
1905, as sorrowful as any of Rouault's clowns (which were also in the
39 Salon d'Automne in 1904), entitled *The King*; and royal attributes are
continually and pathetically mingled with those of the obese but still
stately old jester. Picasso, never really a landscape artist yet certainly
not an observer of urban life either, is through all his career, in one
way or the other, concerned with pastoral. Occasionally this is forced
back into a relationship with the eventful and public statements of
180 neo-classicism. An essential part of *Guernica*, perhaps even its
essence, is in the ritual slaughter by the epic of the pastoral mode. And
many of the problems of that painting, formal ones, are first raised in
36 the *Saltimbanques*. They are of this type, to put things in opposition:
the scope of the mural as compared to the size dictated by easel
painting; the display of subject matter as programmatic rather than
specific; the arena of the whole stretched canvas as surface rather than
backdrop. That such oppositions were not fully regarded as pro-
blematical until they were made into crucial issues by Abstract
Expressionism, at the end of the 1940s, may initially give the

58

impression that the *Saltimbanques*, a pre-Cubist painting, has little to do with them, even if *Guernica* has. But they are nonetheless there, and the fact that this is a pre-Cubist painting perhaps emphasizes them. The way that the surface is variously inflected over an area that is much larger than a normal easel painting gives it a peculiar significance, for post-Cubist art on this scale would be restricted by its heritage of planar rather than surface-recognizing construction. There seems to have been an attempt to make the painting as flat as possible while still allowing volume to the figures. This curiously emphasizes the height of the work, as it happens, because the vigorous directional brushstrokes at the bottom have a vertical impulsion which steepens the immediate foreground to the extent that it is read as actual surface. This again stresses the mural nature of the painting. The effective absence of a foreground and the difficulty of determining the relative positions in space of the woman and the group of figures is akin to the procedures – or, rather, the effect – of painting that is done directly on to a wall high above the spectator.

The *Saltimbanques* has been called, not very illuminatingly, 'the last painting of the nineteenth century'. It is certainly a 'mood' picture, with definite affiliations to the last stages of Symbolist art; and it was surely not constructed with a view to carrying meaning. There is an interpretation of it, a literary and biographical one, which claims that the picture represents, at a remove, the *bande à Picasso*. Apollinaire is the fat jester, Picasso the harlequin, Fernande Olivier the woman, and perhaps Salmon or Jacob the older of the two acrobats. The wandering life of harlequins and acrobats is thus equated with the artist's 'position in society'. This is not so much banal as positively misleading: there is so much evidence, on both biographical and artistic grounds, to support a contrary view. The 'position of the artist', for Picasso, was not understood as an opposition between bohemian camaraderie and a hostile or indifferent public. It was to do with being an excellent artist. That is the point of the relationship between himself and Van Gogh, as seen in the 1901 self-portrait. The *Saltimbanques* is a sensitive and dignified attempt to claim the most recent position within a tradition. And in that, there soon came a conflict with Matisse.

2 The beginnings of Cubism and the *Demoiselles d'Avignon*

36 IN THE SUMMER of 1905, after finishing the *Saltimbanques*, Picasso went to Holland for a month to stay with a writer he had met in Paris. While there he did some heavily proportioned paintings of Dutch women. The rose period was over. On his return to Paris he painted
43 two pictures (they are almost a pair) of a *Boy with a Pipe* and a *Girl*
44 *with a Fan*. The poses have taken on a deliberate and stately manner, as if their meaning were awesome. The boy's gesture is near to that of the single woman in the *Saltimbanques*; a drawing for the painting shows that he was first conceived as seated on a die, as in the painting of the young acrobat. The air of gravity is so impressive that it overwhelms the incongruity of the pipe, and the fact that he has a crown of flowers. Is he perhaps a boy-king, or a poet, or both? One wonders less about this as it becomes apparent in the next year that Picasso's intention was to make such extraneous attributes redundant. The *Girl with a Fan*, again a picture of a young adolescent, inclines one to this view. The shallow depth, profile aspect and hieratic gesture are surely derived from Egyptian art, but the painting is in no way illustrational.

Just as the rose period was dominated, and terminated, by one painting, Picasso now seems almost to have been gathering material for another massive work. This was to have been *The Watering Place*. The fact that it was not executed, and that we do not know why it was not, makes discussion of its aesthetic intentions speculative. However, we can trace the elements of its construction. There are at least four designs for the whole picture, and a number of other drawings related
46 to motifs within that design. One superb painting, *Boy leading a Horse*, relates to, or perhaps was rescued from, its central feature; one would
42 imagine that the drypoint is the most complete of the designs for the absent painting, and may even have substituted for it. What is

40 *The Two Brothers* 1906 (see pp. 73, 76) >

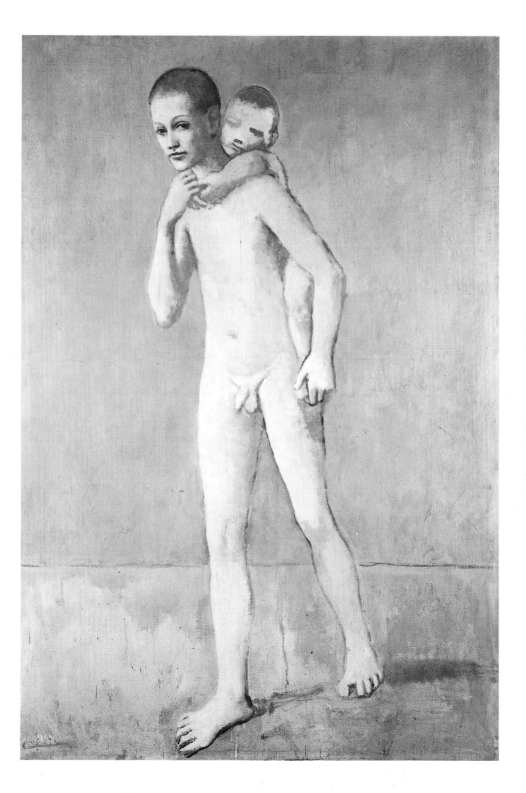

interesting is the closeness, except where colour is involved, to Matisse. The general composition, the artificially shallowed depth of an extensive landscape, and the arabesqued line are rather like those employed by Matisse in his *Joie de vivre*, which was begun in the autumn of 1905. This is perhaps as near as the painters ever came to each other. Picasso would have been aware of Matisse's work. At the Salon des Indépendants in the spring of 1905, just when Picasso was at work on the *Saltimbanques*, was exhibited Matisse's *Luxe, calme et volupté*, a pastoral painting which quite openly takes things from Puvis de Chavannes. There is some uncertainty as to when Matisse and Picasso, the two greatest artists of the first half of the twentieth century, actually met. It seems that it was either in the autumn of 1905 or the autumn of 1906. If the meeting took place at the earlier date there is every possibility that Picasso saw the start of work on *Joie de vivre*. The relationship between the two was never to be an easy one. Picasso was extremely wary of Matisse, twelve years his elder and at this time the acknowledged *roi des fauves*. Fauvism was the very latest artistic movement in Paris, and one with which Picasso had little in common. Leo Stein wrote: 'The homes, persons and minds of Picasso and Matisse were extreme contrasts.' Fernande Olivier's memoirs record how '"North pole and South pole", Picasso would say, speaking of the two of them', and that 'Very much the master of himself at his meeting with Picasso, who was always a bit sullen and restrained at such encounters, Matisse shone imposingly.'

The *Boy Leading a Horse*, a lovely painting that seems unforced in comparison to the many other studies of the same motif taken from *The Watering Place*, leads one on to consider, since they are also of nude boys, the significance of the main paintings that were done in Gosol in Spain in the summer of 1906. From what was said above, it would appear that Picasso was attempting to align himself with the French classical tradition, that he wished to absorb into his art much more of the richness of past generations; the *Saltimbanques* certainly suggests as much. Now, it is obviously simplistic to think of that tradition as a mainstream which one could enter, or ignore, at will; making significant art is evidently more difficult and more complicated than that. Furthermore, the situation in the years before Cubism was extremely fluid. There was such a variety of art, and such an absence of a leading style – the authority of Cubism itself was later to change this – that there was a great and perhaps unprecedented

41 HENRI MATISSE *Joie de vivre* 1905–06

42 *The Watering Place* 1905

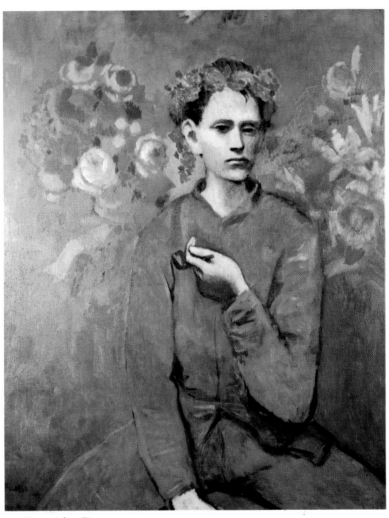

43 *Boy with a Pipe* 1905

opportunity for stylistic and cultural *choice*. In a few years' time, no young artist could begin a career without painting his way through Cubism. But in the twenty years or so before Cubism there were alternatives. We have seen how Picasso, whenever he was in Paris, showed a lively and eclectic interest in many different types of art, both contemporary and classic. The ease with which he could pick out, imitate, or absorb the leading aspects of any given style hardly

64

needs to be stressed. The result was a great freedom to do as he willed, to choose what sort of artist he wished to be. Picasso was still thinking classically and thematically when he projected *The Watering Place*. He now – late in 1905 and in 1906 – came to reject the kind of traditionalism that any accepted classical theme necessarily involves. He began to think in terms of pictures that would be singular rather than programmatic, and began to produce paintings which are

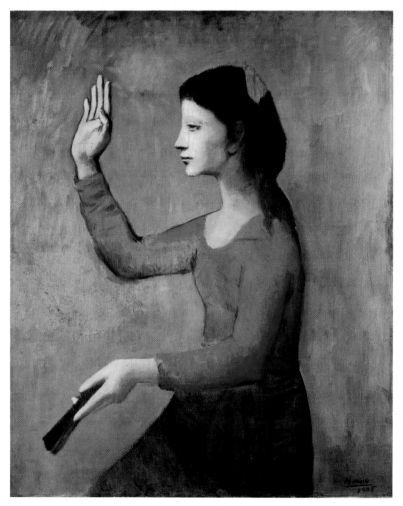

44 *Girl with a Fan* 1905

deny tradition or culture

singular not because they respond to a familiar tradition or culture, but because they deny such a thing, or look to a source so remote that it is the fact of that remoteness that counts.

Picasso and Fernande Olivier left Paris for Spain in the summer of 1906. During the spring Picasso had been engaged on a portrait of Gertrude Stein. She recorded that she had sat for him more than eighty times, but that he became increasingly dissatisfied: 'I can't see you any longer when I look.' The painting was put aside, and not completed until the autumn, when Picasso totally rejected its previously naturalistic character and painted out the work already done on her features. After a short visit to Barcelona, Picasso and Fernande settled in the tiny village of Gosol, in the Pyrenees. The village was primitive and difficult of access; their luggage was carried there on mules. Picasso was obviously struck by the wild country and the ancient and basic self-sufficiency of village life. Portraits of local peasant, of the innkeeper, of a woman with loaves, attest to this interest. Many of the paintings of the time are furnished with the traditional Catalan pottery from which they ate, and the pitchers in which they fetched water. It has been said often enough that Gosol was for Picasso as the South Seas were for Gauguin. This is not so. But something decisive happened there. It is all to be seen in that haunting picture *The Two Brothers*, whose mysterious boldness has always served to obscure how deeply imaginative it is, how radical and how intimately cognizant of the first nature of art. In this book it is considered, for those reasons, as the beginning of Cubism.

THE PROLOGUE TO the achievements of Cubism – the most radical change in art since the Renaissance – was appropriate, and perhaps necessary. Picasso experimented with standard types of painting, and he made an imaginative adjustment to past art which, in one case at least, *The Two Brothers*, can be described as an endeavour to find a primordial vision for painting. The great differences effected by the Cubist revolution were formal. But they were preceded by an important phase, the clearing of a space in which the new art could be made; and these preliminaries were in large part thematic. Picasso made some attempt to by-pass the European and classical traditions by subversion, where previously the relationship (as in the *Saltimban-ques*) had been one of ingestion. However much we recognize the radical manner in which the *Demoiselles d'Avignon* is structured, it is

imp.

still a thematic and even programmatic painting. The point is that the formal innovations of Cubism were not made without a new approach to the classic subjects of art. This is what took place in the remote Catalan village of Gosol, by all accounts as uncivilized a place as any in Europe.

The notion of primitivism as a tactic in modern art had originated with Gauguin. But just as Gauguin, in forming a mature Post-Impressionist style, had rejected the historicism of revivalist procedures, Picasso was now inclined to feel that there was rather too strong an element of *outre mer* Romanticism in the example of the painter who had meant so much to him three or four years before. Primitivism could surely avoid that kind of sentiment; and if so, there was the exciting possibility that it could be not merely descriptive of native or savage life (thus sympathetically employing mannerisms from local folk-carving or whatever: tourist art), but might be applicable to a wide range of classical subjects, including the post-Renaissance genres. Primitivism might be able to gather into itself all art from the beginning of art. If one could imagine oneself at the beginning of art, then all dependence on an immediately preceding generation could be thrown aside, since everything would be prospective; and, furthermore, this would avoid historicism. In the last quarter of the twentieth century, one can see many objections to such a programme: we now know more about such tactics. But the conceptual, anthropological or art-historical reservations that occur to us now were not Picasso's concern in 1906. As always, he trusted his instinct.

The result was that the Gosol phase was remarkably experimental (in the true sense of the term: an achieved work of art, however radical, is never experimental). Looking up everything that was done in the village, one finds that, unusually for Picasso, a major proportion of the works were tentative, were merely sketched out, were hardly begun before put aside, or were taken to some midway state and then abandoned. At the same time, maybe since primitivism implies universalism, there is a catholic attitude towards the genres (but one which still respects the notion of genres). There are portraits, nudes, still-lifes, a landscape, figure pieces; there are even preparatory drawings for sculpture or pottery (never made), and flower paintings. The landscape, which appears to be unfinished, was perhaps painted from Fernande's and Picasso's bedroom window, looking down over

53

51, 49

48

47 *The Toilette* 1906 >

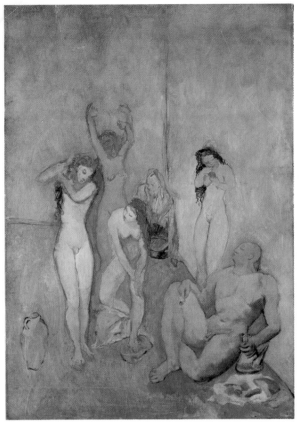

45 *The Harem* 1905–06

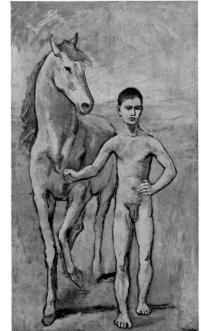

46 *Boy Leading a Horse*
1905–06

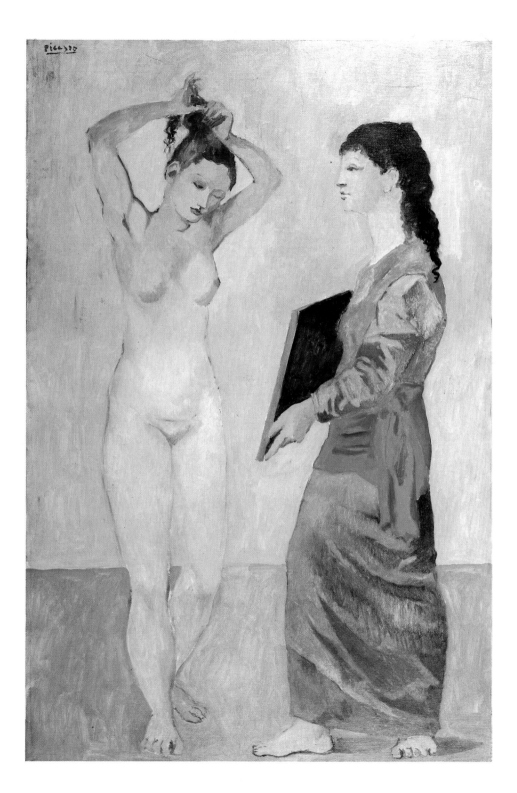

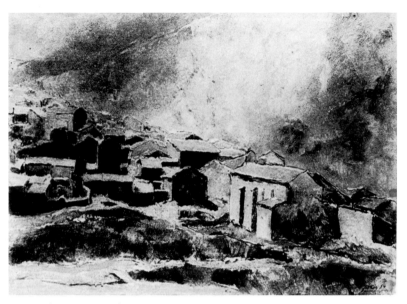

48 *Landscape at Gosol* 1906

the tiny one-room houses of the village, behind them the Sierra del
Cadi. It is not exactly a timid painting – Picasso never produced such a
thing – but it does appear unsure of its own rationale. This might be
said of a number of other works done at Gosol: all the still-lifes of
native pottery; the attempt at a large, El Grecoesque figure
composition, *The Peasants*; and the flower pieces.

Flower painting, extremely rare in Picasso's art, is the most
colourful type of still-life, and the most freshly bountiful. It was not a
subject that could easily fit into his character as an artist. This is to be
personal, maybe, but the pictorial and historical reasons are there as
well. Flower painting had more or less disappeared, once Post-
Impressionism and then Fauvism had made colour into a wide
painterly principle inapplicable to the denotative nicety after nicety,
in sprays and bunches, that flowers demand. (Van Gogh was the last
true flower painter, and in his oleanders and sunflowers we may see
this process at work.) One may suspect that Picasso's flowers were not
as casually undertaken as they look; they were another try at a
standard type, however much it might seem to be doomed to
irrelevance.

70

Two old and revered themes of the composite figure piece, the *coiffure* scene and the harem, appear during the summer at Gosol. The *Toilette*, meditated in a good number of preliminary drawings, became a beautiful oil. It is curiously abstracted both from precedents and from a credible social milieu. The prevailing palette at Gosol, of earthy pinks and ochres, is here lightened and made luminous. This is also true of the warmly modulated rose tones which unify the painting of *The Harem*. The subject is taken, in a general way, from the ambitious *grandes machines* of grouped nudes in secular post-Renaissance painting (and it is more like that tradition than it is like what Cézanne made of it). But the nudes are not assembled here in the grand fashion of such paintings, where a unifying coherence was obligatory. The figures of Picasso's women had all been separately studied and separately developed. The figures do not relate to each other compositionally, the more so since they are at varying stages of finish. The point of the painting must have been to see what could be done with six nudes; but since they so little mesh together, with their

47

45

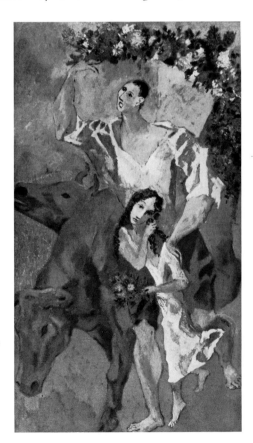

49 *The Peasants* 1906

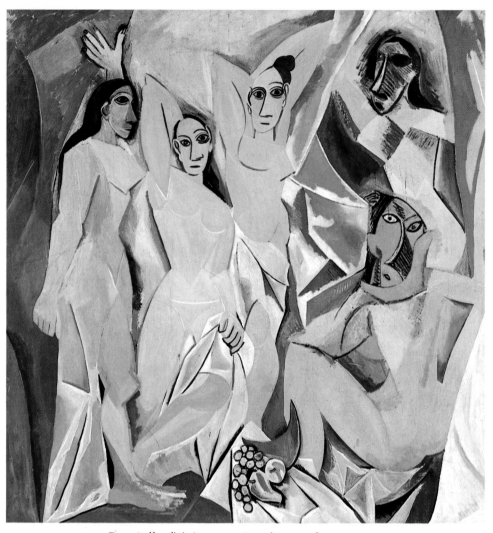

50 *Demoiselles d'Avignon* 1906–07 (see p. 79)

twisted and awkward articulation, it looks as if Picasso was seeking a repertory of forms rather than an orchestration of them. Within figure painting, the approach to a style had to be made through particular study: all-over replacements of previous examples were not possible. A year later, the experience of making the *Demoiselles* would confirm this.

50

72

It is a surprising use of the nude – in its day it must have been amazing – that controls the impact of the greatest of the images of the Gosol period. This is *The Two Brothers*. It may properly be called a haunting picture; for there are such paintings, and they have just this combination of an arresting address and an avowal of inscrutability, of something profoundly reserved. Such a union, much sought and seldom accomplished (probably it should not be sought), had haunted the Symbolist artists of the previous generation. The Symbolists were too literary, and were quite without the pictorial power needed to produce such a tremendous image as this: so frank, so explicitly of a naked adolescent boy carrying a child on his back, and yet primevally mysterious. The picture is a deliberate correction of much that went wrong in the Symbolism-influenced blue period, and of all that was static there. Its image and title supersede the picture of *The Two Sisters*, and its generative themes supersede those of *La Vie*. Its immediate ancestry in Picasso's art is clear, of course. But the familial themes of previous paintings, of circus folk and their kin, and the wandering band who halt at a watering place, are now so much stripped of their civilized resonances that we seem not just to be in an Adamic or prelapsarian world, but to be the witnesses of something more primitive still; and not only because Christian mythology is bypassed. That the boy has a Greek pose, and that the child – note the large head and the relations of the limbs – adds Christian overtones, hardly detracts from this impression. Picasso's imagination has caught something of a world quite unimaginably old, before history, where clothes were not known, nor agriculture, nor art. He has arrived at a metaphor for that chimerical obsession of modern art, the *tabula rasa*. Since this is a metaphor, the burden of the painting is of course thematic; and, indeed, there is nothing particularly original in the way *The Two Brothers* is constructed. But a step had been taken that gave him some kind of psychological freedom, that allowed him to assert an independence from any art then considered in Paris as advanced.

Back in Paris, he immediately returned to the portrait of Gertrude Stein which had caused so much difficulty. Now it was easy. He painted out the face and replaced it with strong, mask-like features derived in part from ancient Iberian sculpture, and not unlike some vehemently stylized recumbent portraits of Fernande he had tried out in Gosol. Anecdote sometimes has it that the difficulties with the

painting were psychological, something to do with that psychic contact that is reputed to flash between the painter and his sitter. This was not so: one thing that Gosol had taught Picasso was that Gertrude Stein herself was not the problem about the problem of Gertrude Stein's portrait. Picasso's famous remark to a person alarmed by the picture, that in time she would come to look like that, reads now as a fine presentiment that portraiture could never be the same again, except through trickery or the assumption of a retrograde style.

All the same, portraiture briefly appeared as an interesting field for making anti-naturalistic advances in art. He brooded on this in the next month or two. The result was a couple of salient self-portraits. The human face, so changeful, subtle, and quintessentially individual, can yet be reduced to a very few elements, and so schematization has a heightened identity as such when applied to a genre which previously had prized an elaborately skilful naturalism. These new self-portraits might be compared with the one inspired by Van Gogh four years earlier. The attribute of the palette is reintroduced, but a normal and acceptable mimeticism is eschewed. The portrait is recognizable as a picture of Picasso because the face can summarily be made recognizable; but the making of the picture is now boldly within the realm of advance in art.

51 *Reclining Nude* 1906

52 *Self-portrait* 1906

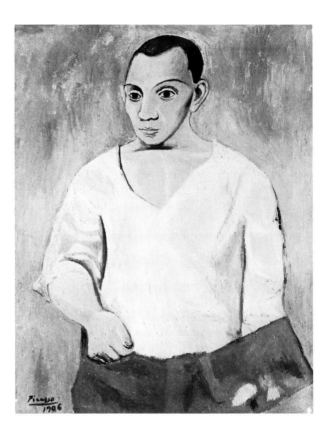

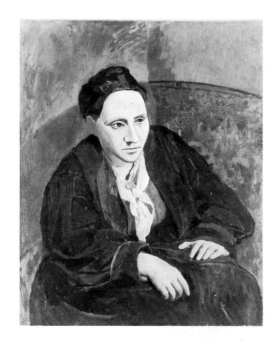

53 *Gertrude Stein* 1906

WE SHOULD PAUSE HERE to remark on a characteristic of Picasso's art which is so general, and so taken for granted, that it is often overlooked. This is simply his great fecundity in creating masterful, 'unforgettable' images, generally human ones. It is a characteristic gift that varies according to the more important qualities that at any time are the leading features of his art. It first developed, this gift, at the end of the blue period, and so it is perhaps a sign of maturity; but it is not apparent in his most mature and important paintings, those of Cubism. This particular kind of inventiveness is a significant part of Picasso nonetheless, and though it is more apparent in him than in any other painter, ever, it is not exclusively personal. One thinks of Manet in this connection; what the two artists had in common was a feeling for flexibility in style and a most retentive memory for previous images. Perhaps these things go together.

An immediate example of Picasso's superb ability as an *imagier* is *The Two Brothers*. Just now its Greek and Christian motifs were mentioned. But the painting is also conscious of Cézanne, in particular his *Mardi Gras* of 1881 (it was in Vollard's gallery in 1904); and it is not conscious of Cézanne in a constructional sense, in the way that Cubism was; Picasso, in this instance, was just attracted by the image, which he brilliantly and surely compacted in such a way that it is the earlier image, not the later one, which seems derivative. Other images, such as the powerfully outlined post-Gosol self-portraits of 1906, came about because the impulse towards the schematic was not yet associated in Picasso's mind with conceptualization. But these portraits, being so near to Cubism, are rather a special case; at other times we feel less historically minded about it all, and just enjoy the inventive fertility; over the years a cornucopia of things which are terrible, wistful, playful, and all by Picasso. Often enough these images seem to have come about as the result of some bizarre decision, or inspiration. The *Boy with a Pipe*, for instance, was recalled by the poet André Salmon as having this origin: 'One night Picasso deserted the group of friends deep in intellectual discussion; he went back to his studio and, taking up this picture, which he had left untouched for a month, gave the young artisan in it a crown of roses. By a sublime stroke of caprice he had turned his picture into a masterpiece.'

Certainly, reading this account, one is inclined to feel, with Salmon, that a chance idea made the picture. That may be so with many of Picasso's images, the ones that seem too right to be fictitious,

and yet are so: two women in flight, a lonely acrobat, sleeping peasants, a naked girl dancing by the sea.

A PAINTING MADE very late in 1906, almost certainly the last canvas before the *Demoiselles d'Avignon*, further stripped down the classical themes of the harem and the toilet of Venus which were considered at Gosol. This is known as the *Two Nudes*. Grace has been transmuted into massive, immovable bulk. The continuity with previous uses of 54 the themes is there in the *profil perdu* of the right-hand figure, and the repeated gesture of the arm raised to plait the hair. But this has an inappropriateness which stresses the new physicality of the con- ception: its plasticity, its sculptural quality. Picasso is no longer interested in the reflexive uses of a mirror, but emphasizes rather that the subject has been studied again from a different viewpoint; for are these two nudes not one and the same woman? This point – only a

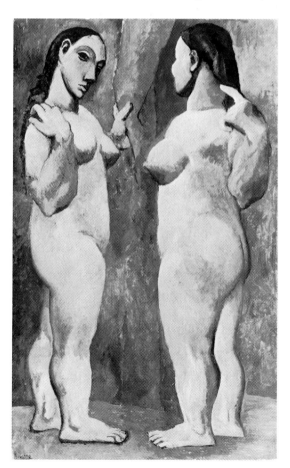

54 *Two Nudes* 1906

psychological guess – is perhaps supported by the fact that the modelling is not consistent with a single source of light, but appears rather to have been twice studied, as though Picasso were trying to get all round his subject – now most avowedly three-dimensional – in one pictorial conception. With this impulse comes a very raw application of paint, as though the artist were annoyed, especially in the arm of the left-hand figure and the back of her *Doppelgänger* companion. That sort of frank treatment, and even the nakedness of the figures, emphasizes the tremendous distance Picasso had travelled since he painted a similar 'subject', the *Two Sisters* of the blue period, five or six years before. He had become a better painter in many ways; but his major conquest had been the rejection of the facility which led him towards the illustration of a subject rather than the making of a picture.

14

The *Two Nudes*, with several of the Gosol studies of women, indicates the interest that Picasso felt for the figure painting of Cézanne, in particular the great series of pictures from Cézanne's later

55 PAUL CÉZANNE *Three Bathers*

years known as the *Bathers*. He was not alone in this. Cézanne was much appreciated by painters of the new generation (like Derain), and by a previous generation too; Matisse had been looking hard at him since at least 1899. The large Cézanne retrospective at the Salon d'Automne in 1906 confirmed rather than created a respect for the master among the avant-garde.

Soon afterwards, at the beginning of 1907, many preliminary drawings for the *Demoiselles d'Avignon* indicate that Picasso was thinking of a painting of monumental nudes along the lines of the late Cézanne. He seems to have wanted to make this picture allegorical, but with a brutal and sexual allegory, not a placid one *à la* Puvis de Chavannes. Cézanne could also give a lead here, in paintings like his *Temptation of St Antony*, for Picasso's intention was to set his picture in a brothel. There were to be two characters more than the ones in the picture as we now know it: a sailor, and a medical student entering from the left and carrying a skull. These were abandoned during the deliberations about the painting. As a matter of fact, so was much else that was Cézannesque. Only in one part of the picture as we know it may we be sure of a specific rather than a general debt to Cézanne. This is in the pose of the squatting figure on the right; it surely came out of Cézanne's *Three Bathers*, owned at this time by Matisse.

55

The *Demoiselles d'Avignon* is an extraordinary painting, so much so that its debts to Cézanne and to African art and its role as a progenitor of later Cubism are all overstressed, as if historians were trying to tie it down. It is interesting to see how violently the painting leaps away from the drawings which preceded it. Some of them are almost tamely Cézannesque. They do not prepare for what we see on the canvas, a wildly jagged articulation. The shrieking lack of harmony goes way beyond any of the quite stately disproportionateness, much deliberated, that is in the Cézanne *Bathers*. As Picasso's nudes went on to the canvas, their violence increased; and the radicalism of the painting increased the more it was worked on (in all, probably a period of some six months). There was never before – and never has been since, one might add – a painting with such a system of internal torques, volume made into a twisted or scything line. That is, what are here called torques are not like the 'facets' we usually speak of when discussing developed Cubism – roughly, parts of a depicted object, observed from any angle but brought round frontally to help

50

define the object's construction. For the *Demoiselles* is not at all ratiocinative in this fashion. It is a very urgent and very *free* painting; free in the sense that it is not dependent on previous deliberations, whether Picasso's or anyone else's. And its internal parts, which do not follow the figural sketching of the initial proposition, are large enough, and strongly enough made, to present themselves as shapely areas: the torquing becomes gores, slices, lozenges, wedges, crazed trapezoids. The fact that the *Demoiselles* is a figure painting, however tenuously so, has obscured this essential part of its character

The figures are conceived in shallow depth. There is little modelling except on the right-hand side, where it is done by barbaric striation; this is the part of the picture that was reworked later. As in 54 the *Two Nudes*, there is a suggestion that a curtain is being pulled back by the woman on the extreme left (this is explicit in the drawings), but that hardly means a deep illusion of space, rather the opposite; and the ochred-brown gores which represents the curtain are not particularly legible as such. The *Demoiselles* is a very shallow painting, and is also very frontal (note how many of Cézanne's bathers are turned away from the spectator); we tend to read it across its surface, and not think at all in terms of the perspectival box which is the inheritance of Western illusionism.

Now, this significantly does not follow the lead given by the 36 *Saltimbanques*: that work strongly suggested that any major new painting of a good size would henceforth be of an expansive sort (although this impression may be retrospectively enforced by the need of post-war art for all-over, edge-to-edge paintings). This is another aspect of the singularity of the *Demoiselles*. For it is an *implosive* painting. The many things that happen in it are held into it. It has nonetheless an internal organization which makes for a freedom and a 'breathing' where the vitality of incident, maybe liable to jostle, would otherwise have been constricted. There is a multiplicity of areas or passages or special lines which serve to give air to the interior. The torqued areas in this part-to-part painting are allied and elided by very ragged strips of white, maybe a couple of inches wide, which negate the decisiveness of the plane-defining line. The draperies often have the same function, and so too has the way that the second woman's bosom and pelvic triangle are drawn in white lines. All this is most dramatically done in the part of the painting *between* the two later right-hand figures and the three on the left. If we make a

progression down from the top of the canvas between these two groups of figures, and then down to the complex adjustments at bottom left, it becomes clear – and clearer as we move out from this corridor – that Picasso was creating an extraordinarily new kind of painting, in which there was a free lack of concinnity, where the echoic was clashed; a painting that had clumsy relations of part to part, at first sight, and used strongly-drawn outlines without holistic or even definitive intent.

There was a long period of intense work on the *Demoiselles d'Avignon*; but it was not the kind of painting that got finished by many hours in the studio. It was a progressive painting, but one which in the end was carrying too much. When we look at all that we know about the way it evolved, we notice signs of indecision, and then solutions; but in particular we find a break in the way that it was painted, and after that the incorporation of a new and alien style. The standard critical and art-historical interpretation is that the *Demoiselles* was abandoned. On the contrary; it looks that way because it was over-used. After half a year's work on one painting, there was a difficulty in maintaining the high daring of its manufacture. Picasso was so aware of this that he overreached any reasonable finality in the painting.

In no picture before this one had Picasso taken so much trouble in making initial enquiries and sketches. But further, no picture of his had then had to be so dramatically transformed while he was at work on the canvas. Between paper and canvas there had been an aesthetic leap, one that demanded the excision of the thematic underpinning of the sailor, the student, the recognizable setting in a brothel. Picasso had not before made such a shift in a big painting. A lot of ground was being covered, for Picasso was accelerating and abbreviating Cézanne's comparable rejection of the illustrational. So we should now consider the internal history of the *Demoiselles*, with particular reference to its finishing point, for this makes plain the kind of thrust he was making, and how he managed to get all his feelings about new painting into separate, coherent, and interdependent works of art during the high Cubist period; that was something important that he learnt from the *Demoiselles*. We want to know whether Picasso finished the painting, but then reworked it; or whether he left it to sleep for a while, conscious that it was not finished and would need to be reworked; whether there was some plan for a really long-term

involvement with the same canvas; or whether (this is the orthodox view) he merely abandoned the painting. These are the main possibilities; other interpretations of what happened either combine or confuse them (though this may be psychologically apt).

The orthodox assumption is such a limp one that it has never been definitely stated, and the evidence should incline one towards the first of these interpretations – that of a finished painting subsequently reworked – for the following reasons. There are good grounds for believing that Picasso left Paris for a holiday in the summer of 1907. This is in Salmon's account; and he was an intimate friend, living in the Bateau Lavoir at the time. It is reasonable to suppose that Picasso left town as soon as he had finished the painting (though on the other hand he might have decided to let it sleep, bearing in mind the example of the Stein portrait the year before). But what is now established is that in the autumn the picture was further attacked, with the impulse of a fresh and unsettling influence, and that this resulted in the overpainting of the two figures on the right. X-ray evidence confirms that they were originally in the same style as the rest of the picture, and this of course supports the view that the picture was at one time finished. Now, this sudden overpainting has to be ascribed to Picasso's new interest in primitive African art, especially its sculpture, which he discovered in the autumn of 1907. This is always regarded as so splendidly innovatory that it is not remarked how it might have been alien to the *Demoiselles* as it then stood. It is sensible to suggest that the African overpainting improved the picture not at all. It is significant that Picasso decided not to go on with the remodelling of the figures in this new, primitive idiom. So we might say that the 'abandonment' of the painting was at the point where Picasso realized that he did not wish to paint over the rest of the picture in this mode. And therefore a hard view of the matter would be that the picture had already been spoilt.

Picasso was about a year behind the rest of avant-garde Paris in becoming interested in primitive African art. Vlaminck, Derain and Matisse were already collectors; in the previous year Derain had taken the step of combining the influences of African art and Cézanne in one painting, his *Bathers*. On the other hand, Picasso had already experienced a more profoundly imaginative attraction to primitivism than they, if the interpretation of *The Two Brothers* given here is accepted. In a way, that experience was in itself more important than

any artifacts that might be said to have inspired it; that is, the experience gave psychological body to the eclecticism. So Picasso could ingest more than the other artists. John Golding's classic account of Picasso's relationship to primitive art in the *Demoiselles* notes that already in 1906 his work could be said to be derived from 'Greek white-ground vases, archaic Greek and Etruscan marbles and bronzes, and Cycladic and Mesopotamian figurines', as well as the Iberian reliefs from Osuña in the Louvre (a likely source for the reworking of the Gertrude Stein portrait). Now, in late 1907, it seems most likely that a visit to the Musée du Trocadéro with Apollinaire suddenly and violently gripped Picasso with the feeling that African sculpture too could be made into modern art. In the *Demoiselles* we can see how intensely this revelation was applied to two of the figures. But we should have some reserve about this, and note that the influence is primarily cephalic, confined to the facial, and does not account for the most radical aspect of the right-hand half of the picture, which is that different views of an object are combined in one image.

The influence of African art on Cubism is an overblown episode. There has been much interest in rival accounts of when the artists concerned first saw, began to collect, or introduce into their own work these dark and totemistic objects. But an influence is not to be evaluated solely by the first excitement it creates. Why not enquire when Picasso lost interest in African art as a pictorial aid? What we then find is that the developing logic of Picasso's art, European in nature and largely mediated by Cézanne, quickly made irrelevant any help given by these artifacts. By the summer of 1908 it is clear that the brief enthusiasm was over. This was when Picasso was painting at La Rue des Bois, in the country thirty miles outside Paris, where he produced a number of landscapes – never a subject that he found particularly congenial, but one that was perhaps essential if he was to come to a deep understanding of Cézanne. Landscape is of course a genre that does not exist in primitive art. Africanism had been an abrupt and dramatic incursion. When we look at the works that belong to the 'Negro period' we find not more than a handful of paintings (and two or three sculptures that seem to have been hidden away), which are strongly individual, striking, and anomalous.

Having repainted two of the figures in the *Demoiselles* in this manner, Picasso turned the picture to the wall. Not many people saw

it, and according to Salmon (in *La Jeune Peinture française*, written soon enough afterwards, in 1912), they were disappointed. These visitors were intimates and *cognoscenti*. If they withheld their approval from the painting, perhaps this was not because of its transgressions of the ordinary 'canons of beauty' but rather because of its almost vicious attitude towards the current situation of the Parisian avant-garde, the people who were trying to do the new paintings. The *Demoiselles* has a savagely polemical stance within the art community itself, let alone the outside world. Those whom Salmon called 'the familiars of the strange studio in the Rue Ravignan who put their trust in the young master' were disturbed by an *anti* Cézannian flavour to the picture. The *Demoiselles* seemed wilfully different from Derain's Cézannian bathers, and from Matisse's great work of 1906, finished in 1907, the *Joie de vivre*: it was said, even, that the *Demoiselles* had been prompted by that work, and was executed in a spirit of bitter parody. The avant-garde, Picasso apart, was in a sober and deliberate mood in 1907. This was natural enough after the sudden collapse of Fauvism and with the increasing respect for Cézanne. Picasso was unconcerned with the former and behind the times with the latter, so that he seemed to be wantonly rejecting all that had come out of his contemporaries' efforts, their ambitions and their patience.

With one artist, especially, the impact of the *Demoiselles* was crucial; this was Georges Braque, introduced to Picasso by Apollinaire at just this time. Braque was the same age as Picasso. He was a Norman, from Le Havre, and like Picasso he had been in Paris since 1900. He must often have heard of the Spaniard before they met. From late 1905 or early 1906 Braque had been painting in a Fauvist style – he was close to Matisse, Derain, and Vlaminck – but with a rather more subdued palette than theirs, and with an interest in the depiction of volume that derived from Cézanne, after 1904, but also from such masters as Poussin and Corot (the Corot of the figure paintings). The Fauvist elements in his style – which in fact had been the basis of it – were fast disappearing by the time he encountered Picasso. The effect of visiting Picasso's studio was to confirm Braque in his not quite formulated ambition to make a more structural kind of painting.

Four or five months after the two young men met, Braque produced his *Large Nude*. As has always been recognized, it is a painting much indebted to the *Demoiselles d'Avignon*. We see this in

84

the large size, the fairly similar palette, the distorted figure and the torqued background (though the inactivity of Braque's background and the lumpy planes which enclose his figure demonstrate how vital were Picasso's implosive structure and constantly activated space). This was Braque's first painting of a nude. In fact, he never in his life made figure paintings except when directly stimulated to do so by Picasso, as happened late in the 1920s and again in the 1930s. So we recognize the importance of the *Demoiselles* to Braque. However, a drawing recently discovered by Edward F. Fry, which must predate the *Large Nude*, allows us to see that Braque's mind was more generally engaged with Picasso's art, and that he was very soon considering what came to be a basic assumption of Cubism. This drawing is of three women, seen from complementary angles: in profile, from the back and from the front. Braque said of it that 'it was necessary to draw three figures to portray every physical aspect of a woman, just as a house must be drawn in plan, elevation and section'. Clearly, when looking around in Picasso's studio Braque had given much consideration to the painting in which this principle is adumbrated, the *Two Nudes*. He must have been taken with the picture's massive plasticity. What he had in mind was the reconciliation of this kind of volume with the picture plane as such. But this was difficult to get into a painting. In the *Large Nude* he adopted the technique in the *Demoiselles'* squatting figure of distending one part of the body in such a way that it seems to have been observed from a different viewpoint; but this was in many ways a partial solution to a problem which was not yet posited as a problem. Looking at Braque's *Large Nude*, one is not exclusively conscious of the debt to Picasso. In the drawn outlines of the figure we see just as much of Matisse's recent work, and the brushwork, especially where it is most applicable to modelling, bespeaks the constant presence of Cézanne. What we do *not* find in this painting, nor for that matter in any other work of Braque's, is a real indebtedness to African art. While Picasso, in the year after the *Demoiselles*, was producing the cluster of paintings that make up his 'Negro period', Braque was turning his attention to Cézannian landscape.

Picasso's use of black art may be swiftly summarized. It meant masks instead of faces, striation rather than modelling, and the employment of totem- or dervish-like figures and outlines to give a *frisson* quite alien to the European tradition, and the more startling

because of its evident derivation from outside that tradition. What black art could not do was to help in the formal, holistic enterprise of a picture. It was bound to be illustrational. There was no way in which it could alter the relations between discrete major incidents in a painting, no way in which it could deal with volume and space without recourse (Picasso tried this) to a violent and arbitrary extension of the primitive system of striation. But bold, separated, stick-like lines of paint could not replace modelling, nor even begin to reconcile depicted volume with the picture plane, without turning the picture into one that was just too aggressively to do with striation. And striation in itself is not very interesting, and gets ugly as soon as a wider pictorial interest is lost. There is a common argument, one which works best when divorced from pictorial evidence, that Picasso found African art to have a 'conceptual' nature, and that this was attractive to him. The assertion is of course unproven. The fact is that the 'Negro period' is not a coherent phase in itself, but is the leading feature of a period of indecision which lasted more than a year, after the mistaken overpainting of the *Demoiselles d'Avignon*, a time during which Picasso retreated rather (as Braque did not), did some brooding, and made some mistakes, including some startlingly bad painting. There is of course an absurdity, simply an absurdity, in the notion of African methods being applied to another flower painting, but this happened in early 1908. It is an odd picture. It is very

56 *Vase of Flowers* 1907

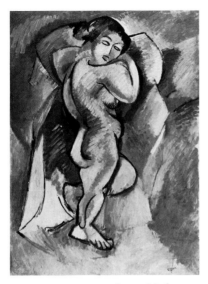

57 GEORGES BRAQUE *Large Nude*
1907–08

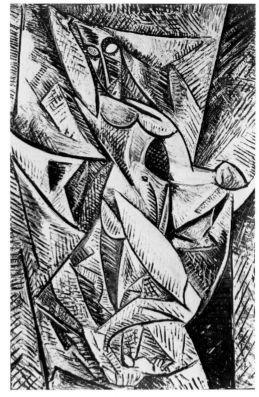

58 *Nude with Draperies* 1907

strong, but as though it were painted by two people. Just after the *Demoiselles d'Avignon* Picasso was subject to wavering and even incoherent impulses, in a way that Braque, a slower and less impulsive worker, was not. Picasso needed Braque.

The peak of the African style, and probably the last thing done in the manner, is the Hermitage's *Nude with Draperies*, which takes the 58 alien *frisson* to a barbaric extreme. This alone might remind us of what Picasso soon came to realize, that it was a dangerous thing about the manner that it had to live at extremes. It was strident and inflexible. But Picasso got as much from it, formally, as he could: the use of striation as a substitute for modelling is here expanded all over the picture. In the *Vase of Flowers* the sticks of black paint in unexpected places were wilful; here they define the ground as well as the figure in a way that would be systematic, were it not for the fact that they are more pronounced *outside* the figure. There is an excited virtuosity in the alliance of the torques surrounding the nude, in the way that the

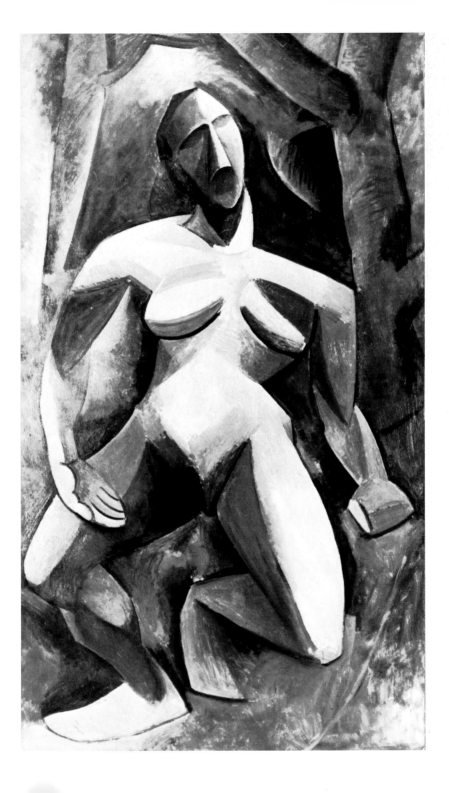

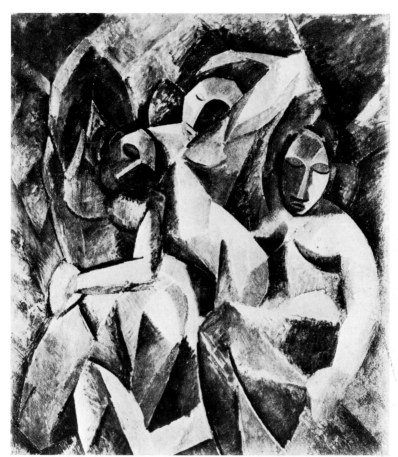

60 *Three Women* 1907–08

sticks of colour bring everything to the picture plane, but it must have been apparent that this was a terminal position within the means of the 'Negro' style. He dropped it immediately, and in three or four figure pieces attempted to consolidate volume rather than surface. We find this in the *Bather* (almost a ludicrous picture), the *Large Dryad*, and the *Three Women*, which was not finished until very late in 1908 and may have been begun before the other two. What helped Picasso, though, much more than any of this, was painting landscapes at La Rue des Bois in the summer of 1908. In these pictures and the subsequent still-lifes one is most aware that Braque's steadier example had brought Picasso back to Cézanne.

61, 59
60

< 59 *Large Dryad* 1908

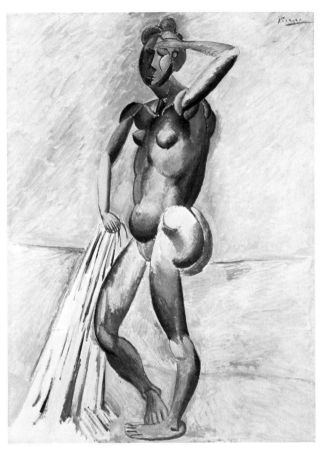

61 *Bather* 1908

In 1908, Picasso gave the famous banquet in the Bateau Lavoir in honour of the Douanier Rousseau, a disorderly occasion, filled with *mauvaise foi*, attended by the Steins, Marie Laurencin, Salmon, Jacob, Apollinaire, Ramón Pichot, Braque and others. It is often said that at this stage Picasso was influenced by the naive vision of Rousseau, and that the Rue des Bois landscapes owe something to his unconventional simplifications. It is thought of as another type of 'conceptualization'. But a naive view of a landscape does not necessarily conceptualize it; and even if it did, where then is the gain to the picture? And if this was a real influence, does that not presuppose that Picasso would not have taken the step of simplifying elements such as trees and houses by himself? However much Picasso enjoyed the Douanier's paintings, with their eccentric qualities, one

feels that the affinity was largely social. Picasso and his friends were taken with the personal and pictorial innocence of this old man from a previous age (for Rousseau was a contemporary of the Impressionists), and enjoyed his pretensions to high art; they were amused by his unsophisticated rehandlings of salon *machines* (for many of his paintings, even those which seem as individual as the marvellous *Sleeping Gypsy*, were in fact reworkings of academic paintings he had seen the year before); and they liked the idea of naive art as the new folk poetry of the industrial city. But there was much equivocation in their attitudes. Apollinaire, for instance, was writing cutting criticism of Rousseau in 1908, the year of the banquet: '[he] knows neither what he wants nor where he is going. . . . One is irritated by Rousseau's tranquillity. He has no anxieties; he is contented but without pride. Rousseau should have been no more than an artisan.' Picasso guyed him. The Douanier's (Apollinaire invented the nickname) remark that he was the master in the 'modern' style, Picasso in the 'Egyptian', illustrates what a gap in comprehension there was, how one-sided in terms of sophistication was the relationship between the old eccentric and his young friends; and it demonstrates too the gulf between the new fine art, deeply meditated, and the fortuitous, happy success of the amateur.

It might as well be acknowledged that just here, in this *lack* of a dialogue between primitivism, naivety, amateurism, sophistication and innovation, there is a final break between the avant-garde and derivative or marginal artists. A tight communal situation some years before, in the group around Gauguin, had adumbrated some of the pressures which lead a self-consciously advanced group of artists to isolation and a high sense of purpose. Yet those artists, or a good number of them, had been essentially romantics, where the Cubists were not; they had been conscious of their camaraderie almost as an artistic value, while the Cubists were not; and the situation at Pont-Aven had been curiously open to amateurs, while Cubism would always exclude such a rapprochement.

The Cubist years before the First World War most decisively isolated the avant-garde as a separate enterprise, of no conceivable interest to the bourgeoisie, to the common man, or for that matter to lesser artists. It became élitist. This has troubled many commentators, and some artists, who find the thought of an élite culture disagreeable; but it is nonetheless a fact. The extreme contrast between the

high quality and occultation of Braque's and Picasso's work during the next decade and the thousands of lax, attenuated or stupid pictures made after their example is evidence enough of the gap. Léger and Gris were the only two artists who managed to join Cubism and at the same time remain thoroughly independent painters, and they had to do so by expunging all their previous artistic experience. Other artists who were in the Cubist circle from an early stage of the movement, like Derain and even Raoul Dufy, very soon had to retire: the pace of innovation, Cubism's emphasis on achievement rather than accomplishment, were too much for them.

Dufy, in the summer of 1908, accompanied Braque to a famous Cézannian site, L'Estaque. Braque painted Cézannian landscapes there with much confidence, so much so that – while the influence of Cézanne is deeply in these pictures – he was not making them before the motif. Picasso was at La Rue des Bois; curiously, although he had not painted from nature for two years or so, he did so now, though it is not clear that any single painting was totally produced in this way. It was surely Picasso's interest in fathoming Cézanne that led him to work in this fashion, and the preponderance of landscapes, not usually a part of Picasso's repertoire, confirm this. Picasso now introduced to some of his paintings a significant technique which derived from a study of Cézanne. This was *passage*, by which the definition of any object in fictive space was elided, merged with contiguous forms on the canvas with which, if the space were real, it would be in a relationship measured by depth. Braque's painting at L'Estaque showed a similar interest in the method – and probably a more advanced interest, for Picasso did not open his drawing as much as Braque. In a painting fully regulated by *passage*, drawing would of course tend to disappear, since any closure of the contours would militate against the brushy melding; but Picasso's firmer graphic sense, as well as his sculptural sensibility, led him to affirm volume-defining contours however much he was using the example of Cézanne to bring all the elements of his painting up to the picture plane.

In the still-lifes painted at La Rue des Bois and on his return to Paris, we find him attempting the Cézannesque depiction of fruits and fruit-bowls; but one of these bowls has a remarkably undulating rim whose depiction is therefore the more obviously contoured. In 62 this painting, the *Bowl of Fruit*, Picasso adopts Cézanne's strategy of poring over his subject from an unusually high viewpoint which then

tilts the plane of the table up towards the surface plane of the picture. Again, different objects are observed from different angles, so that contradictory perspectives are combined in one painting. This should be thought of as a more definite, more deliberate casting of the way that Cézanne had moved around objects in painting them, and had altered the painting in order to relate one part of it to another.

62 *Bowl of Fruit* 1909

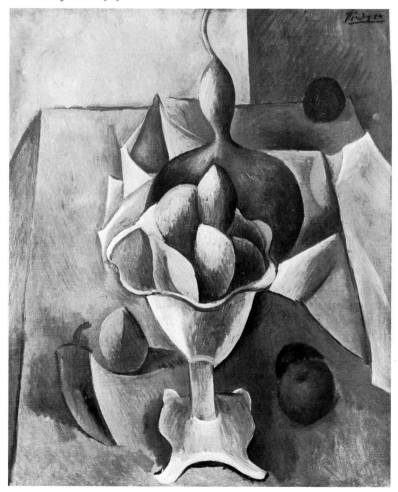

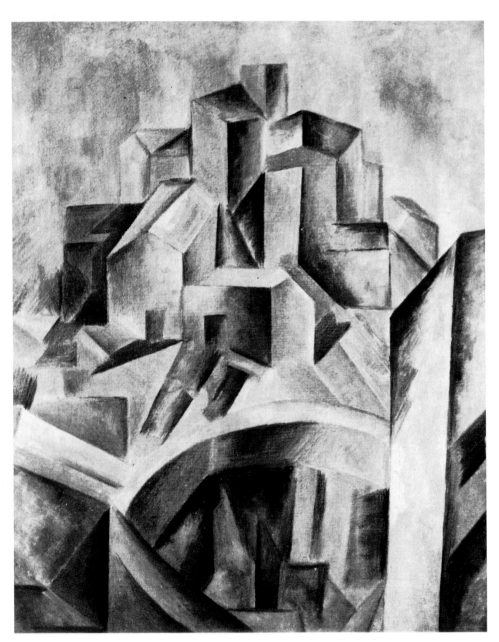

63 *The Reservoir* 1909

3 Cubism

IT WAS IN THE AUTUMN of 1908 that Cubism was christened. Braque had brought a good number of canvases back from L'Estaque, and decided to show them at the Salon d'Automne. He did not yet share Picasso's distaste for mixed public exhibitions. Some of the paintings were rejected by the jury, which included Matisse; Braque withdrew all of them and showed them together at Kahnweiler's. Braque maintained to the end of his life that at this time Matisse had spoken of *petits cubes* in his paintings, and that this description was appropriated by the critic Louis Vauxcelles and made current. Braque and Picasso were not yet the close friends they were to become, but they must have talked a lot that winter, and certainly they looked at each other's work. It was apparent that during the months that they had been apart their painting had become closer, and that in L'Estaque and La Rue des Bois they had separately been examining the same problems. It is remarkable that the same thing happened while the two painters were out of Paris in the summer of 1909, this time for longer periods. Picasso was away from May to September. He stayed in the small Spanish town of Horta de San Juan, and there he produced two important series of paintings, of landscapes and figure heads.

The most beautiful of these landscapes of 1909 is *The Reservoir*. It is a picture which serves to define the first phase of Cubism: the so-called analytical phase. *Passage* is now used as a coherent principle throughout the painting, not in some parts of it. In all the houses and in the (very Cézannian) form of the reservoir at the bottom of the picture, there is no longer any feeling that mass is being represented as mass, but rather that the facts of the visuality of the village are transformed into shifting and merging planes, that everything is being dissolved. There is an illustrational way in which this is emphasized, for all that we see in the reservoir itself as notionally the

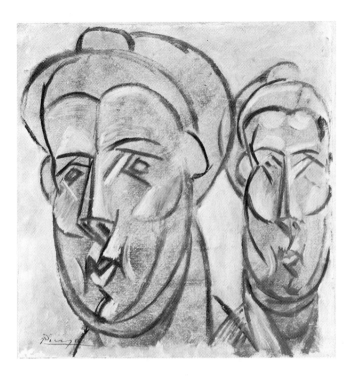

64 *Two Heads* 1909

reflection of the houses above is in fact represented in continuous planes, as though the point where we differentiate between verticals (house walls) and horizontals (an expanse of water) had been totally negated. To add to the tactile and unequivocally painterly nature of this representation, the sky is painted in solidly rather than aerially (Braque had done this too), and the method used to paint the houses forbids us to read any space between them. The palette here, as with all the Horta landscapes, now becomes most characteristic of early Cubism, dominated by buffs, ochres, greys and browns. The dissolution of houses into ambiguous relationships, the making of a fan-like perspective that opens out where traditional painting would have closed it, the persistent tilting of planes towards the surface of the picture, all make the painting centrally important in the development of early Cubism.

This is less the case with the other type of picture that occupied Picasso during his months at Horta, the painting of the human head, for faceting had not yet become sufficiently autonomous to carry the sort of rearrangements of the head that Picasso was making; the

96

psychological potency of the human face was too strong. Picasso, always more attracted to the figure and to portraiture than was Braque, found it hard to give up the representation of the human, as perhaps it would have been wise to do, and the attempt to give new forms to the head was a preoccupation of the Horta period. Many drawings, gouaches and oil sketches attest to the way Picasso tried to reduce the face to various sculptural components; sometimes, early in the summer, with reference to a kind of hacked, wooden development of the heads in the *Demoiselles*; later, as in the *Two Heads*, with 64
curiously scalloped lines. These are clearly experimental works.

The persistent attempts to paint Fernande in a new way were best achieved in the *Woman with Pears*, where the discoveries of *The* 65
Reservoir are made more clenched, more as if they had to do with a struggle for expressing, *realizing* something. At first sight, this might seem a disagreeable portrait, for Fernande's neck and shoulders are tugged round towards the picture plane and all the rounded incidents of the face, the chin, nose and high forehead, are cut with hewn angles, as though it were Picasso's intention to make the sculptural quality as angular as possible. Traditional portraiture, famous for its dependence on the eyes and the mouth for revealing character, is here slapped down. The eyes are heavy rectangles, the mouth coarsely V-shaped. The aggressive nature of the painting, often said to be a search for analysis, can hardly be explained by merely asserting that it is part of a desire to display all available information. Picasso and Braque were concerned with managing different aspects of a form into one image, certainly; but this was hardly the whole ambition of the painting: enough was known about what things looked like already. It had a function as a mechanism to expand the number of things that one could do to depiction as a function of painting rather than as a report on the real world. But early Cubism could not expand on this: portraiture was too intimate a mode. Fernande's portrait is more relaxed and more painterly in the less essential parts of the picture, away from the face; in all the passages, half scoured, half fluffed, in the lower part of the painting and its slate-grey top, in the still-life and the curious impulsion of the bottom part of the green curtain – an individual diagonal common in Picasso around this time which comes straight out of Cézanne. *Woman with Pears* does not achieve the wholeness of *The Reservoir*, though it is a far more determined 63
painting; and it seems that a still-life, strangely the only one known to

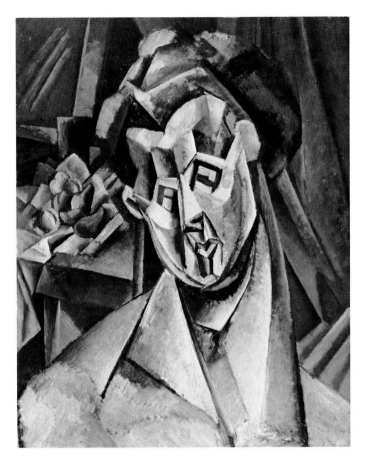

have been painted at Horta, has the best resolution of everything that was discovered that summer.

66 Late in life Picasso confirmed that this important painting, previously misdated, had in fact been executed at Horta, and he elucidated – as indeed is necessary – the content of the picture. It is of a *botijo*, in the shape of a cock. This is a ceramic drinking vessel. Its spout is the cock's head, and this can be distinguished in the upper right-hand area of the picture. To the right of this and a little below is the still-wrapped copy of a newspaper which had been mailed to Picasso. More legible is the glass with a straw between the newspaper and the *botijo*, and the diagonal towards the left of the picture represents a decoratively cut liqueur bottle. The very illegibility of these elements suggests that Picasso had passed some kind of frontier, that he was no

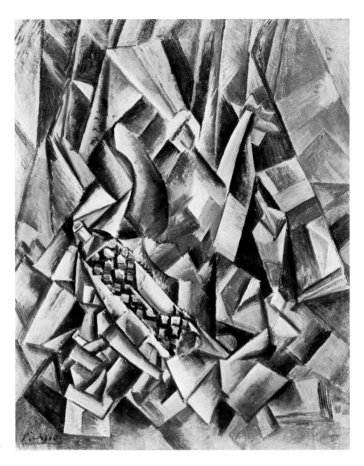

66 *The Botijo* 1909

longer at all interested in the 'analysis' of the subject as having a public
dominance over the substantive facts of the picture itself. The result,
compared with the *Woman with Pears*, is a kind of liberation from the 65
demands previously held to be applicable to a painter's talent for
observation – as if the demands were now being made of the
spectator. *The Botijo* is a little smaller than the *Woman with Pears*, by a
couple of inches, and is rather more cohesive overall, if only because it
does not attempt as much as the previous painting (which after all
incorporated a table with a still-life distantly beyond a background
already indicated by curtaining). Some of the aggressive aspect of the
Woman with Pears is now transferred into the actual attribute of the
paint, the *facture*, rather than residing in the relationship of the means
to the subject matter. The picture has green as the dominant tone, but

99

this is cut throughout half the picture with a sheeny, metallic grey which is strangely surface-holding and appears the more literal because of the denial of the usual use of such paint, which is to convey light reflected from metal. This emphasizes the fact that Cubism had now dispensed with a regular source of light, and that the use of chiaroscuro in some of the Horta heads had been superseded.

However, chiaroscuro did reappear for a time in the paintings made in Paris immediately after the return from Horta. Cubism was a coherent and progressive movement, to be sure; but within its development there was a tendency to shift between the literal and the representational that does not neatly tie in with the view that it proceeded towards an ever-increasing abstraction. One way in which Cubism now developed, from late 1909 or early 1910, was simply in the direction of a more knitted complexity, just in the sense that there were more interrelated parts to the pictures; and this did not necessarily go hand in hand with a more conceptual complication. Previous Cubist paintings, even when they had a meditative and gentle character, like the *Reservoir*, had usually been bold, unafraid to pare things down and make blocky statements. Analytical Cubism now became increasingly complex, with many adjustments to the colour, the touch, the structure of the painting, and to its general status as a transcript of the outside world. The legibility of the paintings now becomes problematic, but it is noticeable that the extent to which normal objects might be discerned within the picture seems to have worried the commentators much more than the artists themselves, and that it was the commentators who made an issue out of the 'accessible' paintings as opposed to the 'hermetic' ones. This is the reason, perhaps, for the popularity of Picasso's portraits within the analytical period, and the relative downgrading of his vital work at Cadaqués a little later. For the painting at Cadaqués was determinedly abstract, while the question of legibility, most acute in the painting of portraits, had been accommodatingly explored in at least four paintings; that of Fernande at Horta, with the still-life of pears in it, that of Fanny Tellier, and then those of Ambroise Vollard and D.-H. Kahnweiler.

The portrait of Fanny Tellier is perhaps more properly known as *Girl with Mandolin*, since, although it was painted from life (until the model tired of it and gave up), it has no pretensions to being a recognizable portrait, and in fact may well have been inspired by a

Corot, *Woman with Toque*, exhibited at the Salon d'Automne a few months before. Perhaps because Picasso was also thinking in terms of a painting precedent – and he would have heard much from Braque about Corot's figure pieces – there is not the same tough attempt to enforce possession of the subject that is visible in the Horta picture of Fernande. The *Girl with Mandolin* is by contrast lyrical and restrained. This is in part to do with the lessening of the sculptural impulse, no doubt; but it also indicates that Cubism as it now stood was sufficiently evolved to allow Picasso some ease and flexibility; what he painted was not so much in the service of a programme. *Girl with Mandolin* is one of those paintings one occasionally finds at a point within the development of a major style where the artist can relax enough to let the style carry him. Certainly, we may have this impression because the painting was not finished; and it might well have become more dense, more graphically unified, and with a lot more paint on it, if Picasso had pursued it further: in which case one might not have had the gentle brushwork, the sandy tan colours and cool blue-greys.

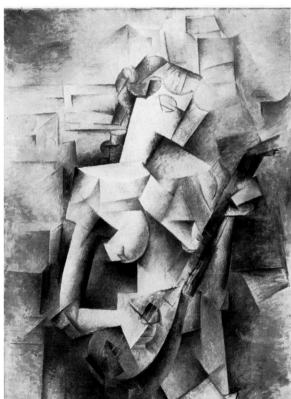

67 *Girl with Mandolin* 1910

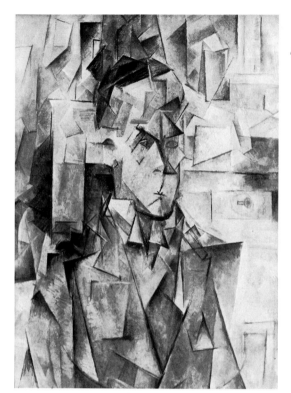

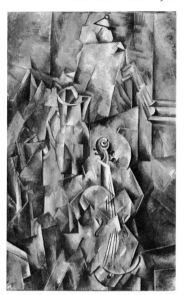

68 *Wilhelm Uhde* 1910

69 GEORGES BRAQUE
Violin with Pitcher 1910

Soon after this picture, the Cubist method became more re-
gularized, and at the same time more fragmented and ambiguous, in
68 the portrait of the German art critic Wilhelm Uhde. The drawing is
much more prominent; line after line, stepping progressively or
contradicting and halting some other direction, takes precedence over
the planes which those lines delineate. This was painted during the
70 period it took to produce a far richer portrait, that of Vollard, which
was begun in 1909 and finished in the spring of 1910. It is a virtuoso
painting, but not only because of its extremely complex structure, its
variety of application, the concinnity with which it presents so many
planes none of which can necessarily be regarded as in front of or
behind any other. It is also a virtuoso painting because of the way that
it holds the balance – as no previous Cubist picture had been able to do
– between the increasingly autonomous and abstracted nature of the
way that the painting was made, and its quotidian referents (if Vollard
may for the moment be so described). Some critics are inclined to

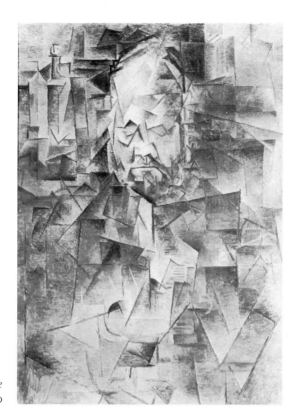

70 *Ambroise Vollard* 1910

stress the representational aspects; but if we were to appreciate the picture because it exists 'on the knife-edge between art and the known world', then we should be fully justified in demanding more data about what it represents. Often this information is provided: for instance, Vollard is said to be examining a work of art in this portrait. But to regard the painting merely as a representational one that has new means of representation is absurd.

The Vollard portrait posed problems for Picasso, and the major one was that this was not a picture that could be repeated. Significantly, he turned to Braque, as he had not done before, and the two painters must have had long talks before Picasso left, in the summer of 1910, for Cadaqués, a small fishing port on the Catalan coast. Braque's early Cubist masterpieces, *Violin with Palette* and *Violin with Pitcher*, were in progress at the same time as the Vollard portrait. In some ways these paintings were more advanced than Picasso's Vollard or Uhde portraits, which might now in one respect

69

appear retrograde in contrast to *The Botijo*. Braque's recent works were more truly conceptual: they were about painting as the subject, rather than painting as what one made out of other things. This was because of their relatively neutral subject matter – for Braque would never have exchanged his common still-life objects for the powerful personalities of Vollard and Uhde – but more because of their painterly character. The drawing in Picasso's Vollard portrait is more important than in Braque's *Violin and Pitcher*. To look at them both is to feel that the Picasso is choppier, and too much concerned with its appearance as a painting of something represented, while Braque's elisions give more the feeling that his work exists within a painterly continuum. It is less sculptural and more surface-regarding; Braque had a long-standing ambition to be able to paint space rather than indicate it. Picasso once said: 'Cubism is an art dealing primarily with forms', while Braque affirmed that 'what especially attracted me – and what was the main preoccupation of Cubism – was the materialization of that new space which I sensed'. Furthermore, Braque's painting announced that what had become a latent characteristic of Cubism might now be claimed as a principle of the style, that its means of representation were relative, not absolute. At the top of Braque's new pictures were illusionistically painted nails, casting 'real' illusionistic shadows; in one of the paintings this nail supports a palette which is hung on the wall. It was a more conceptual approach than Picasso's, at this date, because Braque was thinking about what art is like rather than what can be impressed into art.

Picasso responded to Braque's new example in characteristic fashion. At Cadaqués that summer he pushed hard at Braque's still-lifes in order to make something still more abstract; and some of the work he did there has an extremist flavour to it. The Cadaqués paintings are on the whole upright, as were the Braque still-lifes, and they begin to take an anti-sculptural view of the human figure. It is not now expressed volumetrically, as at Horta, but in terms of longer lines (longer than in the portraits) which mark out the general features of the body, or something like those general features; these lines then serve, initially, as a framework for the interacting planes which make up the picture. In this was the beginning of the full maturity of the Cubist armature, the internal scaffolding of analytical Cubism; and in a very beautiful charcoal drawing from Cadaqués we see quite clearly how it originated. Despite the self-sufficiency of the drawing one

72–3

71

104

recognizes some of the same feeling for the body that is in, for instance, the striated 'Negro' painting *Nude with Draperies*. Yet this drawing is much more developed, and quite without the strain or the febrile tension which characterizes that picture. 58

Some people have felt that the tendency towards abstraction in the Cadaqués paintings worried Picasso, so much so that he retreated from the position as soon as he returned to Paris. Kahnweiler in 1915 had something more interesting to say about this: 'Much more important, however, was the decisive advance which freed Cubism from the language previously used by painting. This occurred in Cadaqués . . . where Picasso spent his summer. Dissatisfied even after weeks of painful struggle, he returned to Paris in the fall with his unfinished works. But he had taken the great step. Picasso had pierced the closed form. A new technique had been invented for new purposes.'

71 *Drawing* 1910

72 *Nude* 1910

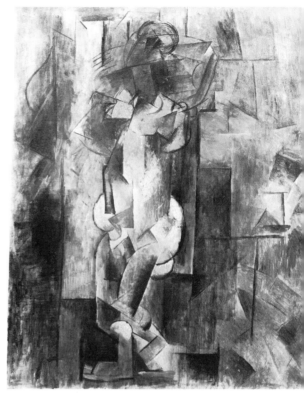

73 *Nude* 1910

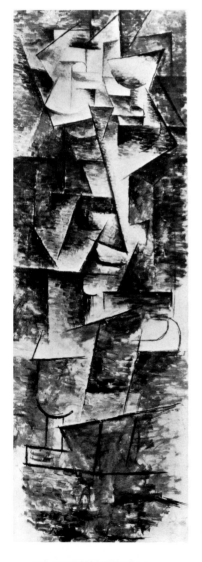

74 *Daniel-Henry Kahnweiler* 1910 >

When Kahnweiler says that Picasso had 'pierced the closed form' he means that the looming sense of volume so apparent in, say, the Vollard portrait had been replaced by a continuously shallow pictorial structure. It is significant that the canvases were unfinished. They may have been completed on Picasso's return to Paris. But certainly a number of the paintings that are securely datable to the Cadaqués period are unachieved, even if fully worked. It looks as if Picasso had difficulty in making the transition from the kind of drawing he was doing there to the fully worked canvas; this difficulty lay in the abandonment of closed form in favour of a planar structure. The Albright-Knox *Nude* shows this, and its seems clear that the most 72 satisfactory works from Cadaqués were paintings of columnar nudes, 73 where lateral expansion was not a problem, and etchings, which could make play with the new armature without worrying about how this would be developed into a more substantial painting. It

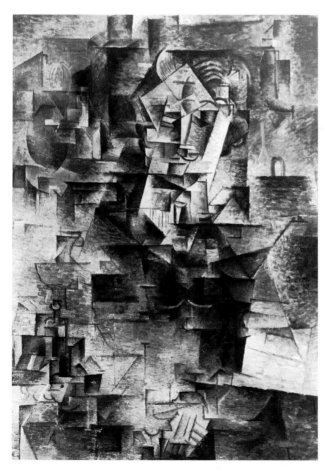

107

seems in fact to have been Braque who immediately substantiated Picasso's figure-based armature, in one of his rare figure paintings, the *Woman* belonging to the Carey Walker Foundation; this painting must have been begun after Picasso returned from Cadaquès, and it is a more 'abstract' painting than any Braque had produced before this date.

Clearly, we are now quite near to a totally abstract art, and it is with some plausibility that the portrait of Kahnweiler, which Picasso painted on returning to Paris from Cadaquès, has been described as a retreat from a dangerous position. It is rather more schematic than one would expect, and even slightly rigid in some areas. It also introduces what are known as 'keys' which establish the sitter's identity; that is, personal and attributive details which are rendered more naturalistically than the rest of the painting: Kahnweiler's nose, hands, watch-chain, and the sculptures behind him. While there is no particular reason to applaud this tactic it certainly demonstrates that at the inception of high analytical Cubism Picasso still felt it necessary (even if only in portraits) to show a decent concern with the facts of the world.

This in no way proves that Cubism was a realist art, however, since it is plain to all that Cubism is the least realistic representational painting one could imagine. Since, however, the individual paintings began with objectness, the interest always lay in maintaining a radical, searching relationship between what we consider to be pictorial and what we visually know. This is not a realist attitude. Yet the public affirmations of the artists and their associates often stressed that the movement had realist objectives, or realist points of departure. Courbet was claimed as a father of Cubism by Apollinaire and then by Gleizes and Metzinger (in their *Du Cubisme*, the first book on the subject). Picasso continually reaffirmed realist intentions (and he was obtusely hostile to abstract art throughout his life). Braque declared: 'when the fragmentation of objects appeared in my painting around 1910, it was as a technique for getting closer to the object'. On the whole, the subject matter of Cubism became more substantive as the movement developed: the pictures are mainly of bottles, glasses, pipes, guitars, packets of cigarette papers – the most normal objects to be found in the cafés and studios of Montparnasse, these later augmented by the ordinariness of the theatre bills and newspapers that were used in collage. However, a democratic subject matter does

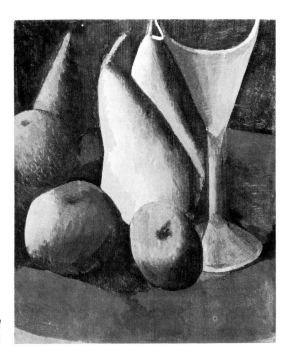

75 *Fruit and Wineglass* 1908

not in itself argue for a realist art, and on the whole question it is necessary to bear in mind the distinction made by Douglas Cooper: 'The basic intention of Braque and Picasso in creating Cubism was not merely to present as much essential information as possible about figures and objects but to recreate visual reality as completely as possible in a self-sufficing, non-imitative art-form.'

In 1910 a distinct advance was made by both artists in another important technical aspect of their art: the nature and quality of their application, the way that the paint was actually put on to the canvas. Both Picasso and Braque began to develop a handling that was more subtle and varied than either had previously achieved. In early 1910, and even with the evidence of marvellously assured paintings by Picasso such as the *Fruit and Wineglass*, one would have said that Braque's handling was the more delicate, the more suave, the more nuanced. But there is good reason to believe that Picasso now took the lead in these matters. He began to feel that the attention elicited by a painting should now reside in its facture, close to, rather than in any boldness of address. This is a major reason for believing in the importance of the stay in Cadaqués in the summer of 1910. It was not

75

an extremist interlude. It was a time when a radical attitude to the figure was almost *absorbed* by a sober renegotiation of the way that artists in the previous fifty or sixty years had put the paint on. The significant thing about the new brushwork is that, while it is not a synthetic amalgam of previous examples, its tessellated, chopped and layered manner comes from previous painters – Impressionists and Neo-Impressionists – in whom (with the exception of Cézanne) Picasso had shown no previous interest. In view of the fact that Picasso is never an artist in whom we find much fascination with the texture of paint as such, this is a remarkable departure. Yet, since the important thing in Cadaqués was to eliminate mass and volume in favour of a shallow surface, it was inevitable that Picasso should turn to those artists whose application was non-sculptural, and this meant atmospheric painters. The atmospheric connotations in the brush-work of the Cadaqués period, combined with the use of non-atmospheric colours, give an impression of airlessness that underlies the use of the term 'hermetic Cubism'.

William Rubin has suggested origins for Picasso's new application of paint in 'Signac's basket-weave variation of Seurat's *points*'; but this perhaps overlooks how many other precedents there were, particularly in the dabs and pats of Cézanne. Most often, individual brushstrokes are now put down, brick-like, in echoic parallels to the edges of the painting and the horizontal/vertical structure of the armature, and these strokes modulate in transparency, size and viscosity with such an unlocked relationship to each other, within and beyond the facets, that they have the effect of gently and meditatively animating the surface of the painting, holding that surface or submerging some fictive identity within it. This is done with a wonderfully fine and varied touch that was never quite attained by Braque. This virtuosity accords with the generally small size of Cubist paintings, and it speaks of a fineness of control which is essentially from the wrist: a favourite posture of Picasso's, always, was to paint hunched over a canvas that was propped at a tilt away from him on a low table. We should note that Picasso's touch at this time – which has never been sufficiently applauded – was not transferable to any of the Cubist imitators or followers. Though it comes out of the Impressionist period, it is a great deal more structural than that of the classic Impressionists, and though it takes much note of Cézanne's constructive application it differs too from his touch, in

that it is rather fatter, is both freer and richer, and can work itself into a featheriness that is quite alien to Cézanne.

Braque responded to this new application, and the more generally planar structure – Kahnweiler's 'piercing of the closed form' – in two of his paintings of late 1910, *The Table* and *Female Figure*, and from this time on the painting of the two Cubists is at its closest. The painters were at their most intimate when the art had arrived at what is broadly regarded as its most difficult and inaccessible point. There were obvious advantages here for both men. It meant that the extremely arcane new painting, way beyond anything else being done in Paris, had a totally comprehending and appreciative audience of one other person, which was enough. This in part explains the uniqueness of high analytical Cubism – the one Cubist phase which was not imitated by later and lesser artists (or was the least imitated, and then by odd people like the Czech painter Beneš) – and the rapidity with which Braque and Picasso developed. There is no sign that either of them needed anything but each other's artistic company in this enterprise, and every sign that they were dependent on each other. Braque later recalled that they were like two climbers roped together on a mountain.

In contrast with the overall rapidity of the development between 1907 and 1914, high analytical Cubism was an extended period, rather more than a year during which there were no fundamental changes in the style. Perhaps this accords with the still, meditative nature of the paintings, and the sense one has that they are quite unconscious of anything outside their creators' companionship. But there were certain innovations that year within the terms of the style. An oval format now became quite common. It stressed, by reason of its deviation from the rectangular norm, that the Cubist picture was an object rather than a representation. And it helped with the problem of what to do with the corners of Cubist paintings; they always tended to peter out because of the use of an internalized armature which did not reach the framing edge. While a round shape would have been so assertive as to demand that the internal elements echoed the shape of their dominant perimeter, the vertical oval format manages to seal off the likelihood of three-dimensional illusionism while still avoiding a decorative identity. Horizontal ovals – which would have been more likely to carry within them indications of deep space, horizons even – are strictly confined to

79–81

corners

table-top subjects; most of them are Braque's. The first time that
Picasso made a horizontal oval was with his first introduction of collaged elements, and then he stressed the object-like ambitions of the work by framing it with rope.

By 1912, if not before, Picasso was making efforts (some less tentative than others) to reintroduce colour to the Cubist palette. The *Violin, Glass and Pipe on a Table* of 1912 has emphatic red accents and a pretty large plane of a saturated blue. This deliberate introduction into high analytical Cubism of something that did not have much chance of jelling into its generally monochromatic structure certainly presaged some aspects of collage in synthetic Cubism; but meanwhile, still within the terms of the high analytical style, Braque had introduced something which was to lead out of the style with a good deal more finesse than any sudden return to colour. Braque began to put lettering on to the surface of the painting. The first picture in which this occurred was *The Portuguese* of 1911; Braque stencilled some figures and the letters BAL on to the picture. To a greater extent than with his depiction of an illusionistic nail the year before, Braque now asserted the autonomy of the '*tableau-objet*': the gulf between art and reality, the factuality of the painted surface, and its nature as just that, not as a transcript or a report on nature. As Braque said, thinking as ever of *pictorial* reality, 'as part of a desire to come close to a certain sort of reality, in 1911 I introduced letters into my paintings'.

Picasso immediately adopted this suggestive and declarative initiative, and in one respect at least with more enthusiasm than Braque. For Picasso, always a lover of puns, disguises, camouflage, double-takes and different or contradictory ways of representing the same thing, revelled in the way that letters and words now allowed a complex of messages and associative private references. In one case at least the wording was almost totally private. This concerned Picasso's new mistress, Marcelle Humbert, known as Eva. Picasso wrote to Kahnweiler that he loved her very much and that he would write it
on his pictures. In fact the words MA JOLIE appear on the canvas. This was a popular song in 1911, and Picasso at the time used the phrase as a fondling name for her. Portraiture as such had been excluded from Cubism since the Kahnweiler portrait, so if the picture is 'of' Marcelle Humbert (there is in fact a woman with a guitar in the picture, or the armature appears to be constructed from such a configuration) then while she is not at all recognizable, the 'keys' used are now both more

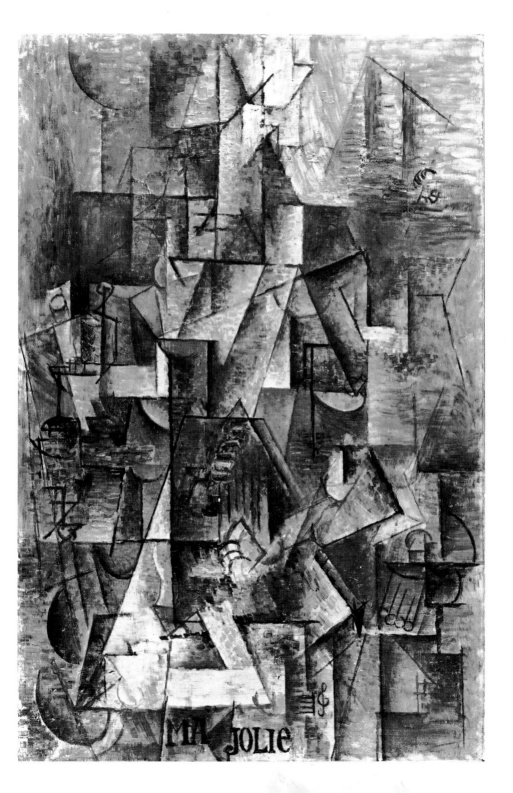

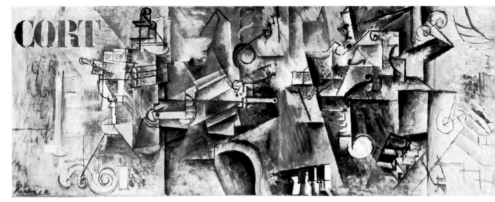

77 *Absinthe Glass, Bottle, Pipe and Musical Instruments on a Piano* 1910–11

semiologically exact than in the Kahnweiler portrait, since they are words, and psychologically impenetrable, since their referent is definable but not recognizable by these linguistic means.

Though Picasso continually played with such matters, the introduction of lettering into the picture was above all a pictorial concern, and the letters often seem most apt when they echo the ambiguities of Cubist pictorial structure. Once only, stencilled letters form part of a long horizontal shape, with the effect of wrenching the frail skeletal armature back up front and away from its tendency towards a vertical vagueness: the one painting of 1911 which is like this may be solitary because so many other things now seemed possible.

The introduction of painted letters was soon followed by the invention of collage; however, it was Picasso's definite recollection (towards the end of his life, to be sure) that his first collage was preceded by the first totally Cubist sculpture, *The Guitar*. According to Douglas Cooper, who knew both artists, Braque began making cardboard models of objects. Picasso followed him, but did so because he realized – as Braque did not – that there was now a great possibility of Cubist sculpture. Braque's models (it is reasonable to call them models rather than sculptures because their intent was circumscribed by their usefulness in working out paintings) were all lost or destroyed. Picasso, however, transfabricated one of his cardboard maquettes into sheet metal and wire, and thereby effected a sculptural

114

revolution. All previous sculpture had been either carved or modelled. It had been reduced from a block larger than the artifact by carving, or it had been induced by modelling, built up from endless supplies of wet clay. Furthermore, sculpture had always been based on the human figure. Astonishingly, Picasso's *Guitar* was the first sculpture that was definitely a still-life, and it was the first occasion when sculpture had been made by putting parts together as opposed to the inductive or reductive methods of modelling and carving. Picasso sheared up different pieces of sheet metal to make them correspond to the planar outlines of a guitar; then he clamped them together. While the piece is very near to a guitar, and indeed very like a model of a guitar, the obdurate nature of its material, so inappropriate to the subject and so unlike previous sculptural media, pull it right away from the status of a model. It is in fact a breakthrough, a single radical step that at one stroke changed the nature of sculpture for ever.

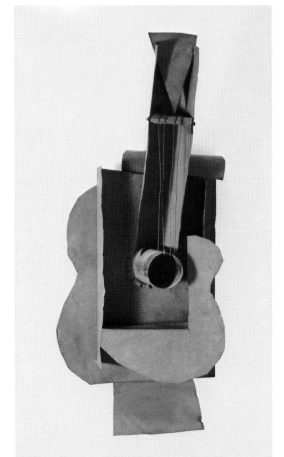

78 *The Guitar* 1912

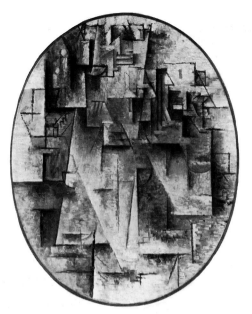

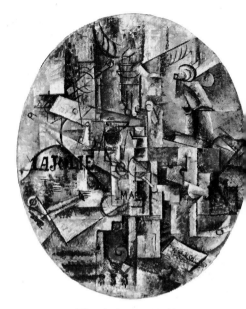

79　*Pointe de la Cité* 1911

80　*The Architect's Table* 1912

THE ARMATURE OF high analytical Cubist painting had tended to be pyramidal, and thus to settle at the base of the picture, a tendency apparent (and more apparent in Picasso than in Braque) since the early Cubist painting of the reservoir at Horta. As the paintings, from the summer of 1910 onwards, became more remote, with that aloofness from any speculation about extra-pictorial reality, this pyramidal tendency was counteracted by further use of the oval format. The *Pointe de la Cité* and *Man Smoking a Pipe*, both of 1911, and *The Architect's Table* of 1912, all dematerialize the stability of solid pictures in just this way, and there are similar paintings by Braque. But, certainly for Picasso, this came to mean that the removed nature of the pictures needed some kind of jolt. The iconography of *The Architect's Table* – the T-square, the words MA JOLIE, Gertrude Stein's visiting card – had been absented from materiality by the subtleties of the brushing and the infinitely balanced repetitions of lines which read as responsive only to each other, checking, weighing, balancing, commenting, some like grace notes, some like jokes. Now, only a month or two later, there was an attempt, in some far less beautiful paintings, to clarify the reality of the objects depicted. This was preceded by etchings by both artists which, in eschewing the qualities

79, 81
80

116

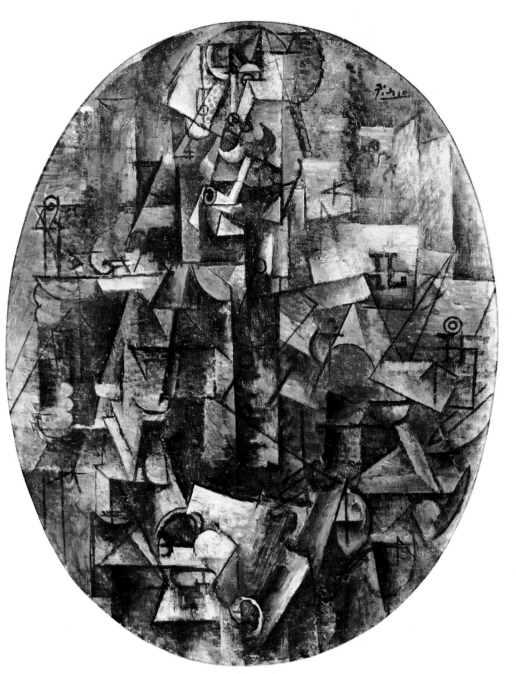

81 *Man Smoking a Pipe* 1911–12

peculiar to brushed paint, isolated the armature and stressed the immateriality of the high Cubist conception. In the new paintings, therefore, shapes became noticeably larger, and were more recognizable. Stress was given to textural effects quite the opposite of the soft and delicate pigment of the previous months. Braque drew on his earlier training as a *peintre-décorateur*, and showed Picasso how to imitate the graining in wood by means of a decorator's comb (and then made a painted representation of that kind of effect, without using the means by which it was effected, in his *Guitar* of 1912). Both men became attracted to a harder paint quality, as if this was an alternative to colour, or an alternative to the extreme delicacy of their work between the summer of 1910 and the spring of 1912. Collage and synthetic Cubism were originated, in large part, as a definite, deliberate reaction from the refinement of that kind of painting.

82 Picasso first made a collage in May 1912. In a still-life which appears to refer to a café scene, with a glass, a lemon and a newspaper depicted in paint, he glued a piece of oilcloth that had been commercially overprinted with imitation chair-caning. This was the picture that he framed in a length of rope, and the incorporation of a pasted element was obviously meant to be a bold one, visibly bold; the oilcloth covers nearly a third of the oval canvas. It was perhaps because of his interest in sculpture that this step was not pursued for a month or two. Then, after the summer when he had been experimenting with three-dimensional models, Braque followed Picasso's example. The two artists were together at Sorgues, near Avignon. Braque noticed in a shop window some wallpaper printed in imitation of wood panelling; apparently he waited until Picasso had gone back to Paris before he went into the shop to buy it. He cut out three pieces of this wallpaper and pasted them to the surface of the picture – they are irregular rectangles, not representing anything by their shape, but only by their notational identity as wooden objects – and then made the picture representative in some way by filling it out with Cubist marks, in charcoal, to indicate still-life elements. The very absence of oil paint in this first of the *papiers collés* suggests how radically, and suddenly, he and Picasso became opposed to the traditional fluidities and niceties of oil paint. Only a few months before they had both been putting paint down with as much refinement and finesse as at any time in post-Renaissance art. But the refinement had now shifted to one of intent, emphasized by the

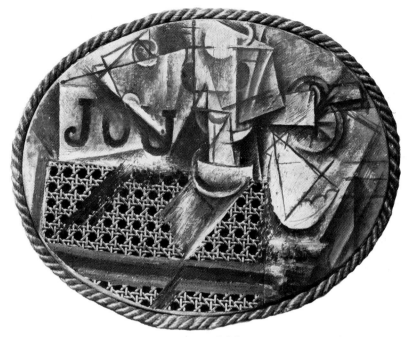

82 *Still-life* 1912

typically Cubist paradox that combined democratic material – bits of worthless things, rags, newspapers, wrapping papers – with a haughty exploration of the nature of pictorial art.

When paper and other matter was pasted on to the canvas surface it was not merely to make a sophisticated Cubist game out of the differences between painted reality and actual reality. Picasso and Braque wished to stress that since Cubist pictures could now be made out of – almost literally – anything, literally in front of the picture surface, then they could not be regarded with an eye accustomed to the most pervasive assumption of post-Renaissance art, that painting's means and ends were always illusionistic. The substantive reality of the collaged elements destroyed traditional recessional space, and did so the more because they were scarcely ever representational as shapes unless, with Picasso, a further double-take was brought into play. But it was precisely the conceptual nature of this development that necessitated a return, after about a year, to the

rich traditions of oil painting, while separating the facient aspects of collage into Cubist sculpture, into a medium that by contrast had little tradition behind it.

Throughout 1913, Picasso and Braque were absorbed with collage, with an absorption (especially on Picasso's part) that developed the possibilities inherent in their new discoveries by continually playing on their contradictory and paradoxical aspects. But there were more broadly formal innovations. This is the phase of their art known always, whether collage is involved or not, as synthetic Cubism. The description was most probably given its original currency by the brilliant young Spanish painter Juan Gris, who had known Picasso for some time before he himself began to paint in 1911. Without a strongly pronounced artistic background, Gris very rapidly absorbed the implications of Cubism's attachment to Cézanne, and as quickly understood the point of collage. Synthetic Cubism is no more a precise term than analytical Cubism, and when Gris used the word 'synthesis' it was with specific reference to an aspect of his own work. But in general the words have been taken to mean the construction of new wholes after the period of patient dissection of visual reality. The main formal difference lay in the fact that synthetic Cubism introduced flatter and broader planes that could not be merged with contiguous elements in a picture without physical overlapping, or without the illusion of overlapping. The paintings are now rather more rapidly made, are little concerned with the quality of the application of paint, and do not have that meditative quality of the paintings of the previous year. They are by comparison rather aggressive works, though there is great serenity in those pictures which are made from one or two pieces of paper and a very few charcoal lines.

As one would expect, Picasso's use of collage was the more exuberant, Braque's the more sober and deliberate. Picasso evidently delighted in the radical and subversive aspects of the technique. Braque never made a picture exclusively out of collaged elements, as Picasso did. This indicates not only that Picasso was thinking more sculpturally than Braque but also that he had a restless need now to try everything immediately, as though it were a matter of urgency. With this swift and ruthless exploration of everything that collage could be made to do Picasso removed himself very far from any canonical or normalized beauty. Whether or not the works were sometimes over-

83 *Man with a Hat*
1912

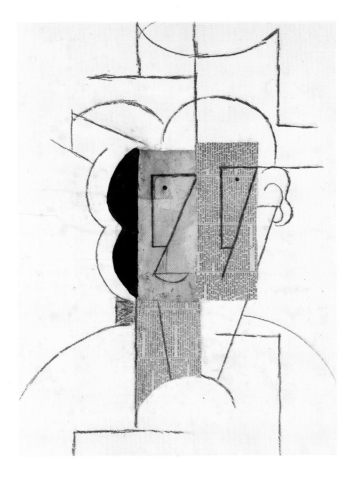

jocular in their use of punning references, a real oddness – a peculiar deviation from the normal – now enters Picasso's art, a way with picture-making simultaneously weird and jaunty. This especially happens when the collage technique is applied to portraiture, always a problematic genre within Cubism. The *Man with a Hat* of 83 December 1912 is made of three pieces of rectangular paper, two of them from a newspaper, pasted on to the centre of a much larger sheet. These forms are quite irrelevant to the shape of the head, but are overdrawn with pencil to give a likeness of the human face. These charcoal lines, however, also have reference to the abbreviated way in which Cubist drawing of this date represented violins and glasses. There are a number of pictures like this. One that does not have this

84 quality of oddity is the beautiful *Coup de thé*, whose spare, firm
charcoal drawing shows how economically Picasso could make
85 complex pictorial statements. Others, like the *Student with a News-
paper*, are remarkable for the variousness of their elements. This
painting does not physically employ collage but does have large areas
which correspond to the way that paper was cut up. These dominant
elements of the design – tall rectangles that give the sense of being
splayed like cards from an axis towards the bottom of the painting –
are played against quite contradictory horizontal areas, and against
lines that are rhythmically waved like enlarged wood-graining and
the painted letters URNAL. The whole is surmounted with the floppy
shape of a student's beret, where the paint is mixed with sand.

Synthetic Cubism, doggedly and laboriously copied by literally
scores of lesser artists, had two important effects on Picasso, one of
them long-term. In the short term it led him close to giving his art,
however brilliantly maintained, too much of a decorative identity.
The long-term effect was that he never subsequently attempted to
develop his ideas of pictorial space. The decorative side of synthetic

85 *Student with a Newspaper*
1913–14

Cubist painting was countered by pictures that began to look for some monumentality. In these paintings the paper or pasted elements were gradually eliminated, or were stripped of their paradoxical functions. In these pictures the use of a richer range of colours, with deep turquoises, more majestic reds and blues, is apparent. The large *Guitar* of 1913 is the exemplar of this late Cubism; it is a painting that 86 prepares for later monumental works such as the *Man Leaning on a* 91 *Table* and the *Three Musicians*. The difference between seriously 102 intended works such as these and the more light-hearted pictures of the same date marks the beginning of Picasso's practice of simultaneous work in totally different styles, as for instance when alternating his classical figures of the early 1920s with still-lifes that were made from a base in synthetic Cubism. It is this division in Picasso which suggests that Cubism had now run its course. Even without the outbreak of the First World War, which separated the artists, Picasso and Braque would surely soon have gone in separate ways. In the late spring of 1914, at Avignon, Picasso and Braque painted together for the last time.

123

86 *Guitar* 1913

87 *Still-life in a Landscape* 1915

FOR SOME, MOBILIZATION followed speedily after the outbreak of war. Picasso said his farewells to Braque and Derain at the station in Avignon. He himself stayed in the town, with Eva, for the rest of the summer. In these months Picasso produced a number of paintings which are sometimes designated, after Alfred Barr, 'Rococo Cubism'. This is stylistically a misnomer, for there are no Rococo elements in the work of this period, not in the proper sense of an elegant refinement of the Baroque (nor, in all his career, does Picasso show any real interest in the Rococo: even in the rose circus gouaches, the sophisticated style is much more mediated by Mannerism). Barr was looking for a name for something that was light-hearted in a way that previous Cubism had not been, that was vivid – there are a couple of Picasso paintings now of a startling all-over

green – and that had a decorative element as pronounced as, or synonymous with, the constructive one. However, the decorative part of these paintings is not particularly linear, which is a prerequisite for the use of the word Rococo; and neither are the pictures maintained by elegance. Sometimes, even, they are made to work by a strangely jocular use of the *faux-naïf*, and that is a different matter altogether. Occasionally in these months, Picasso made explicit a previously cautious predilection for stippling, whole formal areas of the picture being differentiated from the ground colour by a fairly systematic spray of dots of another hue, or of two other hues. Braque did this too, in his *Bottle of Rum* of the same year, but it seems that Picasso liked it more. The technique is often called 'Pointillist', as is anything with dots, but this is an inaccurate term for what was happening in the pictures. Pointillist technique had an all-over constructive role, and also indicated recessional space. Picasso's stippling was essentially and exclusively decorative, and so courted all the dangers of decorative art.

87

When back in Paris in the autumn, for instance, Picasso produced a sculpture which is in all respects close to 'Rococo' Cubism. This is the famous *Glass of Absinthe*. Six casts were made from the original wax model, and each of these casts, apart from one which is coated in sand, has a different kind of stippled treatment; red dots on a white ground, white dots on a blue one, and so on. The only substantively common element is the real spoon which supports a replica of a sugar lump. The gay and offhand nature of this piece, its small size too, and its closeness to the Avignon paintings, emphasize that Cubist sculpture had its origins in the lighter side of Cubist painting. There had been too much of a gap between the *Guitar* of 1912 and the later constructions which, though not securely datable, are most probably from 1914. The *Glass of Absinthe* is the only free-standing one. The others are designed to be hung on a wall. The Tate Gallery's *Still-life* hangs a little meal on the wall. It represents a table on which are pinned real gold tassels. This is set at right angles to two non-illusionistic pieces of wood which correspond to the collaged elements in a Cubist painting; on the 'table' is a wooden slice of bread with wooden salami and a wooden knife and glass. Picasso made several of these little constructions, some of which have now been destroyed. Clearly he was not then interested in developing his sculpture any further; he may have regarded it as a by-product of the

88

89

89 *Still-life* 1914

88 *Glass of Absinthe* 1914

last stages of Cubism, a style that he wished now to develop into more majestic, classical statements.

The stippling, the dots that had defined discrete areas in later synthetic Cubism, can perhaps be seen to best advantage in the engaging picture *Still-life in a Landscape*, also painted at Avignon. 87 Here Picasso is delighting in the way stippled areas attach to the surface or quite on the contrary slide giddily away from it, delighting in the simulated textures of the boskage and the tongue-in-cheek, poster-like treatment of clouds. But the use of dots became convincing only when the part of the canvas that they covered became large enough or significant enough to be read as a discrete area that could be read abstractly. Picasso was beginning to think in these terms by the end of 1915.

127

91 *Man Leaning on a Table* 1915/16

< 90 *The Harlequin* 1915

There is a special development of late synthetic Cubism which
102 begins then and is continued until the *Three Musicians* of 1924; it is of
pictures which have a broader scale than the average Cubist picture,
are quite large in size, and treat figures in terms of large flat schematic
planes. An unhappy circumstance was the occasion for the first of
90 these paintings, *The Harlequin*. In 1915 Eva, Picasso's mistress for the
last three years, died in a hospital in the Paris suburbs. A letter of
Picasso's to the Steins gloomily describes the long Métro journeys to
see her, and the difficulty of working, though 'nevertheless, I have
done a painting of a harlequin which in the opinion of myself and
several others is the best thing I have done'. The mood of the painting
is depressed and bitter. On an undifferentiated black ground are a
number of planes, pretty well unmodelled, tilted against each other,
with a columnar harlequin in the centre. It is an unusual and risky
structure for a painting, and it works by contrast, in the way the white
planes dazzle out from the black ground, in the way the bottom left of
the picture seems so abstract, and in the painterly and rather tactile
way in which the block at the right, half-way up the picture, is freely
brushed around and then left alone, while the rest of the canvas is
more or less smoothly finished.

By far the grandest of the synthetic paintings of the war years is the
91 *Man Leaning on a Table*, which must belong to late 1915. It is a very
big picture indeed, and asserts its size in a towering way, especially
since it is composed of columnar elements which, though frontal,
stress the vertical. It is also, of all Picasso's works since the high days
of hermetic analytical Cubism, the one most likely to be read as
completely abstract. The stippling therefore has a more autonomous
look and, since this is a painting that makes one feel that the facture is
of importance, seems to have been done laboriously and deliberately,
while in the flatter planes of colour the paint seems to have been
slapped down quite rapidly. In fact this kind of difference, and the
constant changes between one column and the next, since they are
fictively in some kind of depth relationship to each other, makes for a
kind of openness in a picture that is otherwise locked together by
massive engineering.

Probably from the early part of 1914, Picasso had occasionally been
drawing naturalistically within the synthetic Cubist style, and in one
92 piece, the *Still-life with Wafer*, there is a very odd attempt to give a
precise description of the surface texture of a biscuit. Now, in 1915,

130

92 *Still-life with Wafer* 1914

Picasso scandalized his intimates by embarking on a series of works
which not only used 'normal' drawing (which Cubism had never
entirely excluded) but were totally executed in a naturalist-academic
style. This was seen by some as a sheer betrayal of all that the new art
had fought for, but Picasso was undismayed – especially since he was
still painting in a form of synthetic Cubism (mainly more com-
plicated planar pictures than the *Harlequin*). These drawings were all
of male friends who were not artists: Jacob, Apollinaire, Vollard and,
later, Diaghilev and the lawyer Selisburg. In a way, they seem like
presentation drawings; for in part they are very highly worked
and 'finished'. They have great finesse as well as resolution, and a
marvellous likeness which is slightly idealized. They are said to have a
'pure' line which is reminiscent of Ingres. This is all very well, but in
point of fact a specific debt to Ingres is hard to find, and there are lines
and lines that Ingres himself would never have dreamt of. These
portraits are not really classicist at all, for that would have meant a far
more regularized, Grecian and marmoreal style than we see here.
They are naturalistic, but do not attempt any unity of finish; and once
the main outline is done they peter out towards the edge of the
picture. In the Jacob portrait is a most recognizably Picassian interior, 93
and in fact the more one looks at these drawings the more clear it

131

93 *Max Jacob* 1917

becomes that they could only have been produced by a Cubist, and very close to the high Cubist period. This is not only in the centralized disposition and the handling of the space, but in many of the details, throughout: in the shading, for instance, the armature-like placing of windows and wainscoting, the purely Cubist motif of the curved top

94 of the chair that is visible under Vollard's arm.

The war years were not particularly productive for Picasso. Of course, this applied to other artists too, even the ones who, like Picasso, were not combatant. The difficulties of the avant-garde were compounded by the political uncertainties which led to the loss of dealers, patrons and galleries. Kahnweiler, for instance, a German national, had been obliged to leave Paris. In the spring of 1916 Picasso, who was not at all in lack of money, bought a house in the suburb of Montrouge. Here he was visited by the young poet and fashionable cultural entrepreneur Jean Cocteau, who had for some time been connected with the Ballets Russes. He had in fact worked with Diaghilev in 1912, and was now eager to organize a new and modern ballet, which Diaghilev would stage, with music by Erik Satie, book by himself and décor by Picasso. He later recorded his triumphant

94 *Ambroise Vollard* 1915 >

seduction of Picasso from a more purely artistic life: 'Montmartre and Montparnasse were under a dictatorship. We were going through the puritanical phase of Cubism. Such articles as may be found on a café table, together with a Spanish guitar, were the only ones allowed. It was treason to paint a stage setting, especially for the Russian Ballet. Even Renan's heckling off stage could not have scandalized the Sorbonne more than Picasso upset the Rotonde café by accepting my invitation. The worst of it was that we had to meet Diaghilev in Rome, while the Cubist code forbade any travelling except from the North of Paris to the South, from the Place des Abbesses to the Boulevard Raspail.'

Whether or not Diaghilev's ballet was improved, made more alert and contemporary, by contact with the Parisian avant-garde, there is no doubt that Picasso, for one, was damaged by the contact that he had with the ballet. It is always pointed out how natural it was for Picasso, with his delight in the performing arts (of the more popular type, to be sure), to collaborate with a theatrical spectacle. This is a major misreading of the nature of modern art, and even if it were not, the illustrational circus period was still twelve years behind him. But various things – the war, Braque's departure, the sheer impossibility of maintaining Cubism on a high level – combined now to slacken Picasso's impulse to make progressive art. He set to work on the ballet with a will, caring as little about the criticisms of his fellow artists as he had when they denounced the naturalistic portraits. In Rome he worked on the ballet *Parade* with Satie and Cocteau and Diaghilev, with such enthusiasm that he certainly imposed many of his own extra-artistic ideas on his collaborators. In the Italian capital he met the Futurists, and got on well with Umberto Boccioni. He also met his future wife, a member of the *corps de ballet*, Olga Koklova, the daughter of a Russian general. Picasso's trip to Italy also included Florence and Milan, but he was back in Paris by the autumn of 1916. *Parade* itself opened there in May of the following year.

Picasso's artistic work for *Parade* consists of painted leotards for some of the dancers, the grotesque sculptural costumes for the Managers, the set, and the drop curtain. The Managers' costumes were meant to tower above the normal human height and to have national characteristics, French and American. The French Manager had suggestions of the boulevards about him, the American looked skyscraperish. Both were done as applied Cubist sculpture, but the

95–6

134

95 *American Manager (Parade)* 1917

96 *French Manager (Parade)* 1917

American one is rather like the painting *Man Leaning on a Table*. Both 91
would be bad if they were considered as sculpture rather than
costume. Similarly, the set for *Parade* was made of attenuated
synthetic Cubist motifs split into flats.

The drop curtain is more interesting. It is naturalistic, and follows 100
the general tradition of scene painting in being illusionistically
charming. Picasso's drop has many painted curtains which act less as
repoussoirs or dramatic elements than as a cushioning embrace which
completes, to the periphery of the drop, the characteristic post-Cubist
space which he instinctively employed. Whatever the day-to-day
experience of collaboration with these theatre people may have been,
the drop curtain has nothing to do with the ballet *Parade*; not the same
setting, nor the same characters, not the same tone. It is wistful, while
the ballet aimed to be brash. It seems to have to do with Picasso's
more sentimental visions of what thespian life might be like, and to
that extent it harks back to the rose period. On the other hand, the
style is not at all like that of 1904. It is a neutral theatrical naturalism,

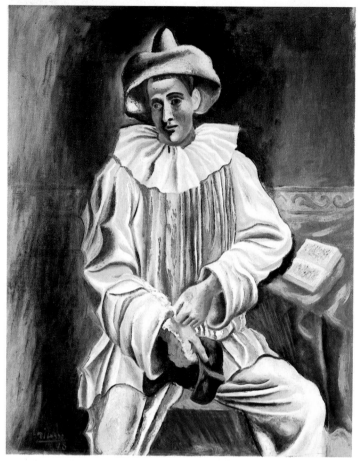

97 *Pierrot* 1918

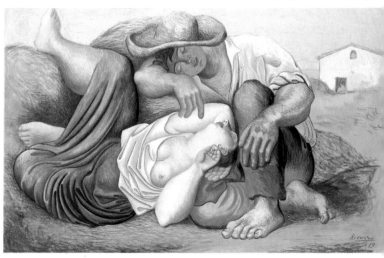

98 *Sleeping Peasants* 1919

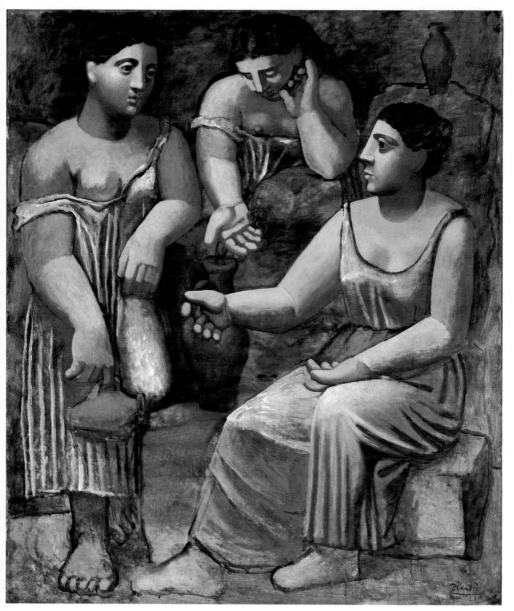

99 *Three Women at the Fountain* 1921

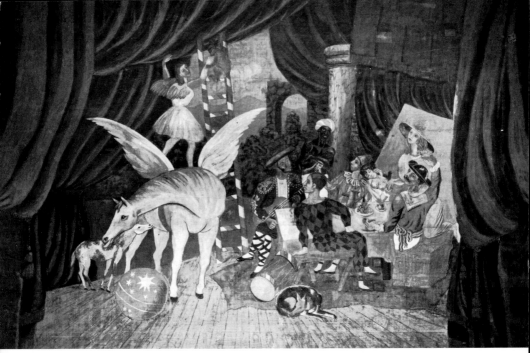

100 *Drop Curtain (Parade)* 1917

flattened with reference to theatrical convention, and rather too big to be comprehendingly seen. Where, in detail, we see touches of the real Picasso, as in the Rococo-Cubist belt around the waist of the figure on the far right, this is just too large in size, and consequently too coarsened, to carry as decent painting. Nothing was solved for Picasso by inflation; but then at this point he was not trying to solve anything. Everything is pleasant. There is a mare with a foal, a ballerina, a monkey, a dog, a harlequin and other circus folk. It has been suggested that the curtain incorporates portraits of friends and collaborators on the ballet; but this is not proven, and they had famous faces, after all. Perhaps it is simply that one feels that there ought to be more significance to the curtain than there is. For instance, the horse is slightly reminiscent of Degas's 1868 picture, *Mlle Fiocre in the Ballet 'La Source'*, which has a similar animal and a guitar player too; but really this is too remote a parallel to suggest that Picasso was consciously making any connection.

One cannot suppose, all in all, that Picasso was making a considered work of art here. But although it is a minor work within the Picasso *œuvre*, it had a long-lasting effect. For large-size painting came to be

138

alien to Picasso after Cubism, and when he subsequently did a large picture (or even a small one with very big content, like the 1930 *Crucifixion*) he always harked back to the experience of this shallow stage set, right up to *Guernica* and beyond. If we bear this in mind, the *Parade* curtain is not so unimportant. Its inexact spatial relations and genial display of figures had in fact taken precedence over a recent indication that there might be another way of constructing a large painting, the *Man Leaning on a Table*. This would suggest that *Parade* superseded more than just that work, which is in any case slightly anomalous; and this is true too. The development of late synthetic Cubism, between the *Harlequin* and the *Three Musicians* of 1924 – a development which Braque did not choose to follow, and which in Picasso's hands, had he not abandoned it, would have shamed the rulered aridity of Purism – was vitiated by the theatrical. *The Three Musicians*, still a rather grand painting nonetheless, betrays that the theatrical had won over the actual, the factual and literal making of a big picture. Picasso, always after Cubism, used the theatre as some kind of a retreat.

107
180

91

90, 102

The period of Picasso's attachment to the theatre, from the later years of the war until the mid 1920s, was also one in which he did a great deal more travelling than the normal pattern he preferred, which was to winter in Paris and spend the summer months in the Mediterranean south. Diaghilev took his troupe to Madrid and Barcelona after their Paris season. Picasso went with them, no doubt because of Olga. At this time we find too many pictures of ballerinas, pierrots and the like, and rather too much sentiment in them. Occasionally Picasso tried to correct this, it seems. An example would be the *Pierrot* in the Museum of Modern Art, New York. It originated as a spare, gentle and wistful drawing; this was then made into another, more finished drawing (finished to about the extent that the Vollard portrait had been, but more truly academic than that); then this was transferred whole to canvas; and finally Picasso uglied it in quite a remarkably lurid way, with sour greens, nasty maroons next to them, the face mauve, with olive bags under the eyes. The painting was completed back in Paris in 1918. He had brought Olga back there with him while the rest of her company went on to South America. They married in July and took a large flat in the fashionable Rue de la Boëtie. Apollinaire died in the autumn. Braque, back from the war, wounded, disapproved of Picasso's fashionable way of life, his fancy

139

101 *Studio with Plaster Head* 1925 (see p. 148)

102 *Three Musicians* 1924 (see p. 139)

103 *Three Dancers* 1925 (see p. 149) >

dinner jackets, his first nights at the theatre: most probably he disapproved of the art as well. Later in 1918, when the Russian Ballet was in London, Picasso and Olga went too. They stayed in the Savoy Hotel, were fêted by the artistically minded part of the Bloomsbury Group, dined with Maynard Keynes. Picasso made designs for another ballet while in London, *Le Tricorne*, and in fact continued to help Diaghilev in one way or another for the next four or five years. At the same time Picasso showed himself particularly amenable to designing frontispieces for books of poetry, frontispieces which often included a portrait of the author. Roland Penrose comments that 'his willingness to comply is evident from the long list of portraits he made between 1920 and 1925. It includes Aragon, Huidobro, Salmon, Valéry, Parnak, Reverdy, Breton, Max Jacob, Cocteau and Radiguet'.

The post-war years in Paris were marked by a classical revival. We see this in many things, and not only in art. Picasso was responsive to the mood of the times, and of course his own classicism was the inspiration of others. In part, the classical subjects that he produced seem to have been a response to a certain kind of Mediterranean culture, and this was certainly immensely more important to him than the image of the city as a vital centre of modern classicism which

104 *Nessus and Deianeira* 1920

inspired many other artists of the time. As he was spending so much time on the Riviera, at Biarritz (1918), Saint-Raphaël (1919) and Juan-les-Pins (1920), it seems all the more reasonable that his classicism should be rural rather than urban. In later years he said of the Mediterranean coast: 'It is strange, in Paris I never draw fauns, centaurs, or mythical heroes . . . they always seem to live in these parts.' The *Sleeping Peasants* of 1920 seems to have come out of the rotund figural neo-classicism of Ingres. *The Rape*, and the drawing of a similar subject, *Nessus and Dejanira* (a subject which Picasso found in reading Ovid), seem to have been derived from relief sculpture on pediments, in the former case, and in the latter from real three-dimensional sculpture of antique origin. But the most avowedly sculptural images are far more original. They were produced the following year, when, after the birth of their son Paulo, Olga and Picasso took a villa at Fontainebleau. These monumental women have plenty of antecedents – apart from the ones in Renaissance painting and the Pompeian frescoes Picasso saw in 1917, the Louvre caryatids and certain figure paintings by Renoir could be mentioned – but strike one as an original conception, in the way that some of the Gosol figures do; nevertheless, they have none of the force of Gosol art.

98
105
104

99

105 *The Rape* 1920

4 Picasso and the School of Paris

STILL LIFE HAD BEEN so obviously an important part of Cubism that at times it seemed to be the medium rather than the receptacle of formal innovation. But this is not the only reason why it is possible to regard the still-lifes of later years as in some way attenuated. There are a good number of these pictures in the early 1920s which are wanting. They were often painted alternately with the classicizing figure compositions. One might conjecture from this that they were not made with the same energy that impels a new direction in Picasso's art. An olympian and classical style, as seen in the contemporaneous work of Léger and of the Purists, Le Corbusier and Amedée Ozenfant, is regulated above all by ennobled human proportions. Picasso found this hard to transfer to still-life; or it may be that he was simply not interested in that aspect of classicism. In any case, the fullness and grandeur is quite obviously absent from these still-lifes. Interest is lent to some of these pictures by reason of the fact that they are more curvilinear than their predecessors, or that a technique of drawing has been developed: Picasso sometimes scratched lines into wet pigment with the wooden end of the brush. But they are almost too recognizable as 'Picassos', and seem to be no more than an assured assembly in an implied, and null, Cubist space. Nobody but Picasso could have painted them, but they still look as if they are playing out the discoveries made by a different artist. Their significance to Picasso's career, one regrets, is that they are the first of the formulaic paintings. This does not necessarily mean that they are actively bad paintings; and of course they could not be failed paintings, for nothing has been ventured. It is rather that their sure-footed accomplishment does no more than to fulfil expectations. They are not *pris sur le vif*: some of the vitality of the innovative artist has gone out of them. Pictures of this sort began to appear occasionally now, but with no indication of how they would flood from his studio in the 1950s and 1960s.

145

< 106 *The Studio* 1927–28 (see p. 167)

< 107 *Crucifixion* 1930 (see pp. 166, 212)

108 CHARLES-
EDOUARD
JEANNERET
(LE CORBUSIER)
*Still-life with
Many Objects* 1923

Towards the middle of the 1920s – we might say immediately after 1924, a year unproductive to the extent that it even engendered drawings which are a monument to artistic frustration – there seems to have been a reaction from this repetitious and rather uninteresting manner. Picasso began to try to make still-life more significant. This meant that he wanted to instil some new complexity of theme into this traditional category, not that he wished to use it as an agent of pictorial advance. Such a desire was not uncommon throughout Parisian art at this date. One reason for a wish to re-complicate still-life would surely be that the Purists had taken the juice out of it; a picture like Le Corbusier's *Still-life with Many Objects*, for instance, must have struck many people as vacuous, however many discrete natural elements it encompassed. But the Surrealists were largely responsible for the change of attitude. No artistic group could have been more vociferous than they were in denunciation of the usual subject-matter of still-life – apples, a bottle and a loaf. It is significant that they should have distrusted the accepted attitude towards still-life, that it was a more or less neutral vehicle for pure painting. Picasso was certainly aware of the limitations of Surrealist art, its acad-emicism, its shallow culture, its desperate need to *épater le bourgeois*. But an increasing need to express turbulent and aggressive emotions

120

108

146

109 *Still-life with Ram's Head* 1925

and a search for an expressive and symbolic vocabulary were factors which contributed to Picasso's important still-lifes of 1925, and 109 something of this was taken from Surrealism. At this time he seems to have taken an interest in what others around him were doing that was keener – or at any rate more evident in his paintings – than at any time since his apprenticeship. This is not to ignore his relationship with Braque, but rather to recognize that the relationship was a special case. For there are very many types of derivation in modern art, from the noble to the meretricious. There are many shades and nuances in the differences between paintings which are influenced by other artists and paintings which come about as a result of an interest in other artists. It is important that Picasso's response to Surrealism was variable. It could be frank, or offhand, or ironic. It is also important that there was a great difference between varying types of Surrealism. And the difference between Picasso's sheer power, as a painter and a maker of images, and that of, say, Dali or Tanguy, can prompt the thought that in the most 'Surrealist' of his paintings Picasso is almost indulgent to that movement; and that is a curious way of acknowledging an indebtedness.

The *Still-life with Ram's Head* of 1925 is deliberately a savage painting, fashioned with crude virtuosity. Meyer Shapiro calls it the

147

beginning of the 'still-life of cruelty' and associates it with later works
182 such as the *Still-life with Bull's Head* of 1938. Something of a Surrealist
influence might be detected in its shocking presentation. Its com-
ponents are all repellent. Apart from the severed head it contains
unpleasant things from the sea, a scorpion fish, a sea urchin and a
squid. The really important work of 1925, the far more considered
101 *Studio with Plaster Head*, is not particularly a painting of the artist's
studio, whatever the title. It is a table-top picture which has been
enlarged to refer to the room in which the table stands. On this table is
the toy theatre Picasso constructed for his son Paulo. Besides this we
find a try-square, a book, two fragments of arms from a dismembered
sculpture, one of them holding what might be either a spear or a
scroll, a sculptured head, a sprig of laurel, an apple and the tablecloth.
The classical quotations and the references to building carry with
them some intimations of both monumentality and transience.
There is in fact more than a touch of pomp about this painting, as if
the deliberation with which it makes classical allusions needed some
assumption of grandeur to indicate how their less classical origins
have been absorbed. For Picasso was taking motifs from two younger
painters, Giorgio de Chirico and Joan Miró.

De Chirico, the Italian Metaphysical painter whose work had been
championed in Paris by Apollinaire and by André Breton, the
Surrealist propagandist, had introduced the enigmatic juxtaposition
of unrelated objects into still-life some years before, from around
1912. His reputation in Paris was not quickly established, however,
and in the mid 1920s (by which time his inspiration had left him) he
was regarded in some circles as an advanced artist. Picasso does not
reproduce De Chirico's mood, the hollow and echoing disquiet that
younger Surrealists like Magritte and Tanguy found so striking; but
takes from him such motifs as the classical head, the carpenter's
square, and the boxed compression of a differently constructed space
within the main picture. The relationship to Miró is less forthright.
But it is worth noting that a still-life of Miró's, the *Still-life with Toy
Horse* of 1920, is similarly crammed with objects on a table, one of
them belonging to a child, and also features an open book, a motif
which is found in the *Studio with a Plaster Head* but is not at all
common in other of Picasso's still-lifes. One sees that Picasso had
taken a real interest in what Miró had been painting. Picasso had
bought a self-portrait from Miró when the latter first arrived in Paris

from Spain in 1919. In the following years, which Miró divided between Spain and Paris, he modulated his style from a realistic Fauvism with Cubist aspects into painterly Surrealism. André Breton wrote in *Le Surréalisme et la peinture* that 'the tumultuous entry of Miró marks an important point in the development of Surrealist art'. Breton's magisterial judgment (penned only four years after the event) was accurate in one sense: Miró was by far the finest of the painters who made any formal declaration of allegiance to Surrealism. Picasso was well aware of this. He had known Miró's work for some five years and had a solid appreciation of it; the sort of appreciation, in fact, that would incline him to adjust his own work.

A painting which in some details – but only in details – has a relationship to Miró that suggests that the two men were looking hard at each other's work is the celebrated *Three Dancers* of 1925. It is 103 a painting which clearly developed and changed its character while Picasso was at work on it, and is a decisive rejection of many of the subjects that had occupied him in recent years. The *Three Dancers* is a picture of dance which opposes the grace of the ballet, just as it negates the spirit of one or two small drawings and paintings of the Three Graces which preceded it. The calm and the replete poise of the women and classical youths are replaced by emaciated, tortured figures that might be of either sex. They are locked together not so much in a dance as in a dervish-like frenzy in which lamentation and celebration are inseparable. The *Three Dancers* is a large picture, so large in fact that the figures are literally life-size. Picasso had painted people in this pictorial size quite recently, in backcloths for the ballet; but this aspect of the *Three Dancers* should be related to the similarly large picture known as *Man Leaning on a Table* of a few years before. 91 That picture preceded Picasso's ballet period, as the *Three Dancers* succeeds it. In both there is an attempt at a pictorial monumentality that is not achieved (as in the case of the fat classical figures of this intervening period) by illustrational means. However, the *Three Dancers*, with its flailing against a rectilinear background – a jarringly domestic contrast – of wallpaper, windows and a balcony, is too wild and bitter a painting to be truly monumental. It is in fact the basis of the expressionistic but still illustrational distortion of the human body that was to occupy Picasso through the late 1920s and the 1930s, and sporadically for many years after that.

There is a biographical aspect to the painting which may reinforce the view that it marks a turning point in Picasso's art. It was painted at the time of the death of Picasso's old friend Ramón Pichot, who had married Germaine, the lover of Casagemas. Some commentators see her features in the figure on the left. The painting may have changed in character after Picasso heard the news about Pichot. Years later, he told Roland Penrose that the tall black figure on the right is the 'presence of Pichot'. One is reminded of a story of Gertrude Stein's, of how at bohemian parties Pichot would give performances of primitive Spanish dances, one of which was concluded by his taking up the attitude of the Crucifixion, on the floor. The crucificial overtones to the painting are clear. In many ways they foretell Picasso's *Crucifixion* of 1930, his interest in making drawings of the subject after Grünewald's Isenheim altarpiece, and his later attempts – always dependent in some way on this central image of Christianity – to commemorate the death of his friend Apollinaire.

The Surrealist overtones of the *Three Dancers* suggest that Picasso found the new movement a vital relief from the tameness of his association with the ballet. He had met André Breton in 1923 and was taken with him. Breton, for his part, was quite shaken by the experience of knowing Picasso, and soon came to regard him as the spiritual father of the new movement. He wrote that 'Surrealism has but to pass where Picasso has passed, and where he will pass in the future.' Breton almost certainly persuaded the collector Jacques Doucet to buy the *Demoiselles d'Avignon* at some time after 1920 (it was then that it acquired its present title); and his magazine *La Révolution surréaliste* was the first to reproduce it, in July 1925. In that year Picasso agreed for the first time to show in a mixed exhibition. This was the first Surrealist exhibition at the Galerie Pierre. Among the company were Mirò, Jean Arp, Max Ernst, Paul Klee, André Masson and Man Ray, all younger than Picasso, and all artists who had come to the Surrealist position only after working through a Cubist phase: that is, they had all been obliged to come to terms with Picasso himself at some earlier stage of their careers. Clearly enough, they no longer felt the same obligation to follow Picasso, and perhaps this spurred him.

110 In 1926 Picasso made a picture of a *Guitar* out of paint, floorcloth, pasted paper and string. All these were materials he had used before, but seldom all together. From the reverse side of the painting

seventeen two-inch nails were driven through the surface into spectator space. Picasso told Roland Penrose that he had also considered cementing razor blades into the frame or stretcher of the painting, to make it unhandleable. These nails, of course, do not have the conceptual elegance with which nails were introduced, as *trompe-l'œil*, into Cubist paintings. Furthermore, the picture is unique in these years in summoning extraneous materials to modify the pictorial effect. It might seem merely an aberration, a picture made in a fit of bad temper (such things can happen), were it not that there is a precedent. There had already been made in Paris, as a product of the iconoclastic and nihilistic Dada movement, an art 'object' which was in itself avowedly physically aggressive: Man Ray's *Gift* of 1921, a flatiron with nails protruding from the ironing surface. This object, which Man Ray made as a sudden thought when he visited an ironmonger's shop with Erik Satie, may have been shown at his exhibition at the Galerie Surréaliste in 1926, or at the second Surrealist exhibition, to which Picasso also contributed, in the same year. In any case, it was already well enough known when *Guitar* was made. It is hardly worth lingering on this sour work, but it shows that Picasso could over-react to a novel development on the Parisian scene. Though he was not averse to lending it for exhibitions, Picasso always kept *Guitar* in his own collection, and made no attempt to develop its object-like aspects.

In *Guitar*, there are clear echoes of that wish to outrage, to adopt provocative positions, to be iconoclastic (literally so, sometimes), that one associates above all with the activities of the Dada artists. Their raging nihilism, after 1915 or so, became the more demanding of attention the more it was brought directly within the realm of art itself; that is, as it became plain that this was not merely outrageous behaviour as a social adjunct to the art, as had been the case with the Futurists' promotional appearances in Paris back in 1912. Marcel Duchamp's second and third Readymades, a bottle-rack and a snow-shovel, commercial objects introduced without modification into an art situation, rapidly made the essential point of Dada: that what was claimed as art was not necessarily art. (*Bicycle Wheel*, 1913, is usually regarded as the first Readymade; but it is also a parody of a salon sculpture, and in the original version was aesthetically modified by the straightening of the bicycle's front forks.) The subsequent developments of this position, largely made after the Second World

151

110 *Guitar* 1926

War, are not relevant here; it is enough to note the attitude, and to point out that the Dada faction was prominent in Paris in the years after the First World War. These iconoclasts (Francis Picabia and Marcel Duchamp were back in Paris from America in 1917 and 1919, Tzara came from Munich in 1920 and Arp from Zurich in the same year, Man Ray arrived in 1921 and Ernst in 1922) courted and clamoured for the status of notoriety for themselves. This was an intention directed towards a fairly narrow target; there is little point in adopting an anti-art position if it is not recognized as such by the art community. For the wish to shock, *épater le bourgeois*, which Surrealism inherited, is clearly a miserable artistic ambition. Art does not thrive by attention to bourgeois tastes, whether the intention is to ingratiate or to irritate. The value of Dada art is often measurable by this consideration. Picasso would have realized this all the more clearly after his stultifying involvement with theatre and ballet design, those public and bourgeois forms. Once, long ago, he had been close in spirit to Van Gogh and Gauguin, and then to Cézanne,

and had himself asserted the haughty privacy of Cubism; there was no one in Paris with more experience than he of the ways in which artistic intentions can be blurred or vitiated by a social mask.

At the same time, he would not have accepted Dada as a salutary innovation, as Breton seems to have done. The young propagandist of Surrealism thought that some kind of *tabula rasa* had been achieved, however much was wanting in the work itself: 'Dadaism cannot be said to have served any other purpose than to keep us in the perfect state of availability in which we are at present, and in which we shall now with all lucidity depart towards that which calls us.' It was clear to Picasso that the *ultra* position was that adopted by the peripheral artists, not the important ones; and so that stance was certainly not for him. In addition – and this simple fact was the origin of great quantities of bad art – it was not conceivable that a Readymade, or anything like a Readymade, could be a painting. For that reason a self-consciously subversive-radical art, a strategy art, had increasingly been made in three dimensions, and was thus, unavoidably and disastrously, governed by the slack and whimsical methods of assemblage. Some of this, admittedly, got into Picasso's work, as in the boxed *Construction with Glove* of 1930. But he was largely free 111

111 *Construction with Glove (by the Sea)* 1930

of the iconoclastic movement. It was totally within his character and experience to work within the means made available by the painting tradition, one by now massively extended by what he himself had accomplished some twenty years before. It is within these terms that we should approach his famous 'attack on the human figure', often interpreted as a radical and iconoclastic phase of his career, but in reality nothing of the sort. It was much more like an internalized, thrashing despair at the extent to which he could only acknowledge, not challenge, that painting tradition.

From the end of the period of monumental classical women and youths until his meeting with Marie-Thérèse Walter in 1932, and then again during the years of the Second World War, Picasso produced a series of human images which were often of a frightful nature. Exclusively of women (though at times this is not easy to determine), these paintings rely on the most extreme distortions. Roland Penrose describes them as follows: 'The recognizable features – eyes, mouth, teeth, tongue, ears, nose and nostrils – are distributed about the face in every position . . . in some cases both eyes appear on the same side of the face, in others the mouth takes the place of the eye . . . in this process of re-assortment the spherical mass of the head itself begins to disintegrate and token hairs are made to sprout from anywhere they may be required by the artist.'

These works have had a considerable public influence, and are often cited as evidence of Picasso's viciousness and hatred of all that is truly beautiful. One popular misconception about them should be immediately excluded: they do not depend on utter distortions of the real human figure. That would have produced realistic monsters, as was done by Salvador Dali from just about this date. Picasso's images distort, rather, the graphic conventions by which the body, the cephalic and the sexual features are simply represented in non-realist art. They negotiate with the limits of pictorial habits. There has been diverse speculation on the origins and motives of this type of distortion, this type of picture. Metaphysical *angst* and the chafing nature of Picasso's marriage, together or separately, are two of the reasons given for the style; most other 'explanations' are similarly extra-artistic. On the other hand, it is also possible to recognize that this manner was born of artistic problems, and that, within the paintings which are loosely assigned to the 'attack on the human figure' category, we will find great differences of tone, born of quite

154

112 *Playing Ball* 1928

separate artistic impulses. The most extreme and peculiar re-arrangements of the body do not necessarily result in art that has to do with subconscious hurtfulness, menace and aggression.

For instance, there is the curious case of the figures in some beach scenes dating from 1928 and 1929. These pictures were done when Picasso, *en famille* and with an English governess for Paulo (one wonders quite a lot about her), was spending the summer months at Dinard, on the Normandy coast of France. In the bathing costumes of the day, figures that seem made out of matchsticks, or to have been awkwardly ripped out of cardboard, disport themselves in games, running and skipping after balls. *Playing Ball* (1928) is the best-known of these paintings; there are a number of others. Picasso did not very often paint on a canvas quite as small as this one, and the neat size of

112

the picture – the others are also small – impels a special attention towards the manner, the application; and one finds then what is largely lost in reproduction, that the odd and bouncy character of the picture is also determined by some quite beautifully managed brushing; and then the colours of the picture make one think of Boudin, who years before had painted on the same coast, at the resorts of Deauville and Trouville – of Boudin more than Monet, or Manet, who also painted there. But the emotional tone of these pictures, in which people are engaged in a preposterously social activity at the edge of the immensity of the sea, is not determined by the *plein-air* painters of Normandy. It is taken from the very funny painting by the Douanier Rousseau of mustachioed football players in striped shirts, leaping up and down like wooden marionettes. The Dinard paintings have sometimes been likened to children's art, as of course has the work of the Douanier. But Picasso, even as a child, never painted an unsophisticated picture, and *Playing Ball* is sophisticated in a peculiarly Picassian manner. It is the way of affectionate jibing, much used to his friends in social life, that we feel here, but as a way of taking things from the tradition of modern painting. Such things are transmuted, transformed, digested, played with, but they are still there in the meaning of the picture. The wide-ranging delicacy with which Picasso could do this, taking what he noticed from so many different types of art, was a unique quality; no other modern artist has any hint of a comparable vastness of painting culture, of this generous embrace which could absorb so much other painting. This quality was always in Picasso, whether latent or not; we saw how his first months in Paris produced deft but still individual versions of other people's styles. But it declined, except in less-than-serious works, as he became, in the late 1920s and the 1930s, a conservative artist. The

207 overdone reworkings of Velázquez's *Las Meninas*, painted with a quite different sort of panache, make this point quite clear in later years. But meanwhile, what we wish to note about the Dinard

113 paintings – and of others, like the 1935 *Woman in a Hat* – is that there is no straight correlation between the degree of alteration of the human body and any presumed blackness of mood. Picasso's painting is autobiographical, certainly, but more about his art than about his life.

In the distorted 'attack-on-the-human-figure' paintings, it is nonetheless tempting to agree with George Heard Hamilton's

114 characterization of a typical example, the *Seated Woman* of 1927. He

113 *Woman in a Hat* 1935 114 *Seated Woman* 1927

calls this painting 'an ideogram of neurosis, threat, and domination'.
We are familiar with work in twentieth-century art and literature
that seems of this type, and not least from Picasso. For such reasons we
very often find that Picasso has to be associated with the Expressionist
current in art: the urgent, nervous, depressed and painterly aspects of
the modern tradition. Whereas Picasso's previous distortions of the
human figure had mostly been made in concert with some process of
rational examination and at the behest of the pictorial structure, the
distortion in these paintings seems at first to be Expressionist in the
sense that it is primarily at the service of the artist's wild emotions.
This is the aura, and sometimes the rationale, of the most important
Expressionist art. It is the source of Expressionism's major difficulty:
the fact that it has to negotiate between its individuality – the solitary
experience of the artist – and the justice and relevance with which it
publicly appears in the art situation. So we need to be careful not to
judge the art on the grounds of any inferred intentions, especially
pumped-up psychological ones. It is an obvious fact about many
Expressionist artists that they paint out of their particular individual
torments; but that does not allow the general thesis frequently

157

advanced by their commentators, that they are also painting the 'psychic expression of the age' and the 'dilemma of modern man'. Picasso has often suffered from this. Good modern painting has no relationship with such imponderables, for it is gloriously limited to the evidence of one's eyes. Expressionist art that wishes to convey such matters is always sterile and grandiose. But Expressionism, and Surrealism too, inflected receptiveness to dramatically heightened emotion, and after the Cubist and Purist periods this became a general problem in Parisian art. Personalities came to create issues as they had not done before. The bizarre, the demented, the anguished and the revolutionary were all there, already quite well known as facts of life within the art community, but less familiar as artistic principles and methods. In the years between the first and second Surrealist manifestos in 1924 and 1929 – years when Chaïm Soutine, one of the Expressionist *peintres maudits*, had a public image largely based on such stories as that of his unnoticed dislocated thumb when in a frenzy at his easel, when Miró accepted days of hunger as a help towards self-induced hallucinations and smashed his head against the wall through dissatisfaction when he painted them, when Masson emerged from a previous dependence on the cool and rational Gris, intent on 'seizing at last the knife immobilized upon the Cubist table' – then there was an atmosphere predisposed towards extreme statements on the canvas.

Some of this atmosphere, without doubt, was engendered by Picasso himself. But he himself responded to the new feelings in the city in a number of ways. When we think what kind of a painter Picasso was in the middle years of his career we need continually to test his individuality against the complex development of the School of Paris as a whole. In what follows, when we consider the nature of Picasso's maturity, it is argued that Picasso's receptiveness to the younger avant-garde was carefully managed, usually, but that there were major developments in painting in which he could not participate; these increasingly isolated him as a conservative artist. Further, it is suggested that he failed to develop what could have been a great period as a sculptor.

Picasso had avoided Dada. The *Guitar* of 1926 was merely a mistake. Its drab and prim composition is not rescued by the malevolent appendages; but there are no other works like it. The re-emergence of the *Demoiselles d'Avignon*, so long rolled up but now

158

obtusely trumpeted by Breton, that chattering megalomaniac, could well have impressed on Picasso that his position as leader of the avant-garde, now of some twenty years' standing, was acknowledged by the young Surrealist spokesman for the wrong reasons, and that he himself needed to make a broad reconsideration of his art. What were the possibilities? Who could he look to? We can now see what the issues were on a much larger scale than that. Surrealism, or most of it, was a dangerous path. The vehemence of the way Picasso was painting deceived Breton into imagining that there was some real community of spirit between Picasso's art and his own idea of art. There was not. Breton misread the artistic scene, for a very simple reason: he had not enough respect for art, and he was over-concerned with art-politics. Another important matter relating to the Expressionist (and Surrealist) artist is raised here, and it applies also to Picasso's position. A brilliant understanding of the vanguard situation is essential to Expressionist art of any worth. Those artists who are less acute to the art of their time, like Munch, are very apt to flounder and not realize how badly they are painting (and, cognately, the most obsessional artists, again like Munch, or Giacometti, do not nourish subsequent artistic accomplishment). Bad criticism, before some of the more 'extreme' of Picasso's paintings, talks often of passions being 'unleashed' at this time in his career. But what really happens in Expressionist art is that there is a precise adjustment in the play between the conceptual control of the outcome of a painting and the willingness to abandon the making of it to one's own whipped up temperament. As we can now see, nothing in modern art is more illustrative of this than the dignity and intelligence with which the Abstract Expressionist painter Jackson Pollock alternated the rushed dripping and slurring of paint on to a canvas placed on the floor with periods, sometimes a fortnight long, of meditation in the studio on the state of the work. Pollock is mentioned here for the further reason that he holds a key position in the development of modern art, in the interplay between the School of Paris and the School of New York, and that a denial of Picasso's example was one thing that enabled him to become a major artist. For at this crucial stage, around 1925 and a little after, there was a most important development in Expressionist painting in Paris, a genuine breakthrough, which Picasso certainly perceived and just as certainly rejected. It was the end of his time as a genuinely innovative painter.

159

This is not, of course, to speak in terms of decisions made immediately, of a considered and rational choice between clear alternatives. Artistic resolutions are rarely of this type. What happened was that for three or four years, when Picasso was most close to Miró, an impetus was given to their work which blossomed in the painting of the younger artist, and beyond that, but which tended to confirm Picasso in a clenched stasis. It was a question of binding new motifs, iconographical elements of a closed and linear type, into whatever broadness or scope seemed appropriate to them. John Golding has pointed out that Miró introduced a new wave of primitivism into Parisian art. He had been deeply affected by Neolithic cave drawings when working on his picture *The Ploughed Field* (1923–24). The ideogrammatic motifs derived from such art became the staple of his own forms, those shapes which seem to have a vital rather than inanimate existence, and mix sexual attributes with the head or the limbs in a free and spontaneous manner. Dr Golding adds: 'Neolithic art also provides the key to some of Picasso's stylistic innovations during the second half of the 1920s, and, like Miró, he exploits its sexual symbolism; it seems likely that the frankness and spontaneity of the younger man's handling of erotic imagery may have acted as a challenge to Picasso's own powers of invention.'

115 *Woman in an Armchair* 1927

Furthermore, Picasso looked to other primitive sources, in particular the hieroglyphs from Easter Island. The *Woman in an Armchair* of 1927 looks like a larger version of one of these images, and in the same year a version of the *Artist and Model* theme brings the manners of prehistoric Easter Island art directly into the conventions of the twentieth-century studio painting. 115 116

Miró, on the other hand, while perhaps less vigorous than Picasso in his adaptation of Neolithic motifs, employed them in a more profitable manner. He had been painting in a manner derived from realistic Fauvism and Cubism; now, as he developed an independent painterly Surrealism, he left behind the cramped logic of derivation. The painting decentralized, so that it did not seem dominated by what it contained. As he expanded across the whole surface of the painting, its broadness was experienced as a field rather than an aperture defining an enclosed structure. Miró had rejected Cubist space. In his wish to 'go beyond the *plastique cubiste* to attain poetry', having come to paint in a way wherein the factual outcome was not so much preconstructed as sensed by the artist during the making of the picture, his biomorphic, neo-Neolithic shapes were improvised with the felicity of liberation. Above all, perhaps, the paintings became expansive. The elements were not bound together, the colour

116 *Artist and Model*
1927

117 *The Acrobat* 1930

118 *The Dressmaker's Workshop* 1926 >

119 *Painter and Model* 1926 >

on which they were floated was often uniform from side to side of the canvas (richly beautiful hues of strong individuality, without tint or shade), and there is no sense of limitation. Picasso, on the contrary, always binds and confines his hieroglyphic forms, which themselves are always made human. They are always enclosed in rooms. Or, as 117 in one horrifying picture entitled, significantly, *The Acrobat*, an incredibly contorted body strains against all four sides and corners of the format. Picasso's whole past career as a Cubist artist, as a realist, as a figurative artist, seems to have inhibited him from picking up the way in which the structuring of a picture could be opened out again. Picture after picture tells us this.

 There are, however, two paintings of 1926 in which one does have the feeling that Picasso was feeling his way towards a continual cursive composition maintained over a large and laterally extended 118 format. One is *The Dressmaker's Workshop*, which, as it were, washes waves over its infrastructure. The other is another rendering of the 119 *Painter and Model* theme. The same size as *The Dressmaker's Workshop*,

162

it appears much flatter than that painting because of the bold lines, meandering with purpose, which stress the surface plane. The usual and by now almost ritualistic indications of enclosure are still there, in the rearing floorboard motif at bottom left balanced by the schematization of a corner of the room at top right. However, the line tends to leap over these factors. It is noticeable that the painting is not finished, and that Picasso seems not to have wanted to close it up on the right-hand side. It remained always in his own collection.

Some of the problems raised by a length-shaped flattened structure, in which the surface of the painting is emphasized and the composition is extensive rather than introverted, will reappear during the painting of *Guernica*, some ten years later. We may feel that those problems could have been better prepared for. This is because the flowing line and running movement is now utilized only *horizontally*, and characteristically in the vivid and dramatic rearrangement of the human figure. There is one very well-known illustration of this point. It comes in Picasso's contributions to a luxury edition of Balzac's *Le Chef d'œuvre inconnu*. This short story is about an idealistic painter who, finally, turns out to be artistically impotent. He works for ten years on the portrait of a beautiful woman, lays down more and more paint, reworks, scrapes out, starts afresh, puts down more paint, and ends up after all his labour, with nothing. In Picasso's illustration the artist looks intently at his model, who has aged and is knitting. Both are realistically drawn. On the canvas, however, is an abstracted Picassian scheme, rather like one of the figure paintings of the date. We very often find that the figure, in these paintings, is looped in and trapped by the very line which defines it. This is most evidently so in the *Seated Woman* of 1927, a disturbing work. But that sensation is elsewhere as well; it is in *The Three Dancers*, in the various pictures of seated women, and in all the pictures that incorporate dramatically large profiles, as well as certain of the *Artist and Model* versions.

The essential questions about these paintings should not be avoided, as they have been, by psychological, autobiographical or social-historical speculations based on the critical assumption that they comment on something beyond themselves. This is a very literary view. The fact is that the paintings are what they were made to be, and their enclosed atmosphere, their imprisoned nature, is actual rather than illustrative, and belongs to the work, not to the

120 Illustration for *Le Chef d'œuvre inconnu* 1924

'subject' of the work. Something was going badly wrong with Picasso's art. We can find out what this was, but we have to do so as it emerges. There are times, of course, when he is making the best of a pictorial limitation with such force that the picture (*Girl in Front of a* 165 *Mirror* would be one) still stands with the great paintings of the twentieth century. And yet nonetheless something has gone wrong, something irremediable. The lofty intentions, the passion, the commitment to other media, the experiments, the jokes, the interest in younger artists, the new love affairs, the search for other symbols, the attempt at writing poetry – all these merely hold off the collapse. It is a bitterly depressing experience to watch this happening. We see the gigantic efforts, the desperation, the pessimism, and then the quietism and total isolation. But this is the truth of what happened to Picasso's art.

SOME PAINTINGS AROUND this date, around the mid to late 1920s, suggest other types of connection with Miró and, more distantly, with Arp and Tanguy. An example would be the *Woman in an* 121

Armchair of 1929. The figure lobs and droops as though without a skeleton. Mirò's new style had brought with it, or had in part been made by, the creation of shapes that seemed to have a form of life within them. These amoebic and biomorphic forms of Mirò's, never human even when billed as such (in the *Imaginary Portraits*), contributed to the whole movement of free abstraction that was later to cross the Atlantic, when the school of New York replaced the school of Paris. There were other artists in Paris at this time who were developing similar techniques. If one puts them together, they add up to a discernible shift in the conventions of making painting. Max Ernst's *One Night of Love* (1927) is an example. It is the result of a bold experiment with technique. It negates illusionism in the classic sense and stresses the surface of the canvas. A lot of paint was put down in several layers, and was then scraped off in places or areas that had been raised or embossed by objects placed underneath the canvas; and then more painting went on, sometimes by means of string soaked in paint. Ernst called his method *grattage*. The look of many of his paintings done by this or similar methods suggests that a certain amount of *beaux-arts* cooking had to follow the aleatory beginnings; but nonetheless there was something new there. Perhaps more to the point, and certainly nearer to the circles in which Picasso moved, were some pictures by André Masson, who was close to Mirò. He proceeded from automatic drawings to a method whereby he was able to translate their spontaneity on to canvas and at the same time give them evident status as paintings; this was achieved by spilling glue and by rubbing around sand, paint and other matter. In the sort of work that Mirò and Masson were doing we can see the beginnings of abstract Surrealism and Abstract Expressionism.

These painterly Surrealists (unlike the academic, veristic ones, Dali, Magritte, Delvaux) tended to exclude the human figure; for them, its possibilities were exhausted. But Picasso was far too devoted to the human form to abandon it, whatever his younger contemporaries were doing. On the contrary, he intensified his examination. One way of doing this was that to the not-quite-incredible adjustment of the features and the limbs are now added further human organic elements, because of the appearance of genitalia. These are female on the whole, though some elements are undoubtedly phallic. They are distributed into confusing roles. A mouth or an ear can double for a vagina. Flaccid or erect, the form of a penis is found in a punning

166

121 *Woman in an Armchair* 1929 >

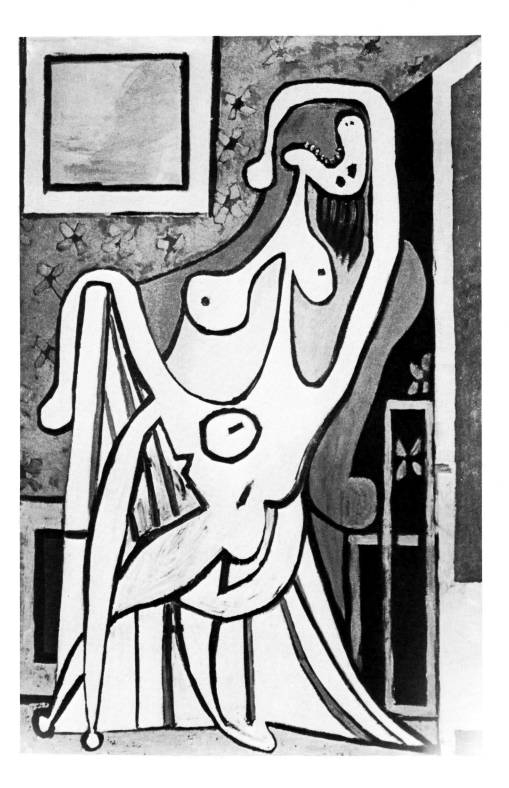

situation, as a nose for instance. This is all very interesting, of course, and corresponds with many of the sexual interests of the Surrealists. But it is not 'erotic art', as it is sometimes said to be. Explicitly erotic work in the twentieth century is either literary-illustrational or has motives other than artistic. That is not the case here. This period in Picasso's art, so urgently and on occasion desperately exploring the last possibilities of painting the human figure, includes sexual matters but is not about them. The matter can be over-emphasized, and has been wrongly interpreted. It should not be welcomed as a step forward socially (as some sort of victory over a bourgeois censor) or as a stylistic liberation (because more things are 'included in art'). It was the end of something.

It becomes increasingly plain, as we study the art of the 1920s and 1930s, that Picasso – whom we habitually think of as an innovatory artist – was in fact struggling with a terminal position: ironically, one that was in large part of his own making. He was involved with the end of the great tradition of European figure painting, not as an innovator but as an artist who could not rid himself of its traditions and implications. The essence of his position was that he was deeply unwilling, at the time in the later 1920s when such a choice could have been made, to effect a personal transition from being a painter of forms to being a painter of shapes (which does not necessarily mean an abstract painter). Picasso's images, however startling, always have their origins in the real world and in past art. In fact, it is because of those origins that they are startling. Picasso's conservatism in the middle years of the school of Paris increased in direct relationship to the extent to which he produced 'shocking' paintings. For if pictorial advance was not available through figure painting the reconstruction of past pictorial culture became inescapable. This is now very often, in an explicit way, the subject of his art, and he now came to paint pictures which were challenging only by their wild concentration on what is instinctively felt as normative and is furthermore hallowed by tradition. The human figure is just such a subject. It is thus not at all anomalous that Picasso painted a *Crucifixion* in 1930. That subject closes in on what has been done to the human frame. It is also, in a larger sense, a testing ground for an Expressionist artist who wishes to display his attitude towards physical and spiritual passions. There is drama and ritual in it. It is the major image of Western European culture, and it incorporates intensity of experience, magnitude of

meaning, recognizability, transformability, and much else. This is the sort of thing that Picasso came to need. Classical and Christian mythology, and a personal symbolism invented by Picasso which has both epic and pastoral connotations, and is given equal importance beside those mythologies, come to replace the restructuring of painting as Picasso's main artistic concern.

The making of an abstract art out of a base in Cubism, the major endeavour of Kandinsky, Mondrian, Masson, Miró, and so many other twentieth-century artists, now appears to us as a vital question which Picasso himself had posed but which he had no intention of answering. This is simply because we can now see the shape of the century. It would not necessarily have seemed that way in Paris in the two decades after Cubism had been invented. The original abstract painting had been done in and around the First World War; but it had been done elsewhere, in Russia, in Munich and in Holland. As the artistic capital, Paris was not especially interested in what was happening elsewhere. There were travellers' tales, of course, and there were visits and loaned pictures, and magazines. But abstraction versus representation was not seen as an issue, in the sense that one took sides, or in the sense that one became dated if new problems were not examined within one's own new painting. In fact, the spread of abstraction, unlike the spread of Cubism, was extremely slow; it was still a major decision for major mainstream artists as lately as 1950. In Picasso's Paris, though, what abstract painting of high quality was there to be impressed by? Picasso thought of Delaunay, and who else was there? There was only one artist of the highest rank in Paris committed to abstraction, and that was Mondrian. He was remote, socially, temperamentally and artistically, but he exhibited tremendously impressive paintings in Paris in 1925 and 1926.

There is one occasion when Picasso approaches geometric rather than biomorphic abstraction. *The Studio* of 1927–28 is quite in 106 contrast with pictures built by expressive deformation, because of its open and rectangular construction and flatly applied paint. The figures are as scantly and unrealistically ideogrammatic as possible. This has the effect of stripping them down from a human presence to much the same sort of materiality – exclusively a matter of line and area – as the table, the canvas, and the picture on the wall. One then sees that the model is not human but a marble bust, and that the artist has little individuality outside his placed function as artificer or,

indeed, artifact. The highly abbreviated depiction of his palette, indicated only by its thumbhole, is read both as part of the painter's own person and as a motif on the large yellow canvas on which he is working; but that area also defines the artist himself, who might be on the canvas rather than in front of it: only his brush tweaks independence from its limits. The economy with which complication is managed in this amusing work seems to have been pared down from the unresolved *Two Women at a Window* of the previous year, which combined rectangular oppositions with ill-assorting rounded forms and profiles. William Rubin remarks on the way in which, in *The Studio*, the space of synthetic Cubism, turning on to the picture plane a form which would be oblique to that plane in real space, is suggested by the tablecloth. So it is also by the whole relationship between the table and the white shape of the plinth on which the sculpted bust stands; for the generally spare and frontally planar aspect of the picture is doubly bent in just this area, space and volume being depicted as though an irregularly shaped piece of paper had been folded. It is precisely the difference between this old Cubist habit, which now looks like a trick, and the fact that the engineered verticals and horizontals and sizeable areas of flatly-applied red, yellow, and black all must remind us of Mondrian that leads to a recognition of the awesome sobriety with which the Dutchman made the move from Cubism to abstraction; and how different his mature painting is from these puckish schematics. One cannot doubt that Mondrian was behind Picasso's painting; what one suspects is that he saw something in Mondrian and responded to it as he had in his youth, by an attempt to outpaint his rival, showing that he could take the leading features of a quite different kind of art and absorb them within a picture of his own that could not be by anyone but him. With an artist as great, and as dissimilar, as Mondrian (who was years older than Picasso) this tactic is quite outrageously magisterial. One cannot but salute the presumption of the painting – that there was no kind of art of any merit that Picasso could not swallow and make his own – but as soon as one recognizes this the painting fails. The quick jocularity of it gives something away; unfortunately or not, there is never any room for humour on the highest levels of art, nor for parody. But the root of the disappointment is not there; it has to do with a descent from the highest imaginative planes.

123

106

The theme of the artist and his model is an artificial extension of the self-portrait, and is nearly as old as the public idea of artistic self-consciousness. This kind of picturing of what an artist makes out of what he has to work on has been a serviceable way of making neat or sleightful points about the nature of what the artist is doing. Half a century of modern art later, this now appears to be rather a weakness, for later painting has won for art some emancipation from the need for internal apologetics; but it no doubt seemed appropriate to Picasso at this time because of the combination of a wealth of possibilities and sheer lack of a major direction. Picasso made little of the artist-and-model subject until he was in his late forties, when he suddenly devoted much time to it. There are a number of paintings and drawings and the revealing series of etchings which form the larger part of the *Vollard Suite* of 1930–37.

The *Painter and Model* of 1928 must be regarded as a major work, 124 though its standing as such is partly because of the tendency in Picasso to paint works every so often which act as a portmanteau for many of the preoccupations of a period. It is a complicated work. The picture presents a chair with a decorative cover, the artist and his palette, a canvas and the picture on that canvas, a windowscape, some still-life elements, a picture on the wall, a plinth and the model. That model, as with the previous picture, *The Studio*, is more convincingly read as a sculptured bust. (This was to become common in the *Vollard Suite*, 148 where sometimes the artist and model together examine the sculptured creation.) The painter's head is sculptural in a different sense, for it appears to have been derived from a sculpture Picasso 122 made in 1928 of a head placed on a tripod. The triangular shape of the artist's body repeats that kind of open podium. The blue areas are doubtless representative of the sky seen through a window. Out of these main elements Picasso develops a repertoire of variations on the differences between representation and signification, more fully perhaps than in any painting since Cubism.

The central feature of the painting is the canvas. This is presented, 124 not as in *The Studio*, but at an oblique angle; nonetheless the profile painted on it is seen as flat, as much on the picture plane as the curve of the back of the artist's chair. These curved elements, like the kidney-shaped palette, are in strong contrast to the bold vertical divisions and parallel lines elsewhere in the painting. There are four circular things on the canvas. They are probably apples, but have been

read as 'breast-fruit symbols'. Two of them have dots in the middle. Now, if they have dots, is there more reason for believing they are schematized? And do the circles which appear on this canvas within the picture represent a schematization of that which is represented more naturalistically elsewhere in the picture? Or are they of the same order as the profile drawn of the sculptured head, which is more realistic in the picture within the picture than it is in the main picture, added to which we believe that it is in any case a sculptured form and not a real one? More questions of the same type can be asked, and that is because the painting – and this is what forbids a real fineness in it – invites us to ask such questions. It insists on its virtuosity. The trick with nails, familiar since Cubism, reappears as a curious attention to detail in the form of wilful dots which indicate how the canvas in the picture has been tacked up on to the stretcher.

109 A change from *The Studio* is that the three eyes of the artist, which in William Rubin's surmise are a sign of the painter's superior perspicacity, are now transferred to the model. In the readings of this painting, both by William Rubin and by Robert Rosenblum, attention is called to transferred sexual attributes (because of the vagina-like mouth or ear of the artist), and it is noted that Freud had

122 *Head* 1928

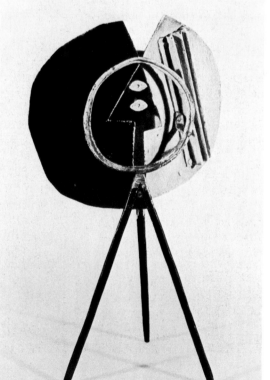

123 *Two Women at a Window* 1927 >

124 *Painter and Model* 1928 >

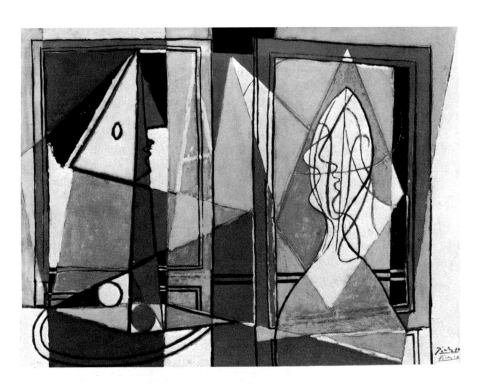

remarked on such transference being common in dreams, and further that this was a current preoccupation of Surrealist artists. In William Rubin's view, the painter's arm (or brush, perhaps) is 'rigidly phallic'. In any case, sexual transference seems most evident in the fact that the model's profile is male rather than female. (Throughout these arguments, of course, runs the supposition that in an emblematic situation such as this all artists are male and all models female. It is reasonable enough to assume this in Picasso's case, though there are in fact some later paintings of a girl drawing.)

The strong and springing rhythms of *Painter and Model*, the alternation of block-like shapes and zones of the picture with more elongated and flowing elements, were not much developed after this painting, though they are certainly there in such a work as the *Pitcher and Bowl of Fruit* of 1931. More importantly, perhaps, there is something of a memory of this manner of working in certain of the

125

125 *Pitcher and Bowl of Fruit* 1931

126 *Vollard Suite* No. 63 1933

etchings of the sculptor's studio in the *Vollard Suite*, where there is a 126
similar combination of forms: a solid and forthright plinth which
squarely dominates the studio, while the artist and his model recline
luxuriously in front of it. This is appropriate. For it could be said of all
the artist-and-model paintings and drawings of this time that they are
haunted not only by the problems of painting but by the possibilities
of sculpture.

PICASSO HAS BEEN famous for his rapid changes of style. These have
seldom been held against him except by the most hostile
commentators, who regard the phenomenon as convincing proof of
charlatanism. In general, they are vaguely commended as being
evidence of energy and a fertile mind. They are most common in the
1920s and early 1930s, and have much to do with the fact that there
was not then the same drive, the same propulsive urge that there had
been before. Some paintings occur which are in a peculiarly realistic
style. They are of people. The very unlikeliness that realism would be
the right path for art to take after the First World War led to some

175

alarm when members of the Picasso circle saw his meticulously 'accurate' drawings of a conventional type. But that kind of drawing was confined to work on paper and was later expanded by the use of oil only on rather unspecial occasions. These have been welcomed by some writers, and by the print industry too, perhaps because timid critics are glad to point out that a vilified modern artist can draw perfectly well in an academic fashion when he wants to. This sentimental naturalism in Picasso is characteristically familial, and 128 appears in portraits of Olga, his mother, his friend Salvoldo, and 127 above all his son Paulo, who is a trifle subjected by his father's fantasies, being often dressed as a pierrot, a harlequin or a matador. These works belong to the biography rather than the *œuvre*. (Roland Penrose recounts: 'Alexandre Rosenberg remembers a story of his mother's displeasure at Picasso's version of her charms. She told him firmly that she would rather have been painted by Boldini, the fashionable Parisian portrait painter of the day. Silently Picasso took another canvas and a few minutes later presented her with a perfect example in the style she desired, signed Boldini.')

128 *Olga Picasso* 1917

127 *Paulo Picasso* 1924

It is at this point that we should note the separation between Picasso and his wife. The circumstances do not seem to be vastly important to the discussion of Picasso's art, and there is really no need to study the matter further than has been done by Roland Penrose, Picasso's loyal friend. It is worth noting, however, that Sir Roland's vague account claims that Olga was both the cause and the subject of some of the violent female figures of the 1920s. He suggests that Picasso had been enticed by Olga into a high life of balls, beach parties, *la vie snob*; that this interfered with his art; and that it became intolerable. An increasing estrangement within the marriage became total in 1931 or 1932, when Picasso approached a striking seventeen-year-old in the street. This was Marie-Thérèse Walter, who became his mistress and bore him a daughter. She inspired, or at any rate is the subject of, very many of the paintings and sculptures of the 1930s. Their importance is discussed below. Perhaps it should be added here that the women who were Picasso's lovers are seldom happily described by his biographers. Not untypical of the attitude towards Marie-Thérèse is William Rubin's commendation of her 'suitability as a vessel for primal feelings'.

After 1918, Picasso had begun the habit of spending long summers by the sea; he was generally in Paris during the winter months. The character of the Mediterranean coast appealed to him more and more. It is reported that this was not a feeling shared by Olga until that coast became the fashionable Riviera. It is hard now to imagine, say, Saint-Tropez as a simple fishing port where artists lived and worked cheaply; but that is what it was. The Picasso family also spent summers on the northern coast, at Dinard. Picasso had the money to do as he liked. Modern artists do not live in castles, as a rule. However, Picasso began to feel the need for a home that was away from Paris but not on the coast, where he operated as a sort of superior *estivant* or summer resident. He accordingly bought the Château de Boisgeloup, near Gisors, in 1932. This was in the middle of the Depression; in Paris, Kahnweiler was organizing a welfare system for his artists. At Boisgeloup, the barns and stables provided ample room for sculpture. In addition, a press was installed there. Picasso began engraving seriously in a way that he had not done since the rose period, thirty years before.

The *Vollard Suite*, one hundred etchings for a luxury collectors' edition planned by the dealer Ambroise Vollard, was some years in

177

the making, and work on the project was not at all continuous. It was begun in 1930 and completed in 1937. Vollard had given Picasso his first show back in 1901, but was not interested in dealing in his pictures after the Cubist period. Relations between the two men were nonetheless amiable. Vollard had a sense as a dealer which combined the commercial and the aesthetic; out of this came a well-judged instinct for originating second-order artistic projects. The kind of books that come in boxes, the *beaux livres* of nineteenth-century French tradition, were precisely to his taste. He used many contemporary artists to illustrate new editions of classical and modern French works. Picasso had recently collaborated with him on the

120,134 Balzac short story *Le Chef d'œuvre inconnu*. There is evidence enough that Picasso approached that commission – he had subsequently a wry regard for the story – with a mixture of feelings, some of them throwaway; that he adjusted his style to suit Vollard's tastes; and that he was inclined to taunt Vollard's pretensions. This is important, since the etching of the 1930s often explores the kinds of unseriousness, parody, criticism, and so on, that are available to that medium but not to painting or sculpture. The facts of the deal he now made with Vollard are not clear, and there may have been types of bargaining of an unexpected sort; most probably to do with Picasso buying back his own earlier work in the dealer's collection.

The *Suite* is not illustrational in a direct sense. Half the plates represent the sculptor in his studio. A quarter are miscellaneous,

149 showing nude women posing or reclining, bullfights, circuses, a
151 winged bull. Smaller groups are concerned with Rembrandt, and a
156,158 rape; and two larger groups have the Minotaur as their subject. Riva Castleman considers the *Suite* a 'refined sketchbook', in which many of the concerns of the 1930s are presented with deliberation. In so far as the plates which are gathered together in the work seem to have been those which most pleased Picasso, or which he felt to be proper to the enterprise, there is some homogeneity. But this is largely to do with the medium, since there is no thematic unity. We shall often return to the *Vollard Suite* at precisely the times when Picasso is meditating on what artistic styles are proper to what media. This is most of all the case with his sculptural explorations.

Picasso returned to making sculpture in the late 1920s. In his painting, however radical, there was a sense in which the possibilities for that radicalism had been preordained by other artists: Cézanne's

178

example allowed him to make Cubism when in his twenties. Sculpture was a different matter. If Picasso wanted to make modern sculpture in 1928, there was no one to look to but his own younger self. In sculpture there has never been the same community of effort behind innovation which is the mainstay of the modern painting tradition. Picasso alone provided the relevant prehistory; but that example was remote, part of his youth. He, Picasso, had set the dimensions of the sculptural problem in making the Cubist constructions, but had then altogether abandoned three-dimensional work. In the intervening years there had not been enough sculpture of great merit to advance what there was of a Parisian sculptural tradition. Quite a lot of it was merely an attenuated three-dimensional transcription of Cubism, or attempts to give a contemporary look to the human figure. This kind of work remained static because there was no real effort to make abstract planes the method and reason of the sculpture; it still relied on varied modelling, or on understood representative planar variations, around a recognized core. Brancusi's search for primordial ovoid forms was a reductionist tactic which could lead nowhere. Constructivist sculpture, that decorative adjunct of the machine age, which remained interior design even when most hopefully enlarged as exterior design, had no attraction for Picasso. Assemblage, a favourite mode for producing Dada and Surrealist objects (rightly always called 'objects' rather than sculpture), was more than anything else a weakening rather than a development of collage and the Cubist construction. All this seemed to be irrelevant. Picasso's problem, then, was how to begin anew, when he had done it all before.

William Tucker's remarks on the earlier achievement are relevant here; 'It was due solely to Picasso, and in particular to the [Cubist constructions], that it became possible to literally "make" a piece of sculpture, for the first time in history . . . until this point in time, the possibility of the free arrangement of parts to create an expressive whole had been denied sculpture.' And now, again, sculpture which had been wedded so long to carved or modelled human representation, and which had been wedded since Cubism to the Cubist 'look', found it difficult to effect that kind of bound into 'making'. It is this ability to be *facient*, the rarest and most essential quality of modern sculpture – additionally a high demand because of the discontinuity of the sculptural tradition, and only really apparent

among other artists in David Smith and Anthony Caro – that Picasso now sought to recapture. The attempt to return to the facient condition was partly vitiated by the fact that Picasso was haunted by the idea of the monumental. Considering that sculpture's enslavement to the reiteration of the human figure had been ended by the Cubist revolution, this now looks as if it were a wrong tack, and that Picasso needed, above all, to rid himself of work that would depend on a recognized sense of human dimensions. However, there may be one very important precedent in Picasso's own work for some sculptures in the period now under discussion. This is the immensely savage totem-pole *Figure* carved – hewn – in 1907. Given the date, one jumps at the affinities, but *Figure* remains a rather puzzling work. There is a difference between this piece and the paintings of the time. Whatever precultural, primitive, or African things were impressed into the service of early Cubist painting, they did not remain such, for they were accommodated in the most delicate and artificial product of European culture, easel painting. This did not happen with *Figure*, which stands alone, without a context. It does not necessarily have high standing as art, and its singularity – there are only two smaller things like it – has meant that it is often overlooked. It may not be finished; but on the other hand there may not have been any need to take it further than it is, in which case it is finished. Only the fact of the making of it seems to matter. But, since he did make it, some problems arose (for in modern art, to be without a context is itself a contextual problem). We can assume that Picasso would not be so obtuse as to make an imitation African piece, so that was not the intention. On the other hand, it is fairly clear that what he had made he did not wish to bring into Parisian art; and so the reason why this remains a solitary and exceptional piece would be that he realized that in sculpture this could not be done in 1907; just the substantiveness of the medium precluded it. *Figure* therefore gives us a unique opportunity to estimate the brilliant intelligence of the young Picasso by reference to what he decided *not* to do. Now, it is likely enough that the only reason why *Figure* is extant is that Picasso never destroyed his own work. But since it is there, it is reasonable to speculate about it; perhaps something about the piece returned to him in the late 1920s as a sort of new possibility. Since it pre-dates Cubist sculpture, it might have seemed a way to be free of the problems in which post-Cubist sculpture still floundered. Moreover, the violent

129

129 *Figure* 1907

Dada and Surrealist years that had come after the calm of Cubism, the new emphasis on the iconoclastic, the presumed alliance between the primitive and the subconscious, the re-appearance of the *Demoiselles* – 50 all this might further have suggested to Picasso that there was a viability in totemistic or fetish-like figures. There are a good number of examples in the figurines of 1930 and the little wood carvings of human figures made in 1931.

However, it is significant that we find most evidence of the idea of the totemistic monument within painting (and drawing) rather than in actual sculpture. Why is this? The facient, substantive reality of sculpture emerged during this century as a separated counterpart of the way painting shed its dependence on illusionism. This became totally clear with the invention of collage and the making of Cubist constructions. But the sculptors did not respond to this situation. Now, after Smith and Caro, when we know how much can be done with sculpture, we realize how *little* was made out of collage in those years, how it lost power the more it was used in relief and assemblage

130 *Woman by the Sea*
1929

object-making. In the 1920s and 1930s, there was a tendency among those who were unsure about sculpture to make it lurk within illusionistic painting. Surrealist sculpture is the prime example. It hardly exists, in fact; but it has a notional life within the painting. If one thinks of the major incidents within the recessive academic scenario provided by Dali, Tanguy and Magritte, one sees the sculpture there. Picasso's case was not quite the same, of course. But there were three or four years in which he drew, or painted, imaginary or putative sculpture within a generalized landscape or seascape setting. The sea, in fact, is never far distant, just as the forms which these imagined sculptures take are like rounded bones and pebbles, cast on some deserted littoral after the surge of thousands of tides had worked them into primigenial forms. There are a cluster of works like this. A peculiarity of them is the way that they all – even 131 *Seated Bather*, perhaps the most famous – carry evocations of maternity. The theme is explicit in other works, though the *Seated Bather* itself has much more startling attributes: for the woman's mouth is constructed as a *vagina dentata* and her head resembles that of the praying mantis, an insect notorious for its mating habits and popular among the Surrealists for that reason. (William Rubin

182

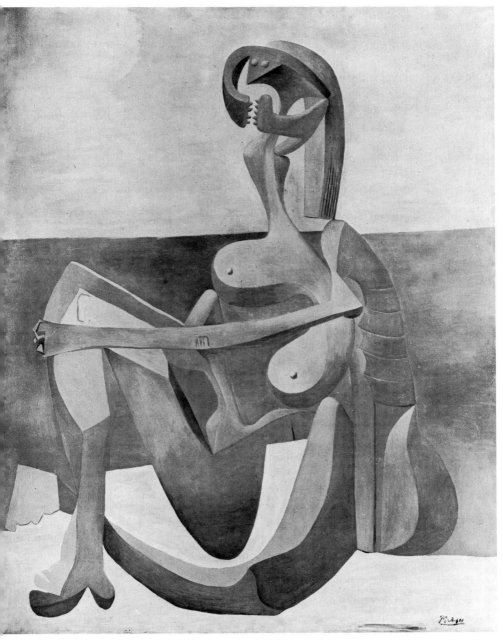

131 *Seated Bather* 1930

connects the image with his speculations about Olga Picasso.) Clearly enough, there is some sort of connection between Picasso and the Surrealists here. But he is a long way from their procedures, at least from those veristic ones which use academicism in the interests of subversion. The painting is more frankly a modern painting. Instead of the great vistas and deserts of Dali, or Tanguy's viscous canyons in which the horizon cannot be precisely located, the tripartite division is frankly drafted, and the figure given up to what Picasso does to it. In this picture it is as though the figure is being invented rather than distorted, one reason why one finds it preferable to the preceding

130 *Woman by the Sea*, with its gruesome reminiscence of the *coiffure* scene in Gosol. The appearance of *pentimenti* in *Seated Bather* is rather cheering. They make plain how remote the picture is from the enamelled virtuosity (the finished virtuosity of a sham aesthetic) that appears in Surrealist painting *à la* Dali. They also fasten attention on the real pictorial force with which the fashioning – sculpting – of the lower half of the body has been carried out, at some point forcing the line of what we take to be the beach right out of true.

There are a cluster of paintings of this sort, and a very large number of drawings which depict things even more avowedly sculptural. Some of these may be classed among conceivable projects for a proposed monument to Apollinaire, which Picasso was invited to design. The details of this project are vague. What one can be fairly sure of is that Picasso, who had great difficulty always in commemorating friends, would nonetheless have made something if he had wanted to; that is, if he had wanted to make the sculpture rather than make the gesture. But he vacillated for years and would not make his ideas, which undoubtedly exist in these drawings, actual. We can be fairly grateful for this, looking at the drawings. Perhaps graphic work kept him away from major mistakes in sculpture. His acute eye for the separation of the sculptural from other

132 media was expressed in some amusing drawings in the *Vollard Suite*. These were done in a burst of a few days in 1933. Their point becomes clear as one attempts to visualize what these sculptures would be like if they had a real existence; then their absurdity becomes apparent. They have some basis in reality, however; they look rather like the Baroque histrionic grandeur of the statuary by such sculptors as Coysevox in the gardens of the royal palaces outside Paris, at Sceaux and Versailles. These are not serious drawings, but they are serious

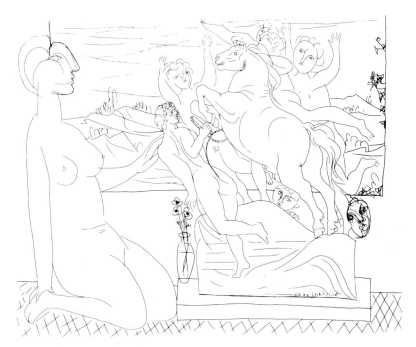

132 *Vollard Suite* No. 66 1933

enough about what lies behind them, a feeling for what works as sculpture and what does not. In this case the adoption of a historicist parody gave Picasso a detachment from the looming and nagging Surrealism in a number of sheets done in 1933, and collectively known as *An Anatomy*, which are compartmentalized and show variously sculptured forms. 133

Of the sculptures that were actually made at this time, considerably fewer than one might expect from the amount of rumination that went on, the open wire constructions of 1928–29 are the most renowned. They have been connected with the doodled drawings of 1924 put at the front of Balzac's *Chef d'œuvre inconnu*, and with the geometrical painting *The Studio* of 1928. To these we may add the right-hand portion of the linear *Painter and Model* discussed above, for the tripod-torso is repeated. 135 134 106 124

The whole construction is claimed as human primarily by the button-like head which surmounts it (Alan Bowness suggests that it

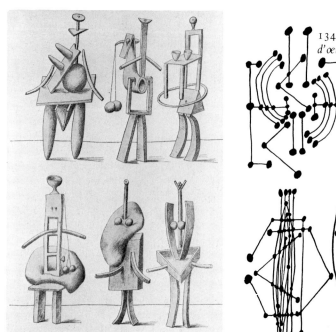

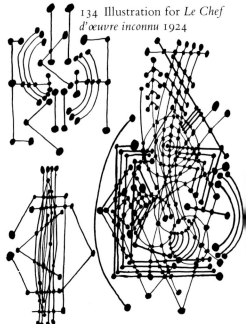

133 *An Anatomy* 1932

represents a woman pushing a swing); but it is in other respects a most abstract work for Picasso to have made. One is not led to examine the piece to find what parts of it 'represent' what parts of the body. All the vertical lines are made of thicker pieces of wire than the horizontal ones. Six of these verticals are anchored to the base. The curved parts, the long ellipse and the two crescoids, are in planes at right angles to each other. But the construction seems to have been freely and intuitively made. It is not mechanical or calculated. Most important, perhaps, is the way that a sculpture has been made that does not have a core, a centrally placed mass which dominates its dependent volumes. It was this natural disposition of sculpture – again, a condition imposed by the predominance of the human figure – which had held sculpture back from facience. The tripod does not constitute a core, and there is enough of the rest of the piece to balance against the assumption that it 'stands for' such a thing, in particular the definiteness of the suspended rectangle at one end (where the horizontal wires are as thick as the vertical), and of course the fact that it has six 'legs'. The fact that it is made of wire means transparency,

186

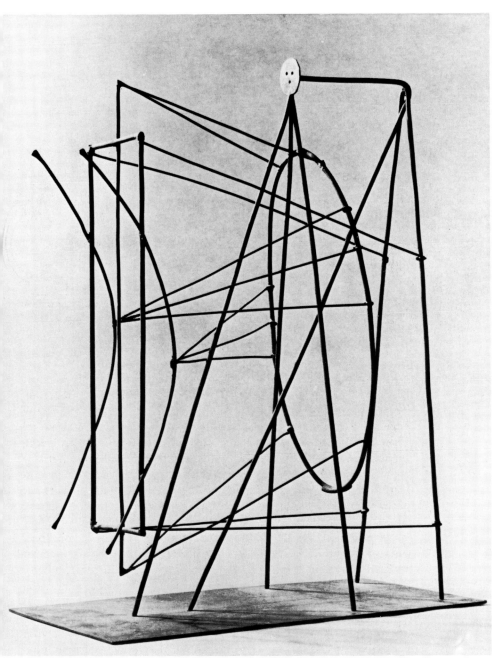

135 *Wire Construction* 1928–29

and that means that there is no *mass* to the sculpture. It has, as it were, an inside but no centre. The facture is often referred to as 'drawing in space' because of this, and because of the thinness of the wires. In that phrase is also something of the slightly unsatisfactory, because evanescent, nature of this sculpture. For as one examines these twenty-six straight lines, one ellipse and two vectors, the ways that the lines cross each other continually change. One enters on a miasmic negotiation with the piece quite dissimilar from the way that one finds an optimum viewing point or succession of viewing points in a more substantial open structure. It is a common experience with this work that one wishes to *draw* it in order to capture more experiential reality from it. A further point should be made. The sculpture's natural habitat seems to be aerial, not floor-based. It is always exhibited on a rather high stand or podium, and Brassaï photographed it in such a position when it was in the stables at Boisgeloup.

Some illustration of the way Picasso's work of the late 1920s and 1930s related to other sculpture might be useful at this juncture. Apart from Julio González, with whom he collaborated, he was perhaps nearest to Alberto Giacometti. And yet there is a huge gulf between them, in the fineness of their art. It has been suggested that the balls, cusps, and hung elements in the drawings entitled *An Anatomy* are indebted to sculptural objects by Giacometti like *Man and Woman*, *Suspended Ball* and *Disagreeable Object*, all of which were made between 1929 and 1931. This may be so. It is also suggested that Giacometti's *Palace at 4 a.m.* derives in part from Picasso's wire constructions. This may also be so. But in this area talk of reciprocal influences can blur the issues, which are large ones. Take the notion of the cage, as often applied loosely to these two different works. The cage is a Surrealist and Dada cliché. It had been employed by many artists as a simple and potent way of exciting interest. This had to be done through object-sculpture made out of smallish assembled environments, and relied on a sure way of making bad art, the directing of nasty psychological pressure towards the spectator. Just as, structurally, the cage is not columnar and does not have a core, that absent core is imagined as something living which is trapped for inspection; thus a cage has no real outside; it is a mere convenience for the inspection of what it contains. (Often, the Surrealists supplied this centre, with stuffed animals, heads, rotting limbs, broken dolls, etc.)

133

Such notions about cages are deeply a part of our non-artistic cultural expectations, and Surrealist art blatantly exploited this. There are many other examples of Surrealist tactics of the same sort; the anti-tactile, the stinking, the physically painful, etc. Not many of them need to be mentioned here. It is simply worth saying that the imaginative poverty of Surrealism is more marked in its object-making than in its painting.

The *Vollard Suite* as a whole has a fairly wry attitude towards the way that sculpture could be made, or had been made. Picasso, in the *Suite*, drew some imagined Surrealist sculptures, imagined in the sense that they were what other people, not he, might have made. There is something to be said about the way we imagine this work to have been constructed. The *Suite* looks at sculptural methods which were current in new art but which Picasso himself did not care to try out. For we must now add two more ways of making to the traditional distinctions in sculpture between carving and modelling. These are assembled sculpture and constructed sculpture. Though the two new modes will sometimes be indistinct, the major differences between them are clear. The methods of assemblage may be seen in the piece of work the nude model is gingerly examining in *Vollard* 136 *Suite* No. 74 (4 May 1933); in Picasso's own *Construction with Glove* 111 *(by the Sea)* of 1930; in Miró's *objets poétiques*; and in any number of works by Dali, Giacometti, Tanguy, Duchamp, Breton, Ernst, and all their progeny. Assembled sculpture differs from both carving and modelling in that it is a putting together of various different parts; but this does not make it facient in the sense described above. It very often uses found objects, things which had a previous life before their introduction into an art context, and these objects or materials are often juxtaposed in an uncommon, humorous or startling way. These materials are malleable, on the whole; they are wood, plaster, cloth, cardboard and the like, and the joinery is characteristically done by gumming and pinning. Assemblage is handleable in size, or its various elements are. When it is relatively large in size, that is because of an increased number of elements. This handleability leads often to a toy-like air (a large number of dolls and stuffed pets are used), and in the more aggressive pieces to an attack on what we normally find pleasantly tactile: Meret Oppenheim's fur-lined cup and saucer is the best example of this. Assemblage is never wholly abstract, not only because recognizable pieces of the real world are incorporated but

136 *Vollard Suite*
No. 74 1933

because its whole function is as a malicious commentary on the things that we take for granted. Picasso's model reaches out to touch a sculpture which has been made in just this sort of way; it is replete with references to the 'art' of stuffed garments and the sort of anthropomorphic furniture which Giacometti made and which, on occasion, Picasso drew. But here again is a sort of art that Picasso did not wish, in reality, to fashion himself. There are two examples only

111 of assemblage sculpture at this period. One is the *Construction with Glove* and the other is in the way that, perhaps only for the photographer Brassaï's benefit (but one regretfully doubts this), he

137 draped toys, rags, a doll and a cobbler's last over an iron figure in 1931.

 A type of sculpture that does not appear in the *Vollard Suite*, and which we now recognize to be the most important of all, is that which

137 *Figure of a
Woman* 1930
(with assemblage)

Picasso made by open construction. This was an innovation, and one of those innovations in modern art that we recognize by its fuller developments in later artists. By constructed sculpture we mean that which is made from a neutral material, usually metal, which is welded together, or bolted, which depends on the putting together of discrete elements which had no prior significance. It is open, it is not dependent on a core, it is not dependent on human proportions, and it occupies space on its own terms. This type of sculpture may be figurative in some way, though that is a danger, and it may be representative; but it is not illustrative. It leaps away from the Cubist innovation of making still-life a sculptural subject by making the use of sculptural means into an abstract fact, an awkward addition to the world, with its own beauty. In constructive sculpture, the abstract formal qualities are the leading ones, whereas in assemblage the abstract qualities are the least important (so that it is essential to the functioning of an assemblage piece that one ignores the nullity of its composition). The best constructive sculpture is very frank about its construction, and is superbly without extra-artistic connotations. Picasso began to move into a situation where he was making sculpture of this sort around the end of the 1920s. The wire constructions anticipate constructed sculpture because of their openness, but the metal is not felt as having been worked – and the point of the wire seems to be not so much that the material is neutral as that it is immaterial; and so one wants to draw it in order to substantiate it.

At the time of the wire sculptures, Picasso had begun to see something of an old Spanish friend, the sculptor Julio González, slightly his elder. Like many Spanish sculptors, González was from a family of smiths. Picasso became interested in metalwork as a result of visiting his studio, and González showed him some techniques. The question of collaboration and influence is hard to determine. It is sometimes said that González was in some way responsible for the wire sculptures, but this can hardly be so. It does not take an expert knowledge of welding techniques to put wires together. At this stage, Picasso was primarily making use of the facilities in González's studio. His new interest in sculpture might also have been stimulated by Jacques Lipchitz rather than by González. Picasso visited Lipchitz in his studio, where he admired what he was doing. Lipchitz had been making transparent sculpture since 1925, as in his *Harlequins* and in

The Harpist of 1928. He later recalled, with pride, 'Picasso liked them very much and one day spent half an hour studying a piece.'

González perhaps got more from the partnership with Picasso than Picasso did, as Lipchitz believed. His excellent *Harlequin*, dated 1927–30, has the appearance of having been made with great verve, not particularly a characteristic of González beforehand. The two men worked together in Paris, where Picasso probably put together the tripod-figure that we have seen in the painting of *The Studio*, and 106 González followed Picasso to Boisgeloup, where they were able to make use of the village smithy. Picasso's development of sculptural technique now took a step forward. Previously he had used González as a technician in building something whose drawn outlines were already in his head and, indeed, on paper; then, one suspects, he had put things together from pieces of metal he found in González's workshop, and González had showed him how to weld them. Now, Werner Spies relates, Picasso moved quickly from making paper drawings of the kind of shapes he wanted to cutting those shapes directly out of metal. This was important enough for us to conjecture that all the help and 'influence' he had from González, apart from the banausic fetching and carrying, amounted to precisely this.

Whatever the nature of the partnership, at Boisgeloup Picasso made *Woman in a Garden*, which is one of the great sculptures of the 138 twentieth century. It is much more 'modern' than anything he painted at the time, and for that reason one is shy of over-stressing its prophetic aspects; but they are nonetheless there. For a different view of the sculpture one must refer to Alan Bowness: 'The *Woman in a Garden* has a characteristic Picasso head: a flat triangle set against an oval disc, with two small pin-like eyes placed close together, and a five-stranded quiff of hair swept upwards as if by the wind. The two plant-like forms on tall bending stems suggest the vegetation amid which the woman stands, although one cannot make too specific an interpretation. The basic formal language remains that of synthetic Cubism, and we feel that Picasso had simply assembled interesting looking pieces of metal that he found in González's workshop, allowing a figure to emerge mysteriously in the process of making the sculpture . . . some of the components of *Woman in a Garden* are quite sophisticated.'

But the sculpture's major feature is the shedding of 'the language' of synthetic Cubism; and its relative lack of interest in figurative

193

representation is an *active* characteristic, so free is it from the conventions of how human-figure sculpture ought to be made. Even today, there seems an odd crankiness in the construction. Some parts are of wrought iron, other parts are welded, other parts are bolted. Its articulation, in the places where it is jointed, mortised, split, forged, is of some eccentricity. Its abundance of fantasy seems wanton, zany, and overflowing; and yet the piece always reserves in itself a real elegance: that elegance which comes from an uncompromising mastery sure of its own way of being eloquent. These flourishes and separate delectations are made by a brilliant artistic sense that in no way is ingratiating. Even the base, an irregular triangle, announces the awkwardness, especially since it seems slightly too small in ground area to have a wide basic control over the burgeoning activity above it. And yet this is properly so. The base is a real and integral part of the sculpture, not a vestigial pedestal; this can be seen in some photographs of the sculpture which set it in tufty grass and thus badly detract from the total plastic effect. And if one reads the piece upwards, it is seen to rest on diverse *points d'appui*: a dog-leg, a simple upright rod, splayed and joined vectors, a crude supportive triangle, and a hilariously small subsidiary platform three or four inches raised from the base. These elements at no point develop into core, cadre, or framework, but immediately transmute into a massy round form, a flat but daringly tilted plane which has previously been curvingly cut from a rectangle, taut bows, a curved kidney-shape, and so on, right to the waving top of the sculpture, which triumphantly makes valid the abstract substantiveness of the piece by its comically jeering assertion that flowing hair can be 'represented' by riven iron.

According to Werner Spies, who had the good fortune to talk to Picasso about his sculpture, the episode when *Woman in a Garden* was made was recalled with pleasure: 'We had a good laugh when we were doing that one.' It is perfectly possible that Picasso did not realize, as we now do, the importance of the sculpture; its exuberance may have obscured its significance. In any case, the methods of open construction were not pursued (and this is so, however one reads the obscure chronology of the sculpture of the time). This was a major loss. González reverted to the position of a technical assistant, an odd-job man. 'I said to González, go and get me some colanders.' This was Picasso's account of *Woman's Head*, and the art had gone wrong. How one regrets, not only the maintenance of a personal hegemony

139

194

139 *Woman's Head* 1931 140 *Figurine* 1931

over his associates, but above all the sudden retreat to puns and
metamorphoses, to things that turn out to be not what they might
appear to be. This piece is a reversion to the loosely improvised
approximation of the human figure. The colander forms a major part
of the work, and is able to display its own identity sufficiently to
destroy the abstractness of the construction. This was, in fact, a
reversion to the methods of assemblage; it was to have woeful results
in the years to come, when Picasso seemed quite unable to take
sculpture seriously.

In these later years, only the lingering idea of the totemistic made
some sculptures look more authentic than others, as we can discern in
190 *Man with a Lamb* (1944), *The Pregnant Woman* (1950), and *The Bathers*
(1956). All these works have the 'normal' size and scale of European
sculpture. In and around 1930, however, the attempt at the totemistic

196

was combined with sudden dislocations of our inbred notions of size and scale. *Figurine* of 1931 is a significant work in this respect. Only eleven inches high, its scale is so totally disjuncted from its size that this gap is its most active aesthetic component and yet dramatizes its wrongness rather than any achievement. Two simple pieces of metal with wire twisted around them blow up to a vast and massy portal, or Laocoön's mighty struggle. Yet it is always clear that, if the piece were the size that it looks as if it ought to be, then it would not be majestic but merely exaggerated. Picasso's difficulty in making the relationship between size and scale was not solved by the tiny wooden figures of 1931. The uneasy result of miniaturizing the product was the look of a whittled toy. Picasso was to make many such small objects and figures to the end of his life, but their inspiration was generally occasional rather than artistic. The mad, throwaway gesture of festooning a figurine with odds and ends was one of *je m'en foutisme*: of abdication in the face of that problem.

137

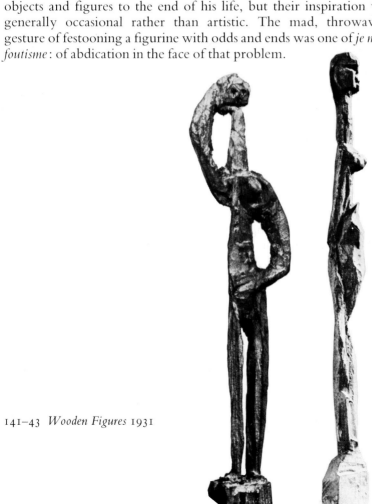

141–43 *Wooden Figures* 1931

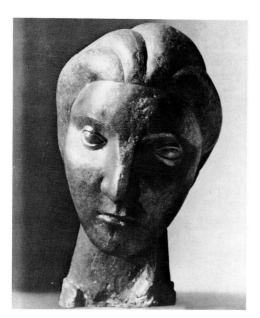
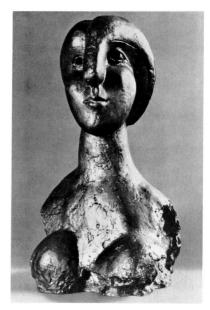

144–47 *Four Heads* 1932

It is possible that Picasso sensed that *Woman in a Garden* was so near to a full sculptural abstraction (more so than the wire pieces were) that he recoiled from its implications. This would be perfectly in character. All we can say is that the later history of sculpture emphasizes how much was lost, and how much richer the sculpture of later years might have been. Picasso's rapid return to modelling the head seems all the more disappointing because of this.

144–7 Of the many modelled heads of Marie-Thérèse that were made at Boisgeloup, there are four which are over life-size and which seem to form a sequence in which the head is treated in a progressively operated-on manner. They were probably made in response to Matisse's progressive sculptural simplifications in his four-part *The Back*, which was finally completed in 1929. A spirit of rivalry would not be unexpected, in any case, and there were odd ways in which the two men had been recently placed in quasi-competitive situations; in 1930, for instance, both accepted commissions to illustrate books for Skira (Matisse's Mallarmé, Picasso's *Metamorphoses*); two years later, both declined invitations to produce murals for the Rockefeller Center on the theme of the 'March of Civilization'. If there was such a competitive response, then it was one without a fine artistic spirit in it,

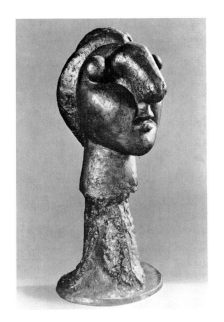 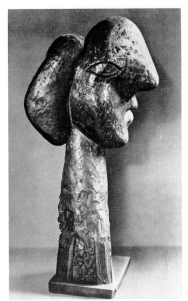

and this gives the Marie-Thérèse series a misplaced tendentiousness on top of being fairly disagreeable otherwise. How Picasso misunderstood his own sculpture! He develops Marie-Thérèse's features from a quite simple portrait bust (in some respects not at all unlike Matisse's *Big Head* of 1927) into a plastic, massy 'expressiveness'. The features, the cheeks, nose, eyes, become swollen and protuberant; the forehead and nose are joined to make one undifferentiated feature; this finally swells, and swells sideways, to become almost as large as the rest of the head. (Picasso found this a good place to make a pun on the form of a penis.) These bulbous heads, modelled in plaster and cast in bronze, their surfaces roughly pocked or on occasion varied by the impression of leaves or other textures in the wet plaster, artful on the surface yet swollen, doughy, tumescent in their massiness, are far from being pleasant works; yet they still do not have any challenge in them, anything that makes one want to reconsider the idea of the sculptured head. Their notional existence as engraved drawing within the *Vollard Suite* is so much 148 preferable to their actuality that we are drawn – yet again – to the conclusion that Picasso's linear, graphic methods were what saved him from a welter of misdirections.

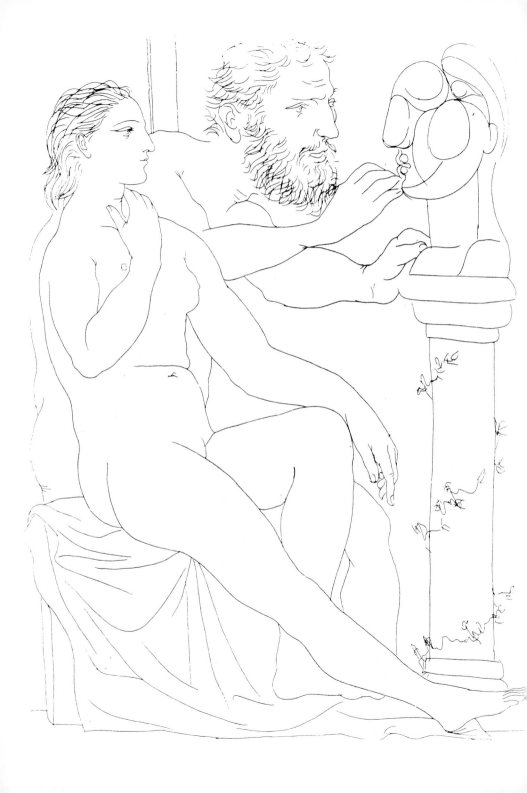

5 From the *Vollard Suite* to *Guernica*

IF WE RETURN to look at the *Vollard Suite* we see that the many plates which have to do with sculpture seem above all to be concerned with the *marmoreal*, making a clean and pure line out of mass. There are constant references to Greek, Roman and neo-classical sculpture. It has always been remarked that the coolly incised line of Ingres is pervasive; but this is rather too blunt; within an amalgam of various neo-classical manners, there is not a great deal more reason for thinking of Ingres than of David, or indeed of Canova or Flaxman. It is less common to note the appearance of two other artists in the *Suite*, Rembrandt (in person) and Goya, whose influence is apparent in the aquatints. There is a very good reason for the summoning of these two masters. For graphic artists since Manet, that is to say in the tradition of the Parisian avant-garde, there were two rival traditions of etching of which it was necessary to take account. One was of sooty floods and washes, alternated with brilliant whites; this was Goya-based. The other tradition was a Northern one, and derived from the linear methods and cross-hatching of Rembrandt. Now, it had been possible for many artists (Renoir was one) simply to find the nearest graphic equivalent to their painting practice and mine what opportunities were there (which explains Renoir's happy work in soft-ground etching). But with some artists who had a strong sense of the coexistence of different types and styles of painting, like Manet himself, etching was a most interesting medium for seeing what could be made of rival traditions, different ways of working. In this single respect, Picasso in the *Vollard Suite* appears to have some affinities with Manet. Both used etching for sly comments, parodies, double-takes and experiments. Both exploited its indeterminate status *vis à vis* the major media, making it a sanctuary for wit and a kind of bold carelessness which is rather different from any painterly

148

201

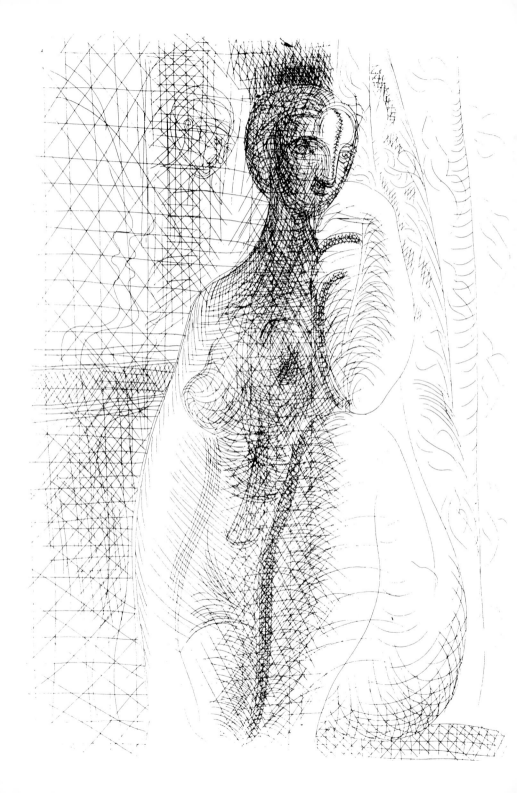

150 *Vollard Suite* No. 9 1931

bravura; and so it developed into a situation where one could do quite surprising things and not be overmuch troubled by what came out. Thus, some plates in the *Suite*, like Nos. 8 and 9, seem to have been scratched around in an experimental mood. No. 1 is as deliberately spare as possible, while the first plate of Rembrandt himself (No. 34) is worked on to the point where he is hardly visible. 149–50 155 151

There are many suggestive, mocking, or serious points about art in the *Vollard Suite*, some of which we have already noted. Others could be mentioned: No. 82, the *Four Nudes with a Sculptured Head*, has references to Fontainebleau art, and No. 37 brilliantly shows a *kouros* from behind. Often enough, there are places where differing experiences, or differing types of art, are combined in the same sheet; as in No. 59, where the artist is shown at work in his studio before his subject. She is fully modelled, but he is represented in a linear style, and appears to be drawing rather than carving, while she might well 153 154 152

< 149 *Vollard Suite* No. 8 1931

152 *Vollard Suite* No. 59 1933

be a marble statue rather than a human model. We have seen this sort of thing before, of course, in the *Studio* paintings of 1927 and 1928, but there the intention was much more formal, and was formally to do with painting. Now we begin to feel, in the graphic work, that Picasso was brooding over some felt need to separate the different demands of different media, but that thinking about sculpture was nonetheless something he was not prepared to do without a debilitating irony. His broad-minded but wry regard for the whole arena of art past and present came to be a deceptive quality, as is quite often seen precisely at times when Picasso approached a new medium, when fluency paradoxically became stultifying. His mastery of techniques, the facility with which he absorbed them as soon as they were adopted, meant that the technique or the medium hardly made demands on him, and led to nothing that was really new. As we have seen, only the *Woman in a Garden* is an exception to this, and that particular line of enquiry was immediately abandoned.

106,116

138

< 151 *Vollard Suite* No. 34 1934

153 *Vollard Suite* No. 82 1934

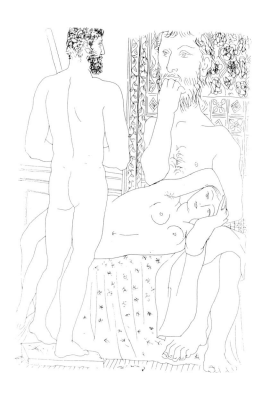

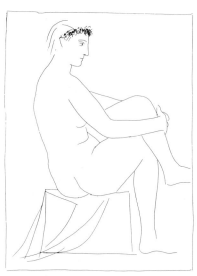

155 *Vollard Suite* No. 1 1930

154 *Vollard Suite* No. 37 1933

The *Vollard Suite* indicates that Picasso's future as an artist was to be in drawing, or in making sculptural drawing into clear frontal painting. We will return to this topic, for it has much to do, formally, with the painting of *Guernica*. But there are other things in the *Vollard Suite* that we must now collect and describe that are not at all of a formal type. In a sense, they are extra-artistic; they have to do with the establishment of the Picassian mythology, and the milieu for that mythology. This now becomes, through its undoubted imaginative power, the bedrock of his art. Briefly, it is an Arcady where terrible things can happen. The elements of the mythology are mixed, and can be contradictory. They are pagan, or Christian, or simply personal to Picasso; they are universally recognizable, or remain arcane; and so on. But they have the Picassian stamp on them, unmistakably. This was becoming a more natural activity, perhaps, than putting his stamp on other people's art. Less purely inventive formally, in the making of the picture, and less responsive to the work of his contemporaries, he became more imaginative at making up a kind of cultural heritage for himself. Though many dates overlap, it is fair to think of this interest as succeeding his involvement with the theme of the artist and his model.

That theme is replaced by more immediately potent psychological situations, which are often sexual. It was said above that the juggling around of ideogrammatic forms of the features, limbs, tongues, penises, vulvas, in non-representational, 'abstracted' paintings, was above all to do with the last possibilities of figure painting within the pictorial structure developed in the late 1920s. Graphic art, drawing, had since then meant a return for Picasso to a more figurative style, and there are no drawings which seem to have an interest in making the work of art more abstract; they are illustrational and anecdotal. Picasso's return to an amatory subject matter in 1931 and 1932 (when he met Marie-Thérèse) makes plain that the interests of drawing and painting were rather separated. The paintings are made of swirling forms, bright colours, and represent her alone, often asleep. They are also quite daringly composed. The drawings, on the other hand, are relatively explicit and representational, and their tone is not seldom extremely aggressive. A number of them are of a rape. This is not 156 shown as in classic art, or indeed as in Cézanne, where someone is carrying someone else away through a landscape, but actually and specifically in the moment of physical possession. These drawings

have a niche of their own; their problematic nature is not much clarified by reference to previous erotic art. Erotic art has always been made, since the late Renaissance anyway, but we know little about it. It tends to get destroyed, or it is concealed by the powerful censorship of Christianity. It surfaces in odd places sometimes, for instance when made to order for sultans; but generally it only becomes public in the service of some sort of lascivious sophistication, as in Fontainebleau art and many types of French Rococo, where it belongs to an atmosphere both worldly and socially restricted. Of course, the fact that Vollard was making his publication so expensive, and directed towards a few well-known clients, might have increased the erotic representation there in just that sort of way. One cannot tell. But it is worth bearing in mind that Picasso felt that in these circumstances a number of drawings of rape were appropriate.

157 Not all the drawings of sexual situations have this disagreeable power. Goya is beautifully acknowledged in one aquatint of brusque tenderness, where a faun or satyr comes to unveil a sleeping girl; the French word *dévoiler* is expressive of the mood. Several other drawings are like this. They are the development of an old theme in

156 *Vollard Suite* No. 87 1933

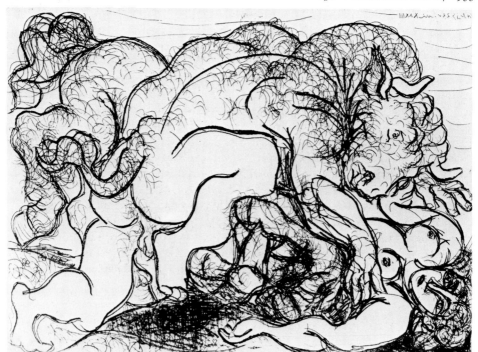

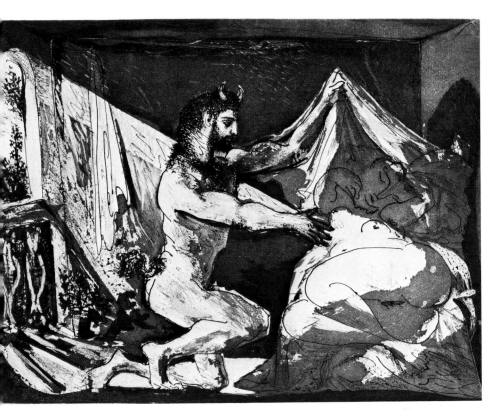

157 *Vollard Suite* No. 27 1936

Picasso, one which has been discussed by Leo Steinberg, that of the sleeper watched. He refers to the 'gloom of the mind and the beauty of the body' as a characteristic of the theme. One thinks especially of *Meditation*, the softly modulated watercolour of thirty years before in which a brooding Picasso watches over his new mistress, Fernande Olivier. 28

Perhaps we may consider these new drawings as an extension of the theme of the artist and his model, with the special development that both the social and artistic dimensions of that situation have now disappeared. We are in some sort of legendary or mythical realm, naturalistically depicted, where art does not exist, nor human civilization. The creature who has leapt over the balcony out of the sunlight, and who with swarthy triumph lifts away the flimsy veil or curtain to reveal the sleeping girl, is some kind of rough faun; he has

horns and a tail. He is the denizen of hot and ancient Mediterranean lands, filled with olive groves, vines and cypresses, stony but always near to the sea. This is now the Picasso landscape. The most important and fully-developed of all the half-godlike characters that live in this landscape is the Minotaur. This monster was picked up from the Surrealists, as it happens; they found the myth attractive. Picasso illustrated their magazine *Minotaure* in 1933. The Cretan Minotaur is classically described by Ovid as *semibovemque virum, semivirumque bovem (Ars Amatoria)*; and he is the issue of a white bull and Pasiphaë, the wife of Minos. Picasso has no interest in the rest of the classical story, the confinement in the labyrinth, the exacted tribute from the Athenians, the defeat by Theseus. His Minotaur must not be constricted to playing a determined part in a legend, and needs to be kept away from heroes. He has some freedom of action. He appears, holding a glass of wine, in a scene of Bacchic frivolity in the sculptor's studio (this rather preposterous situation is his only contact with art).

158

158 *Vollard Suite* No. 85 1933

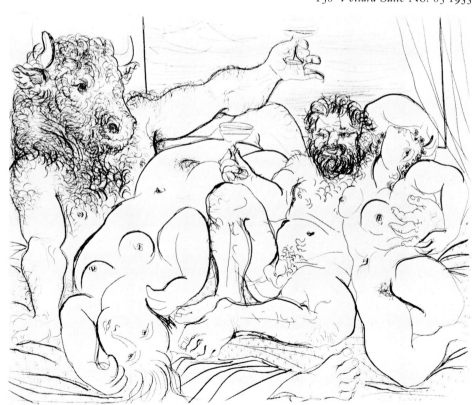

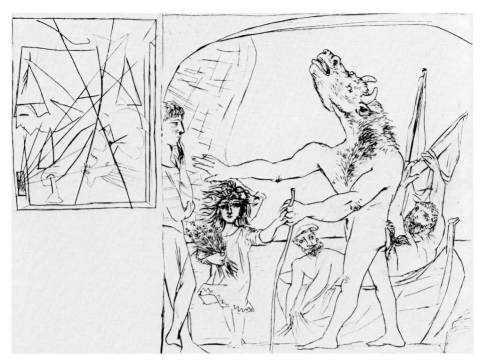

159 *Vollard Suite* No. 94 1934

Two models, parodies of the women in Ingres's *Bain Turc*, sprawl
voluptuously in front of them. In another drawing the Minotaur
sleeps behind a veil, while a girl watches his slumber; but in two more
we witness, again, a rape. The Minotaur is gentle, savage, and lustful;
he has human emotions but literally brutal impulses. When he is
blinded or wounded, we feel compassion; when he disembowels a 159
horse we feel horror; and when he crouches over a sleeping girl,
stroking her cheek but not waking her, we sense some kind of
impermanent primal tenderness.

Clearly, this is not quite like the monsters and nasty animals
favoured by the Surrealists, and not only by them, during the 1920s
and 1930s. The Minotaur is a more deeply imaginative creation, and is
of an interestingly amoral type. For we are now confronted, in
dramatic situations, with the basic ethological question: whether men
are more like beasts than beasts like men, is one way to put it. We are
led to ask to what extent the behaviour of the Minotaur is human
behaviour. This is a most important part of Picasso's private Arcady,

and thus of his personal mythology, and thus of the stock of symbolism which was used in the major painting of his later years, *Guernica*. Picasso has begun to develop a darker and less rational world than that of a mythology which invents gods activated by anthropomorphic behaviour patterns. Picasso's Minotaur is of the opposite type: he is a mythological being whose essence is bestial rather than anthropomorphic. Hence the darkness of spirit, the foreboding, and the irrationality. One cannot but think of Goya's note on one of his etchings in time of civil war ('The sleep of reason produces monsters).' A point about Picasso's mythology is that it is not humanly rational and that lessons are not to be drawn from it, unless it be the simple lesson that this is what life is like. Picasso's neoclassicism, partly because of its strongly pastoral and amoral tendencies, differs significantly from the major tenets of previous neo-classicism. That had been civic, didactic, replete with moral and political significance, imbuing Roman or Napoleonic heroes with an active secular superhumanity. The instinctiveness and peculiar irrationality of Picasso's mythology was to nullify *Guernica's* authority as a political statement.

180 *Guernica* (1937) must be considered in terms most closely drawn from the problems of Picasso's art in the decade that preceded it. The establishment of an iconography, whether mythological or not, became increasingly important in the twelve years between the *Three Dancers* and *Guernica*. If there is a common factor in all the elements of this iconography, or one prevalent attitude, we find it in the refusal to give much credence to civilization, and in the pessimism: a pessimism not of a sober and contemplative type, but thoughtless and ferocious.

107
103 Packed into the tiny but important *Crucifixion*, of 1930 (which is usually taken as a halfway stage between the *Three Dancers* and *Guernica*), we find an amazing diversity of styles and sources, with some reference to the cultures they represent, all making what John Golding calls a 'work . . . deeply irreligious in spirit [which] evokes the sensation of some primitive atavistic ritual, cruel and compulsive'. A mere listing of some of these sources will give an idea of how much was compressed into the picture. The painting is first of all, and exceptionally, Christian; but it is also primitivizing, has references to neo-classical or perhaps Greek art, makes use of a complex symbolism derived from pagan religion and the idea of the sacrifice of a

212

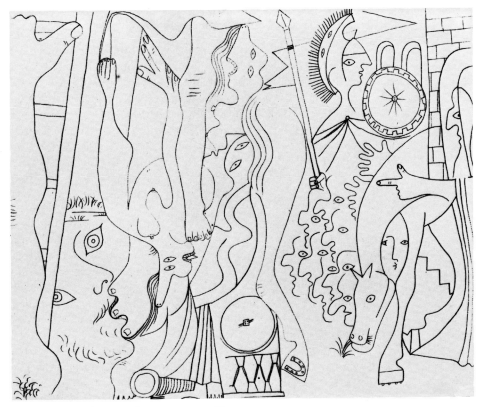

160 Drawing for *Crucifixion* 1929 (see ill. 107)

king-god, has strong overtones of Mithraic cults and of the rituals of the bullring, and makes use of stylistic devices from Cycladic sculpture, of Australian aboriginal art, and of scenes of men and animals drowning together from an eleventh-century illustration of the Flood. This painting, whose size provokes the suspicion that it might have been made (something very unusual in Picasso) as a maquette for a larger work, was preceded by three or four years of drawing towards the subject. In one drawing in particular, some of the sources are rather clearer than they are in the painting, and we also find motifs which subsequently disappeared in the oil version. Significantly, these are motifs which relate most specifically to the traditions of Western European art in its later and more cultivated stages. For instance, the brick wall and colonnade suggest classical architecture and city life. The soldier, with his spherical shield and

213

lance, reminds one (at a distance, to be sure) of the martial figures in David's *Oath of the Horatii*, in the Louvre; or, if not of that picture, then of some Greek vase. The row of heads, which Roland Penrose describes as the 'ghoulish faces of a crowd of spectators', while doubtless they do have such a role, are also stacked in the classic manner of caricatured heads, an invention of Leonardo da Vinci's developed by the Carracci, and later to be directly copied by Picasso in a lithograph of 1948. (Caricature was in the air, in a number of ways. The Surrealists exhumed from his proper obscurity the artist Giuseppe Arcimboldo (1527–93), who by visual puns constructed ugly allegorical figures out of their attributes: Water (a kind of Neptune), out of fish; Herod, from the bodies of massacred innocents. But caricature's true function is always to make visual comments on classical beauty.) In this drawing there is something of Picasso also caricaturing himself; we recognize the horse from the curtain of the ballet *Parade* (which we have already related to Degas), now sottishly chewing a tuft of grass. One could expand on all this; but, in short, there are a number of civilized elements in the drawing. They are dealt with sardonically, and even with some sort of disgust; but they are there, and this implies some sophistication. All this disappears in the sore, flaring hostility of the painting itself.

The field colour, jarring against dirtied but still acid yellows, is red, but it is not a red field that gives unity. It strikes attention by its flat prominence in a whole large area of a painting otherwise taken up by busy detail, and we see that it goes round the picture as an interior frame all around the bottom to a fifth of the way up the left-hand side. It forms the ground behind the praying-mantis figure and the base of the crucifix, and is used as a contour-defining line throughout the painting. At no point can any colour or line rest. All is dissonant. Many of the personages have different limbs painted in such a way that the limb which is furthest from the picture plane is in an advancing colour, while the more prominent is in a receding colour. Something of the effect of this reversal of normal colour values is repeated in the extreme contradictions of scale, within the whole picture and within individual figures. The picador is minute, hardly the size of Christ's head, at which he thrusts with his long staff. At the very front of the painting, a dice-player's leg and foot is larger than his body, as large as a whole pile of victims or mourners beneath the cross. The dazzlingly vicious compression of all this matter into so

small a painting tempts one to loosen it apart, to see how it was made, or to see how it could have been differently made, and when we do so we find a rather unexpected source, which is in the *Parade* drop curtain of 1917. If we look at the relative positions of the *Crucifixion*'s foreground, this corresponds, surely, to the stage boarding; so do the positions of the actress on a horse and the picador; so do the shut-off curtained effects made by the flat red in *Crucifixion* and the simulated curtain in the *Parade* drop curtain. The impression is strengthened as we recall that the horse from *Parade* was in the preliminary drawing for the painting; and as we look back to *Parade* we also find the colonnade, the ladder, the military drum and the group of people engaged in some social activity below the main action. All this, quite apart from the other sources, Picasso has condensed into the making of his picture.

What does this mean? First of all, of course, it reminds us of what we already know, that Picasso never forgot any previous painting of his, and that there were no parts of his previous artistic production that he regretted or rejected. The *Crucifixion* also shows how he tended to be conservative in his handling of pictorial space, even when working on such a small scale and in such vibrant, aggressive and high-pitched colours. Most of all, it shows that, even if the painting looks furious, it was not the mere and isolated result of some explosive inspiration. The backlog of its characteristics, extending at least as far as 1917, and the drawings around the picture, both before its execution and after, lead one to the conclusion that it came about as a result of much previous thinking and experience, and that it was meditated afterwards. The important works that lead up to *Guernica*, and most of all that mural itself, are similarly full of art and old knowledge, and old habits too: they are replete with the kind of sureness that is the result of many years of being an artist, which jars with their generally negative and destructive tone. A young person could not have painted them, only an old artist who was given to raging at his own maturity.

For the minute, therefore, it is pleasant to turn to another group of works which – however much this seems unlikely – were being made concurrently with the increasing gloom and disguised doubt that we have been discussing. We have seen how involved he was in different kinds of sculpture, we have looked at the way that he was drawing, the way that he was making graphic art, we have noted how he

215

conducted a running conversation with the Surrealists, and was making a huge attempt on history, with the aid of prehistory, in his painting of *The Crucifixion*. He must be given an accolade for the fact that, in the midst of all this, he could yet embark on a series of pictures which again are quite unlike, and in which he approaches a type of modern art quite alien to his own temperament and typified by a great but artistically remote modern master, Matisse. It is the sheer *elasticity* of Picasso's impulse to make art that we must salute here. We have argued that his progress led to a retreat, led to literary rather than artistic situations, became a kind of stasis; and all this is true, in the long view. But Picasso, as in the paintings inspired by Marie-Thérèse and influenced by Matisse, could still for a time make an artistic leap, to make that long view seem a little irrelevant.

161 A photograph taken by Cecil Beaton in 1931 shows Picasso standing under a painting not catalogued by Zervos which is clearly of Marie-Thérèse. This date may therefore be taken with some certainty as the beginning of their liaison and the initiation of this particular sub-group of works in Picasso's development. The change may be seen in paintings other than figurative, particularly in the

125 three pictures titled *Pitcher and Bowl of Fruit* and the remarkable
162 *Still-life on a Table*, all of 1931. The finest of the fruit paintings, and the still-life, respond to a kind of art which Picasso, by reason of his sombre early romanticism, his Cubism, and the subsequent heavy burdens, had somewhat avoided. This was the decorative side of modern French art, the sprightly, vivid, untroubled painting with Impressionist and Fauvist forebears but only a tangential relationship to Cubism. The fruit paintings feature a rectangular table; horizontal and frontally inclined, they always fold at certain points into the indicativeness of post-Cubist space; but the *Still-life on a Table* is not like this. It is vertical, and has an unexpected twist and buckle, with an accompanying swell, quite different from the usual ways of post-Cubism. An undulating line bisects the picture vertically, and from this division curved lines take off towards the perimeter of the picture. These lines are definitional of space, to be sure, but they do not enclose that space. There is a strongly arabesqued aspect to the composition, and we might think of a late *cloisonniste* method, since most of the twisting and curving lines, in black, enclose flat areas of unmodulated colour: yellow, red, lilac, a peculiarly striated blue and a pungent, greeny turquoise. The picture is full of vitality; the three

216

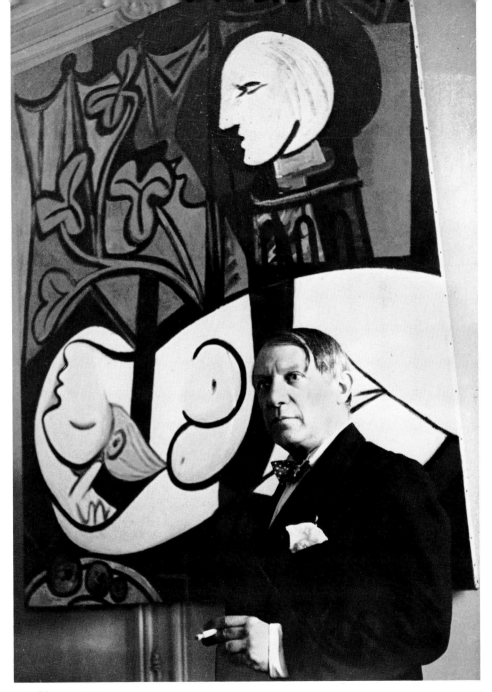

161 Picasso 1931

162 *Still-life on a Table* 1931

table legs have the air of sentient organic things, and the composition, linear but bunching together rounded forms, appears to sprout from nodal points and from a central axis which is almost experienced as the stem of a plant.

Such images are appropriate, for in the figurative paintings Marie-Thérèse, seated or recumbent, often asleep, acts as the recipient or originator of a multitude of expanding organic forms, shooting out, burgeoning, germinating into fruit and flowers, in one instance sprouting from her belly. The paintings overflow with the sense of fecundity, felt in the girl herself and in all that surrounds her. A favourite image, in many of the paintings and also in the sculpture 138 *Woman in a Garden*, is the philodendron plant, with its extraordinary capacity for growth, waving branches and aerial roots (it was a real one, in the Rue de la Boëtie flat). Picasso could not celebrate Marie-Thérèse – and that seems to have been in large part his intention – by looking at Matisse's sculpture, but he does approach 164 Matisse in certain of the paintings of her, in particular *The Mirror* and 163 the *Reclining Nude* of July 1932.

218

In making a new style with Marie-Thérèse as its subject it would of course be most appropriate for him to look at what Matisse had done to the subject of the gorgeous and sensual figure portrait. So we find some similarities, mostly in the *Reclining Nude*, though they are hard to pin down. In that picture the extreme tilt of the foreground to make a decorative plane, the forthright arabesques without overt constructive function (not approaching Matisse's elegance, however), the large central portion of black, the striped pillow, all put one in mind of Matisse, but somehow without allowing us to see the similarities as real; nothing could really bridge the gulf between the two artists. Something about the picture that dawns on one as a peculiarity is simply that it is rather more direct than one expects, for one has long lost the experience of frankness in Picasso. There is a way in which the hedonistic picture needs to be more candid than any other type. There was much in Picasso's temperament which made this strangely difficult for him: it is akin to the way that he was attracted to the primitive but not to the exotic.

163 *Reclining Nude* 1932

164 *The Mirror* 1932

These paintings of Marie-Thérèse, so definite in their employment of voluptuous curves and images of fecundity, made with unabashed sensuality and not very like his other paintings of the time, lead one to ponder a little over the types of utterly sensual painting that are apparent in the School of Paris and in later art. This is an area where one needs the support of many qualifications. For instance, it is a fact, not at all such an odd one as might at first seem, that the great hedonists of modern French art were the bourgeois – Renoir, Bonnard, Matisse; but it is not a fact that their achievements are attributable to any domesticity of vision. Again, it is not true – in fact it is an extremely vulgar fantasy – that a lavishly delectable art must be conveyed by an erotic subject plausible enough as representation to arouse mundane emotions, viz. lust; and yet the case is that the female nude was a staple of this kind of art. Picasso, here alone, makes some kind of rapprochement with it, in so far as he was able. The contrast, always, is with Matisse. And what Matisse had that Picasso always had to deny himself is everything that sheer and beautiful painting has since taken as its essentials: colour beyond the ordinary, an unconstricted composition, a breathing surface, and great candour about its making and its address to the spectator. In combination, these are the attributes of a very high art, but not at all an ingratiating one. For with all the lushness of display there is a sparkling intelligence. Also, there is a sense of relaxation which is quite foreign to Picasso, whose best pictures are never his easeful ones. Nor could he transcend, as Matisse unconsciously did (his mind on higher things), the nude as a *subject*; in all his Marie-Thérèse paintings there is in the end a sense of something observed rather than something made. They are quite characteristically dominated by the reflexive manœuvres associated with mirrors in painting: yet another way of avoiding the straightforward. A comparatively simple example is the picture in which the mirror depicts the bottom half of her body rather than reflecting the top half turned towards us in front of it. There are others. But the most full picture is the dazzling *Girl in Front of a Mirror* 165 of March 1932.

In this painting all Picasso's virtuosity, and love of Marie-Thérèse, is directed towards a dense and complex expression of circularity and contradiction. We already know how deeply suspicious he was of pictorial reality; this informs all his attitudes to art since Cubism. He now expands this by an empathetic portrayal, packed with

implication, of youthful human beauty. One cannot ignore the biographical fact that he was now living, for the first time in his life, with someone very much younger than himself; a circumstance which is liable to give mature men much to brood over. *Girl in Front of a Mirror* is hardly at all a celebratory work. It is a return to the traditional *Vanitas* image, the emblem of human transience: an image that he had painted often enough before, but not with quite this personal relevance, this concentration, and this tone. Carla Gottlieb, who has published the definitive account of *Girl in Front of a Mirror*, relates it to a picture which Picasso would have seen in Madrid in 1917. Given his pictorial memory, this is not at all extravagant. This painting, perhaps dating from the early eighteenth century, was in the collection of his friend Ramón Gómez de la Serna, and is known as *The Dead and Living Lady*. It shows a woman within an interior oval format; she holds a mirror within which she is reflected as a death's-head. Her own person is divided vertically. One half of her body is painted naturalistically, while the other half is given up to her bare bones. The emblematic spirit, simply gloomy rather than moralistic, surely struck Picasso as appropriate when he used the memory of this picture as a hint towards his own creation, composing a set of variations on the simultaneous presentation of opposites.

In Picasso's painting the girl is cleft, vertically, by an undulating line which is not particularly emphatic but does suggest that there must be different interpretations of the body on either side of it. These would first of all be in the opposition between clothed and naked. But we have to go rather further than that, since we are forced to think of exterior and interior, of the inside of the figure. Here we must follow Meyer Shapiro's metaphor of the X-ray. As in the Spanish painting, we see into her body. The circular shape within the outline of her rounded and protuberant belly cannot be understood as anything other than her womb. The black striations on the left-hand side of her body might well be read as clothing (they relate to the striped bathing costumes of the Dinard pictures); but the rounded ochre striations to her right have the unmistakable connotations of a rib-cage. In a number of paintings before this one we have seen interchangeable sexual imagery, rounded forms that are liable to double as breasts, pomegranates, and so on; but this is the first time that the metaphor actually penetrates the body. One recalls that there was an attempt at foetal imagery in *La Vie*; so there was in some other art of the time

222

165 *Girl in Front of a Mirror* 1932

between Symbolism and Expressionism; and so there was, currently, in some Surrealist works.

The girl is shown with a double head, a combination of profile and full-face view which Picasso had employed, with many variations, since the mid 1920s. Her profile view is in a pale lavender, but the rounded completion of the face is painted in a strident yellow and orange. In addition, there is a white halo-shaped curve around her head. That might be, less spiritually, a headscarf; but such a mundane reading is probably inappropriate in this painting. Wylie Sypher and William Rubin think of the head as a contrasted sun and moon, an 'astral metaphor'. Rubin reports Sypher in these terms: 'The double head thus becomes by metaphoric extension the two faces of Eve, or that of "a contemporary Mary who is also Isis, Aphrodite".' Such speculation is most interestingly supported by Carla Gottlieb's observations on the form of the mirror in which we see the girl's reflection: 'The artist has introduced into his picture a clue which tells the beholder what the young beauty is discovering when studying her image. This clue is the form of the looking-glass – a figure-length, free-standing plate fitted with an adjustable inclination. . . . Such a mirror is called *psyché* in France and Austria, *psiche* in Italy, and *psíquis* in Spain. The English translation of this Greek word is "soul". . . . As regards the transference of the name "psyche" to a mirror, it is founded on the popular belief that the plate does not reflect the outward likeness of the person who is consulting it but his/her soul.'

William Rubin's interpretation of the right-hand side of the painting, where we approach this mirrored image, is most convincing. There is a difference in the upper half of the reflection, 'where Picasso is concerned with pictorial counterparts for the mind rather than the body . . . the recessive chin, which is here substituted for the firm one we see in the girl's lavender profile, strikes a note of anxiety. This falling away of the face is counterbalanced by a swelling forehead, in which the unsettling dark green oval (a kind of symbolic "frontal lobe"), the tiny red disk below it and the mass of red to its right are at the heart of the mystery – the awesome nexus of the picture's iconographic network. The setting of these purely emblematic forms within the girl's dark lavender and purple head infers an "otherness", a psychic distance intensified by the way the face is shrouded within veils of lavender, blue, black, purple and green.'

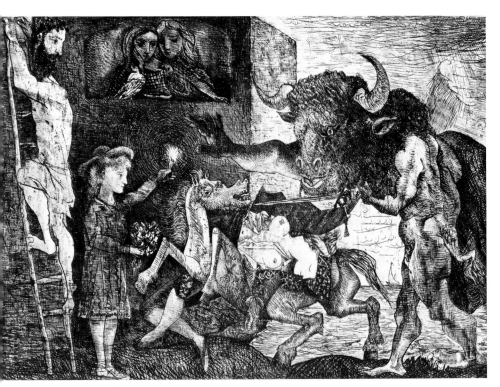

166 *Minotauromachie* 1935

THE SPIRITUAL dimension which we must find in *Girl in Front of a Mirror* is insistent in other works of this period. Many of these have a naked classical beauty in them; on one occasion she emerges from the sea to show the Minotaur his own reflection in a looking-glass. Other pictures use the device of a young, pre-pubescent girl to represent innocence, or something akin to it. Of course, this is thoroughly traditional. At a time when the notion of childhood innocence had taken some beating from Freudian theory, to the Surrealists' glee, Picasso still quite naturally presents young girls in this traditional and Christian sense. The major example is the etching *Minotauromachie* of 1935, too large and perhaps too individual to be included in the *Vollard Suite*. In an atmosphere which is not clearly that of night or day, the Minotaur hulkingly advances towards a small girl, who fearlessly holds out a candle; in her other hand she holds a bouquet of

166

flowers. Between them a disembowelled horse, its entrails pouring on to the ground, bears the body of a dead or unconscious female matador. On the left a bearded man climbs a ladder towards safety, looking over his shoulder, and above the scene two more girls, with doves, calmly witness the confrontation.

What are we to make of this? How do we reconcile what is going on with what we might be asked to believe of what it means? What is the relationship between representation and implication? We will impoverish our response to the art if we deny the significant element, but on the other hand it does not seem useful to try to construct meanings. This is made plain by a couple of examples, collected by Rudolf Arnheim, of the way that imaginative critics have chosen to interpret the etching. According to Herbert Read, who finds Jungian archetypes appropriate, the bearded man on the ladder represents 'the saviour or redeemer', the female torero the 'overpowered libido', the young girl the 'bearer of higher consciousness'. Schneider, however, will have none of this. He believes that the etching portrays 'various aspects of the sexual act as it might be conceived by a child'. If this be so, then Picasso must have been trying for some time to arrive at the full expression of such a subject, for the etching is full of his recent and not-so-recent art. The young girl with flowers is first found in the blue period. We have seen the use of the ladder in the curtain for *Parade* and in the *Crucifixion*, and we know that the Minotaur had been in many drawings of the past two years, as also had the portrayal of disembowelling. The theme of the bullring and the bullfight was no new one. It had made sporadic appearances for many years. It may now have gained in significance – and previous bullfight pictures were by comparison documentary – because of its origins in ancient Cretan rituals, Crete being also the classical home of the Minotaur. As we know, the significance of all these motifs in Picasso's art is highly elastic. The meaning of a picture hardly therefore becomes more definite when they are combined. So one must discuss *Minotauromachie* with caution, as does Alfred Barr. He writes only that 'apparently the scene is a moral melodramatic charade of the soul, though probably of so highly intuitive a character that Picasso himself could not or would not explain it in words'.

But is not Alfred Barr's good sense the sign of too comfortable a position? One asks this because *Minotauromachie* is extremely close to *Guernica*, as all commentators agree. For this reason one has to

negotiate a particularly difficult area between the spiritual and the political, unless of course we wish to deny the mural any political dimension. We have to decide between the personal and the public, between the demands of the world and the demands of art. Do we have different criteria for social and soulful works of art? Does one, for instance, while agreeing that mechanistic interpretations of the etching do not illuminate the work but on the contrary seem jarringly obtuse, nonetheless wish for specific meanings and recognizable symbols in political art? The fact is that we are all pretty well inclined, like Alfred Barr, to allow spiritual matters, where we detect them, some dignified nebulousness. Politics is about reality, though, and so is modern art. When we think of *Guernica* in its thematic aspects, are we allowed to applaud its political stance while also fudging this out by saying that it is not political but spiritual, and thus beyond words? A lot of double-dealing goes on when these questions are raised, especially among those who are most eager to see *Guernica* as specifically political.

For the moment, we will think of Picasso as a committed artist. Kahnweiler, who was close to him as friend, agent and dealer for more than sixty years, described him as 'the most apolitical man I ever knew', and we can take this as a fair report. But Picasso became involved in political matters in the late 1930s, and ever afterwards was a political figure, of a kind. The socially committed career of the ageing millionaire began with the upheavals in Spain. In early 1936 a large touring exhibition of his paintings, organized by young Spanish intellectuals, was seen in Barcelona, Bilbao and Madrid. This was the first time that he had shown comprehensively in his homeland since 1902, so this exhibition represented a lifetime's work. A few months later, when Civil War broke out, the Republican Government saluted him (with a thought for the publicity value, no doubt) by appointing him Director of the Museo del Prado, the Spanish national collection. However honorary this charge, Picasso was nonetheless entrusted with a most definite symbol of the traditions of Spanish art, and of much European art too, and there is no doubt that this moved him. Soon afterwards he agreed with the Republican Government to make some showing in the Spanish pavilion at an International Exhibition to be held in Paris in the following year. *Guernica*, his contribution, is still the official property of that government.

227

167 *The Dream and Lie of Franco I* 1937

167–8

Months before the famous mural was begun, Picasso produced a much more avowedly political work of art. Like *Guernica*, it is one of the very few works that he titled himself: *The Dream and Lie of Franco*. Most of it was done rapidly, in two days in January 1937. It was then put aside, and finished in a different manner in June. It is an etching with some additional use of aquatint. Its original purpose, if not its final nature, was quite purely propagandist. It is a personal attack on Franco as an *étron*, a turd (Picasso still referred to Franco in this way many years later), a Fascist, a false representative of what is Spanish, and a false artist (for Franco was a painter). The circumstances of the work were benevolent, in a comradely fashion; the prints were intended to be sold for a defence fund. The usual questions surrounding such endeavours no doubt arose, and we should mention some of them now. How was this political art to be made, how

228

168 *The Dream and Lie of Franco II* 1937

distributed, and who would get the proceeds? Could it be assured that those proceeds were not dirty money, given Picasso's fame and past clientele; that is, would the cash not come from speculators and class enemies? Was the etching to be very widely distributed as a broadsheet-type production, or was it to be more concentrated than that, in a limited edition – but thus costly and a collectors' item? To whom would it be addressed? Do peasants and workers have the ability to appreciate avant-garde art, or should the artist make some adjustment to his work with them in mind? These questions were no doubt discussed – they always are – among the organizers of the project. One doubts whether they were put to Picasso himself. But it looks as if the problems raised were in his mind, and as if at first he responded to them. The two large plates which constitute the *Dream and Lie* were divided three times each way, so that each scene would

229

be about the size of a postcard when subsequently printed and separated. In the event, though, they were sold together, in a special folder, and with the facsimile of a poem that Picasso wrote for the occasion. The *Dream and Lie* itself is cast in a popular manner which has nationalist overtones. Its format is not so much that of the comic strip, as some Americans like to believe, as of the traditional Spanish *aleluyas*, cheap woodcuts with some narrational content which could be either homiletic or satiric. Further, there are quite clear references to a Spanish national myth, the story of Don Quixote. Franco is depicted as a repellent louse or bug, a 'polyp', fat, bristling with short coarse hairs, his nose like a snout. He rides forth in false pomp, a sword in one hand and a Catholic banner in the other; he walks on a tightrope with that banner attached to a monstrous penis; he attacks a classical statue with a pickaxe, dresses up in traditional women's clothes yet still cannot conceal his nature; he straddles a pig, worships money at a shrine surrounded by barbed wire; he slaughters women and animals.

This attack on Franco has its obvious aspects, suitable to a broadside. But when we look at the complete work it is to realize that all Picasso's previous art – and commitment to art – comes to jostle with the simple messages and straightforward hatreds. Werner Spies was the first to point out one inconsistency of this sort: 'To what extent is Picasso, who has converted distortion and deformation into a neutral, non-psychological basic principle, in any position at all to create a caricature? Even the head of General Franco . . . first occurred as a head of a *Seated Woman* before he committed his attack on the Caudillo to paper.' Picasso was able to get over this, of course (as Dr Spies points out), by giving Franco some foul attributes, and in point of fact the Franco-figure is not very like the *Seated Woman*. But there is still an important point here. Picasso's art and temperament were not much suited to this type of social caricature; he was too deeply subservient to the example of his own past art.

All through this book it has been asserted that caricature is a function of fine rather than popular art. The question now comes up again. Picasso could not become a popular artist. This is why he was to abandon the *Dream and Lie*. There is a difference in style between the first and the second plates. The former has a coherent manner which was surely assumed for the purpose, like a special disguise; it appears nowhere else in the *œuvre*, though there are some hints of

167

169 *Ubu* 1937

it in throwaway obscenities. It is a style too trenchant to be called
faux-naïf; yet its principal quality is a kind of vicious childishness.
Brilliantly unpleasant and indecorous, its scatological and shocking
aspects recall Picasso's closeness to Jarry and the figure of Père Ubu, 169
whom Picasso drew a few months later (again accompanying the
drawing with a poem) with some of the same features as Franco. But
are we going to look at this plate from the standpoint of art, or not?
What has to be said of the plate is that it has extraordinary talent, and
is utterly ignoble. Not to recognize this point amounts to aesthetic
betrayal. Obviously, Picasso felt this dirty manner to be suitable to his
subject, when he started out. But then, as soon as he turned to the
second plate, the style is continued only in the first compartment 168
(reading from right to left, of course). There follows a slain woman
lying on the ground, a sketch which has overtones of Goya but is
much more reminiscent of Manet's dead matador. Franco is not to be
seen. In other words, fine art has crept back in. Then again comes a
strange and delicate subject (and a unique one): a white horse lying on
the ground and resting its head against the chest of a bearded man,
who embraces it.

231

The last four compartments of this second plate are different again, for they were added in mid-June, by which time Picasso had very probably finished work on *Guernica*; they look like thin and hasty spin-offs from the mural. The unsureness and mixture of styles in the second plate means that it does not have the political and anti-aesthetic bite of the first. The way that it is indefinite in its address is recognizable because it is so like the way that – in another small and compartmentalized work, the title page of *Le Chef d'œuvre inconnu* – he drew little sketches of more finished drawings as a kind of advertisement for his illustrations. One's suspicion is that he rapidly came to the conclusion that the series of Franco etchings was far from being the real effort that was appropriate, either to art or to the political situation; that he gave up, put the project aside for months (are the comrades still waiting for their money?), and then finished it off fast when he had got over *Guernica*, plumping it out with a poem.

Picasso had begun to write poetry some time in 1935, as far as we can tell. It was in Spanish. According to Roland Penrose, he was initially bashful about his new activity, but this disappeared soon enough, perhaps with the sound of acclamation. What he wrote he declaimed to Spanish friends, and then he encouraged Sabartés, who had recently returned to Paris to become Picasso's secretary and factotum, to arrange for the publication of a French translation. All the poems are of an unrhymed stream-of-consciousness type with marked Surrealist overtones. Some attempt a connection between two arts by occasionally using blobs instead of words; these have never been published.

Here is a characteristic excerpt, quoted by Roland Penrose, from the poem which goes with *The Dream and Lie of Franco*, a rolling denunciation which celebrates what it curses: 'fandango of shivering owls souse of swords of evil-omened polyps scouring brush of hair from priests' tonsures standing naked in the middle of the frying-pan – laced upon the ice-cream cone of codfish fried in the scabs of his lead-ox heart – his mouth full of the chinch-bug jelly of his words – sleigh bells of the plate of snails braiding guts – little finger in erection neither grape nor fig – commedia dell'arte of poor weaving and dyeing of clouds – beauty creams from the garbage wagon – rape of maids in terror and in snivels – on his shoulder the shroud stuffed with sausages and mouths – rage distorting the outline of the shadow

which flogs his teeth driven in the sand and the horse wide open to the sun which reads it to the flies. . . .'

This goes on for some time. One is not interested in determining the aesthetic value of these poems. But it is noticeable that Picasso appears closest to Surrealist automatism when using words rather than paint, and that he felt it appropriate that the poem should be published as a facsimile of his handwriting rather than set in type. Some people think that his most 'abstract' work was in a script-drawing of 1941. But these are rather peripheral questions, and seem the more so because we now need to trace the making of *Guernica*, the most famous painting of the twentieth century and one which has often been taken as Picasso's masterpiece.

Picasso had become close to the cause of the Spanish republic, and he still owed them something, having abandoned *The Dream and Lie of Franco* after one day, when three-quarters finished. He had not begun to work on the large painting that had been promised for the Spanish Pavilion at the 1937 International Exhibition, although Dora Maar (a new mistress, a Yugoslavian photographer who spoke excellent Spanish as a result of a South American upbringing) had found him a large new studio on the Rue des Grands-Augustins which, it was hoped, would encourage the patriotic endeavour. Then, at the end of April, a catalytic spur presented itself. The Condor Brigade, aircraft belonging to Franco's German allies, bombed to destruction the ancient Basque capital of Guernica, on its market day. As sometimes happens with political events, this leapt immediately from the world of fact to the realm of symbol, and with the peculiarly contemporary addition of assertion and denial via the media. For there was a straight propaganda issue involved: Franco, the Germans and the Vatican denied the bombing and claimed that the town had been dynamited by retreating Republican forces. Picasso immediately began a series of preparatory drawings for the huge mural-size painting that we know today.

As most commentators do, we will follow the way that these drawings developed. This is made easy for us because *Guernica*, having an extremely public function, was from its inception the subject of comment and especial interest, and all the preparatory material was collected and conserved. Picasso was totally amenable to this. He had long been careful to have a record kept of all his production, and had quite recently (in 1935) remarked on an interest

he had in making a public record of the workings of his mind as he proceeded through a painting. 'It would be highly interesting', he said, 'to fix photographically not the successive stages of a painting but its successive changes. In this way one might perhaps understand the mental processes leading to the embodiment of the artist's dream.'

Here was the opportunity for such an investigation. Nonetheless one suspects that this undertaking – the first time that an artist had thought to preserve all the stages of a painting, and catalogue them, *before* embarking on the work – was in large part the work of Dora Maar. All or nearly all the drawings were preserved, and the work on the canvas was photographed by Dora Maar seven times, from the first graphic delineations to the final product. Picasso himself was photographed while painting the picture, and he received visitors in the studio while work was going on, and talked with them about it. So *Guernica* is a work that we know intimately, in some ways. We know how it was conceived, how it was built up, what stock of images were available, how they were juggled and negotiated, put together, put in opposition, and so on; and we also know, from the photographs, a great deal about how the picture evolved when it was actually on the canvas. But what we know about the picture most of all, since we have been told so one million times, is that it is a masterpiece, by a genius, and that it is on the right side in the Spanish Civil War. In this respect at least one of the intentions of the painting – to have a propagandist function – has been triumphantly fulfilled. But at what cost to right thinking about its artistic merits?

Since the preservation of all the preliminary work was part of a conscious design, certain intermediate stages were given firmer status as works requiring separate attention than might otherwise have been the case, and we should respect this. Work began on May Day, as it happened. Two pencil sketches of the briefest sort immediately laid down the basis of the painting. A bull and a horse are placed together underneath a building. A woman with a lamp leans out of a window to illuminate what is going on. A bird hovers over the bull's back. In the second drawing this becomes a miniature winged horse, a Pegasus, while the horse has been twisted into an agonized position nearer to the bull, its head and neck assuming a phallic form. The drawing marked '3' is accretional rather than compositional. Some parts are separated from the rest of the sheet by a continuous encircling line around them, and on one such part is written *bas*, no

170
171
172

234

170 Drawing
for *Guernica*
1937

171 Drawing
for *Guernica*
1937

172 Drawing
for *Guernica*
1937

doubt to indicate (but to whom?) that the motif was to be placed lower down. Here the theme of disembowelling enters, apparently with reference, for the first time, to the human body. Two more thoughts about the figure of the horse are surely correctly interpreted by Rudolf Arnheim, who finds a difference between its possibilities as an active or passive character in whatever drama is being constructed.

173 Then, at the end of the first day's work, the manner changes considerably, and a drawing is made which differs from the previous ones both in its finish and its conviction. As is appropriate, it is on wood board rather than paper and is done in pencil but on a gesso ground; that is, on an inflexible support covered by white pigment mixed with water-soluble glue. Gesso is more suited than oil grounds to linear methods, and one feels here that the character of the drawing, while approaching the status of painting, has regained (in

173 Drawing for *Guernica* 1937

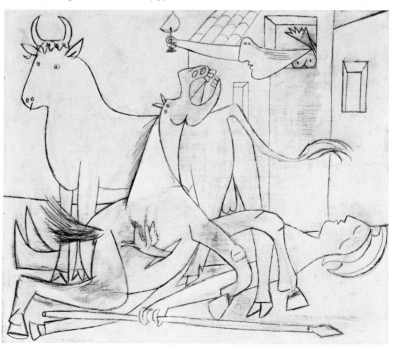

236

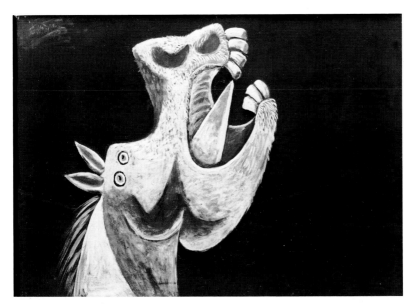

174 *Horse's Head* 1937

contrast to what preceded it, at any rate) some of the firmness of a
spare and deliberate etching. The figure of a slaughtered warrior is
now introduced, intermingled with the fallen horse and the legs of the
bull (which here, inconsistently with any notion that its role is
malevolent, appears with some form of laureation). And it is in just
this area that the drawing is impressive. Its decision is mixed with an
unfinished approach, too urgent to be merely exploratory. There is
none of the fluid and 'poetic' quality of so many of the graphic works
which had preceded it, and which by contrast are rather too smooth
and illustrational. In fact, there emerges from this central portion a
realization, which would hardly come from looking at drawings of
that other type, that this was done by the same artist who made *Les
Demoiselles d'Avignon*. This is not to suggest a reminiscence, any-
thing copied or consciously pulled out of the past; only that we sense
here the challenge of a big picture, and of themes which had to
be depoeticized and jagged up. The natural volumes of limbs are
torqued and twisted into linear clashes; different manners are com-
bined in the same drawing, from the smooth and almost jocular

237

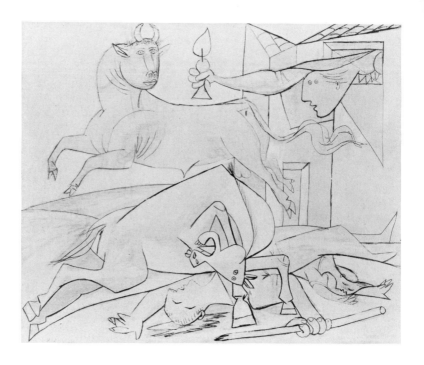

ideogrammaticism of the bull's head to the ugly lines of the warrior's spear-bearing arm and legs. Even at this early point, one might feel that it was predetermined that the painting would not be in colour. But all sorts of things of a formal type seem to be there in embryo. Picasso cut down on the formal urges at all points after this, however.

This might have been because the method of building up to a grand statement and a masterpiece was deliberately accretional. More motifs would mean more meaning, and then the design of the picture 175 would solve itself, when the time came. Another drawing on gesso was made on the next day, and is of the same linear type. At the same 174 time the horse's head, twisted upwards in suffering, was made the subject of a separate oil painting on canvas, in shades of black and white. In the gesso drawing there is another look at the warrior and the introduction of a dead woman, rather small and still incidental, for the two animals are dominant. It seems that nothing more was done for six days, and when compositional studies were 176 recommenced on 8 May the horizontal format of the picture was established, and made more or less final the next day in a soft 177 chiaroscuro pencil drawing, quite unlike the bite of the gesso panels.

238

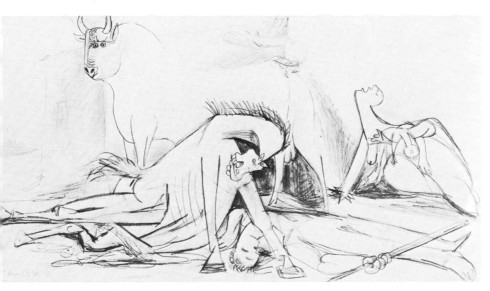

176 Drawing for *Guernica* 1937

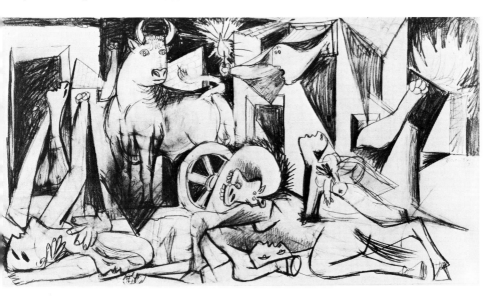

177 Drawing for *Guernica* 1937

Why this break occurred we do not know. There might be a simple reason, that he was seeing Marie-Thérèse; he did some portraits of her at much the same time that he was working on *Guernica*.

At this stage it might be reasonable to wonder whether anything has been gained or lost in the making of the picture, from the iconographical point of view. For if we wish to interpret the iconography of the finished picture, we ought to be interested in its previous mutations. One must start with the bull. He is prominent in all the early parts of the sketching and designing, where he is a leading figure – the real protagonist – in a way that disappears in the final version. His significance is problematical. At no point does he seem frankly vicious. If we take him to be aggressive, it is only because we know it to be in the nature of bulls to be so. If he has slaughtered the horse, there is yet no overt sign that he is responsible for the other animal's suffering. Indeed, the evidence of the preparatory material points in the other direction. Picasso tried to move our expectations of what is bull-like in an unexpected direction. Some drawings, such as that done on 10 May, present him with a serene and god-like expression, a Grecian and beatific bull. But this is quite at variance

178

with what Picasso himself said about the role of the animal in the painting. So uncharacteristically that one feels wary of believing him, Picasso delivered himself of a plodding symbolic interpretation: 'The bull is not Fascism, but it is brutality and darkness . . . the horse represents the people . . . the *Guernica* mural is symbolic . . . allegoric. That's the reason I used the horse, the bull and so on. The mural is for the definite expression and resolution of a problem, and that is why I used symbolism.'

There are no neat resolutions of this contradiction. The horse, though, is treated throughout as a suffering animal; its character is not differentiable from its torment. There is no ambiguity in its theatrical role. A changing intention, however, may be found in the abandoning of an early idea closely associated with the horse: this was in the bird and then the Pegasus figure, which in the first gesso drawing leaps from a split in the horse's belly. Perhaps such a symbol of regeneration was thought too obvious. And so it is, for the justice of emblematic motifs in modern art does not lie in their translatability (or their obscurity, for that matter). Picasso may also have felt this about the clenched fist upraised in salute, the immediately recognizable anti-Fascist and pro-Communist gesture; it was in the designing drawings and on the canvas, initially, but was painted out 179 later on.

179 *Guernica* 1937 (in progress)

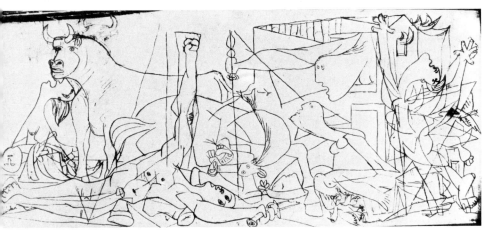

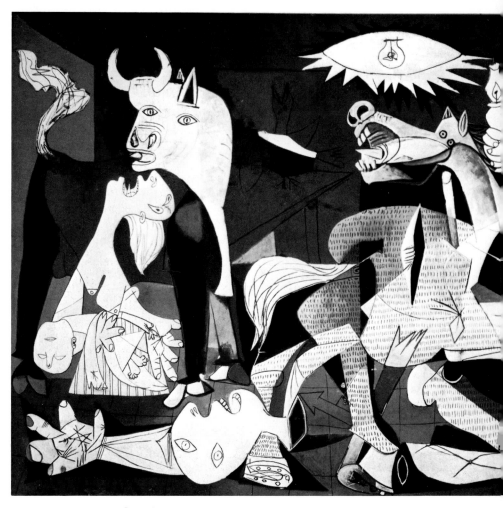

180 *Guernica* 1937

That salute, however, with its blazoned militancy, must not be ignored, even if the purpose of mentioning it is to point out that it was rejected. It is merely perverse to deny a social aspect to the painting, though we need to correct the way that it has long been 180 over-interpreted as a major political statement. *Guernica* had political intentions, but nothing other than artistic means. Picasso did not forget forty years of being a subtle, egotistical and *aesthetic* artist as the

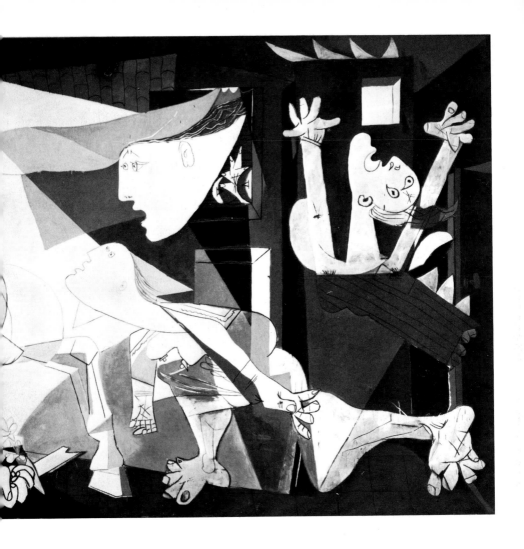

result of a bombing raid. Any kind of deliberation on the picture as a commentary on current events necessarily ignores everything else we know about Picasso as man and artist. The 'symbolism' does not help a political interpretation. The clenched fist was painted out; it couldn't go in the picture. The other motifs were not invented for the purpose of this painting; they had established connotations and artistic functions antecedent to the bombing and unconnected with it.

They did not suddenly become political in themselves; they were made so by the circumstances, the titling, and the surrounding propaganda.

Yet there was a tactic available within his own aesthetic which would provide a parallel to the political situation without falling into the banal literary processes of translatability. This parallel was interior to Picasso, though; it was not one that straddled a separation between 'art' and 'life'. He summoned his own contradictions into drama: the surge and destructiveness, the knowledge, the despair, the inventiveness of his own art. There was plenty to draw on, and he had long been used to ambitions of universalism. *Guernica* is not to do with the aggressors and the sufferers, Fascism against the people, darkness struggling with light. Instead, Picasso clashed two cultural modes, two ways of looking at the world, two very old artistic attitudes and conventions. The distinction is between the classical (and neo-classical) traditions of the pastoral and the epic as experienced in modern art. The differences go as follows. The epic mode is nationalist, secular, heroic, rational, precise, historical and urban; or, rather, it is not so much urban as *civic*, pertaining to the ordering of affairs, or rights and duties, in an organized society. The pastoral mode, not at all public in this sense, is Mediterranean, non-intellectual, mythic; actions, because they are instinctual, are not heroic; it is an ahistoric mode, it is not purposive, and it is essentially rural. These are rough distinctions, and not sensitive to nuance, but they hold well enough, for the moment. Now, Picasso had had pastoral themes in mind, one way or the other, since the period thirty years before when he was engaged on the *Saltimbanques* and *The Watering Place*. Though such subjects may be dropped for years or decades, they do not thereby lose a continuing importance for such a retentive artist as Picasso. The last few years had seen quite a lot of pastoral work. We might enlarge on its nature. It is not at all a floral pastoral, where seasons change and shepherds meet lovingly. It is a harsher world than that. Beasts are as important as humans, and in most respects more capable, especially in conflicts: conflicts which are not martial but natural, or darkly ritualistic, when their naturalness appals the civilized. Fauns may pipe and gambol, but *la lutte d'amour* and evisceration are normal occurrences. None of this makes Picasso's pastoralism incompatible with the general characteristics of the mode as noted above; but now, at the last time that pastoral appeared in

36
42

serious art, Picasso shifted the tradition into a more individual and sombre key.

As it turned out, this depression of the symbolic pastoral, freely expressed – the dislocation of significance from a former simple relationship – was a useful advance in the history of painting; or, rather, within the history of the ways that modern artists have used to get their paintings started. Picasso, here, caught up a little with Miró; for his own egotistical symbolism began to eliminate the rigid one-to-one relationship between signifier and signified, leaving the way open for a stress on the purely substantive facts of the painting. By 1950 in New York, when symbolic material disappeared from art, it was a great relief to have such considerations out of the way; absolutist painting then assumed its own identity, stripped of extra-pictorial matter. But there needed to be, meanwhile, some great example of a non-specific symbolic art in which motifs were personally held but had vast cultural significance, as much primordial as European and classical. This was required by the first wave (the 'mythic period') of Abstract Expressionism; and although the artists needed to fight off Picasso's pictorial methods, the example of his personal nobility of theme was important to them. He has been too little praised for this. But the sign-systems of early Abstract Expressionism, for example in Jackson Pollock's significantly entitled *Search for a Symbol*, painted only six or seven years after *Guernica*, indicate that Picasso's high regard for the availability of all culture was a bedrock for artists from a new country who nonetheless felt that they had to supersede Picasso in morphological terms.

The American artists – Pollock above all – well understood that *Guernica* was not, in itself, a progressive painting, that it had the stasis – how unlike the *Demoiselles d'Avignon* – of official deliberation. With this, by the American argument, was the fact of its fallacious construction, in that the picture, for all its grand intentions, is not able to reconcile its motives with the facts of its making. Much of this has to do with *Guernica*'s epic and neo-classical heritage. Clement Greenberg, uniquely qualified to understand the American response to Picasso, was precise and damning about the picture. His criticism is eloquent of the way that, as far as the new art was concerned, *Guernica* was felt to be irrelevant and even reactionary: 'Bulging and buckling as it does, this huge painting reminds one of a battle scene from a pediment that has been flattened under a defective steam-roller. It is as

if it had been conceived within an illusion of space deeper than that in which it was actually executed.' Although Mr Greenberg did not enlarge on the strained neo-classical aspects of the work, he was clearly aware of them. During its composition, *Guernica* came to be thought of as a frieze-like work, and its compositional elements were flattened to take account of this. Naturally as breathing, Picasso drew in the first intimations of shallow Cubist space and then tried to float over them the spread-out, precise, sculptural manner of the great Davidian battle scenes. It is not suggested that David is there, in the picture, as a visible 'influence'. What is suggested is that Picasso's neo-classicism, long established in his own art, now becomes grandiosed into a stately display of conflict which has a strong undertow of David's tradition. For instance, an immediately recognizable link between *Guernica* and a neo-classical painting would be in the combination of stasis and turmoil; controlled with such a clench in neo-classical paintings of the best sort, though falling apart in Picasso. The reason why the protagonists of neo-classical battle paintings can be so frozen in their attitudes and yet appear so powerful is that they are charged with precision. *Guernica* is a *vague* painting. Nobody knows what is going on in it, and it is the merest literary double-talk to maintain that this is what gives it universal application. The vagueness is iconographic: there is no possible reading for the bull, the dominant figure, because it is always possible that the bull might stand for something else. But it is also pictorial: why should we have to decide whether the light in this barn is electric or supernatural? And there is yet a deeper artistic vagueness, betrayed by the making of the picture in its final stages, the sweeping up and harmonizing, the smoothing tinkerings, the personal turmoils given a public veneer. The comparison with the *Demoiselles d'Avignon* is irresistible. *Guernica* is the opposite of a breakthrough. It does not have a true concinnity of artistic intention, but broods competently on its political and old-master assumptions. The best things about *Guernica* are its first impulses, the gesso drawings, and certain subsequent spin-offs – though some of those, like the too-celebrated *Weeping Woman*, protest too much.

50

181

181 *Weeping Woman* 1937

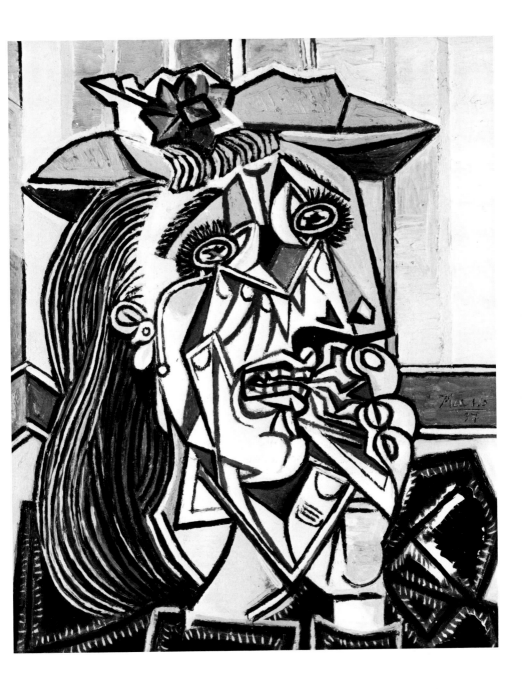

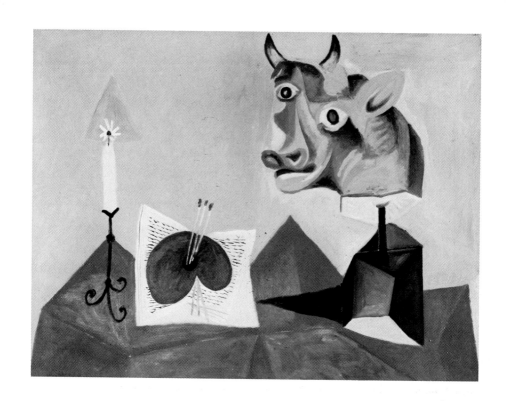

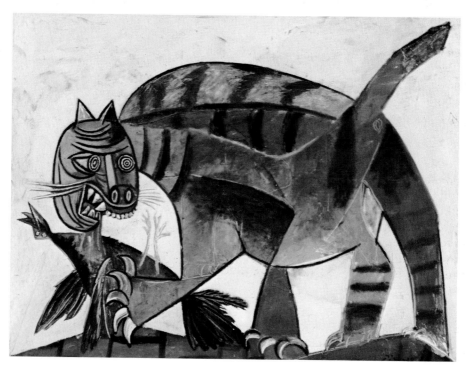

6 After *Guernica*

As war approached, *Guernica* travelled the world. The picture was taken first to Norway, then shipped to London and New York. The outbreak of war meant that it was inadvisable to bring the huge painting back to Europe, and it has remained in America ever since. Picasso spent some time illustrating the poems of his friend Paul Eluard, and also worked at an edition of his own poems which was to be published in a limited edition by Vollard. Violent still-lifes were painted; in one of them, the *Still-life with Bull's Head*, the animal's head appears to have been flayed, and is impaled on a table top with a candle, a palette and an open book. The picture strikes one as a *memento mori* produced with great heat. Another contemporary image of some power is the well-known painting of a cat, stalking and predatory, with baleful eyes; in its mouth it carries a bird which it has caught, still fluttering and bleeding. Picasso, personally, seems to have been restless. He went to the Mediterranean for the summer, returned to Paris when he heard of the death of Vollard, left Paris after the funeral when he heard of a bullfight; his chauffeur drove him through the night to Fréjus.

Staying at Antibes, just as Hitler was preparing to invade Poland, Picasso painted a large and interesting work, *Night Fishing at Antibes*. Nobody has ever been able to decide on the seriousness of this picture, in some instances because they feel that Picasso should have shown more concern at the looming war; but in any case the tone of the painting is difficult to catch. Picasso came across his subject when walking in the evening round the old port, where men were catching fish by the light of a powerful acetylene lamp. In the painting André Breton's wife and Dora Maar, pushing a bicycle, watch from the quay as the fishermen net and spear their prey. Here is one of the first examples of Picasso's new Mediterraneanism, the holiday culture of *la*

182

183

184

249

plage, of suntans and casual fashion, not the Mediterranean of his own pastoral, certainly not that of the serious painters – Signac, Matisse – who had worked at Saint-Tropez forty years before. *Night Fishing* has a queer mixture of descriptive reportage and thematic dignity, of the old and the contemporary, of the quotidian but ancient professional activity of the fishermen and the vacation-*sportif* mode in the girls, gaily dressed, licking at an ice cream cone. Much in the painting is whimsical; and yet the central motif is the killing of animals. It is a decorative painting – it even reminds one of those mosaic murals in primary schools – yet fairly significant things are being done to the organization of pictorial space and the idea of a wall-size painting. Perhaps the clue to its tone is just that Picasso's more lightsome moods are simply unbelievable. The bicycle is quite interesting. It is not often that we find something of fixed design and more or less constant appearance metamorphosed into the Picasso style for the first time, as is the case here (Picasso hardly ever painted anything mechanical). The result is that one can see how neatly right the bicycle now is within the terms of the metamorphosis, how easily and judiciously it is summarized, and yet how pert is its decorative nicety. The strange and quirky poetry which Picasso brings to the picturing of the women is somewhat akin to the way in which he painted Marie-Thérèse reading at a table; but that does not well accord with the general treatment of the fishermen.

Night Fishing is a pretty big picture, nearly seven feet high and eleven feet across. More or less tripartite, as was *Guernica*, it has the same tendency to subdivide into large triangular areas, but these gores are a great deal more flexible – fluid – than in the previous picture; and it is in that fluidity, considered literally as well as metaphorically, that we find a significant thing about the painting, its location within a discernible type of modern art which had importance both in Paris and, later, in New York: a peculiar development of painting with submarine connotations. This is not an eccentric observation: there was such a trend, with firm iconographical and formal reasons for the theme; that is, the theme imposed formal changes, or marched with formal changes. ·Underwater art comes from Miró, from Léger, perhaps Kandinsky, and from Klee (whom Picasso had been to visit in the autumn of the previous year). It gave the opportunity for associated but not locked forms – as they would have tended to be locked around an armature in Cubism – and allowed these forms to be

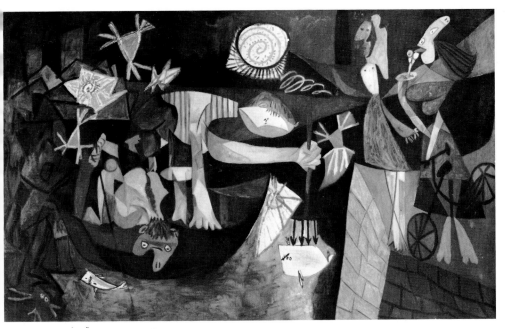

184 *Night Fishing at Antibes* 1939

freely and lyrically placed in a flat surface that still allowed some vague recession. Simply, it was a way of circumnavigating Cubism by getting up to the surface of the painting; and we find pictures doing this all through the twenty years taken in developing a flat, all-over structure rather than a Cubist one. Masson's *Battle of the Fish* of 1927 probably began the trend in Parisian art, unless we claim that Miró's amoeboid forms of a year or two earlier count as fish (observe, incidentally, how Miró could use *words* in paintings by floating them in a manner quite unlike the written additions to Cubist paintings); and the Masson painting is the one mentioned above with reference to its exploratory, quasi-automatic technique, stressing the surface by use of sand and glue as well as paint. Lots of Abstract Expressionist paintings testify to the interest in submarine art, or its usability, pictures by Adolph Gottlieb, William Baziotes, Milton Avery and so on; the most important of these is the painting by Jackson Pollock originally entitled *Moby Dick* (although its submarine qualities are not the most important thing about it: it was soon retitled *Pasiphaë*).

Night Fishing relates to this tendency, this definite way in which art got from Paris to New York, in the extreme way that various elements of the picture, far more than in most art of Picasso's, are tilted up to become the picture plane. The reflection of the light on the water, for instance, is as firmly locked on the actual surface as was a passage in another picture it resembles, the painterly and non-illusionistic treatment of the foreground in the *Saltimbanques*. *Night Fishing* is striking because of this loosening of Cubism; one wonders whether this happened as a result of looking *down* at a subject (in this case all the fish and crustaceans in a shimmering transparency) in such a way that the whole visual cone was occupied without reading objects in recessional space. The painting derives quite frankly, and exceptionally, from an acute natural visual experience rather than an artistic precedent; and, appropriately, it is free of the initial marking-out gestures of Picasso's usual approach. There was a sense utterly ingrained in Picasso of making the first deft and ever-present indications of flattened Cubist space; as if he could not grasp the subject until this were done. Not in the neo-classical drawings, but always present in the post-Cubist modern style, are the few lines in the corners or sometimes the central part of the picture, depicting floorboards, a table, a cornice, a window space; anything that would enclose, and not be a horizon; Picasso didn't like horizons much. Those lines, as the progressive photographs show, appear as soon as he knew what *Guernica* was going to be like. Perhaps *Night Fishing* seemed like a holiday to him.

185 Much the same might be said of *The Soles*, a modest and little-known painting, in which the underwater principles begin to be applied to still-life. Very charming, beautifully brushed, it is nonetheless rather like the *Still-life with Bull's Head*, except that its appeal is enhanced by the relative lack of portentousness.

An aspect of *Night Fishing* which has aroused interest is that it seems to have a general formal resemblance to a painting in the Louvre by the seventeenth-century Dutch artist Nicolas Maes, his *Bathers*. It is very likely that Picasso had a memory of this picture, but its position as a really active ingredient of *Night Fishing* is hardly proven. One might, and with more relevance, note the stooping figure's resemblance to the bathing woman in Manet's *Déjeuner sur l'herbe*, a motif which itself derives from one of Raphael's fishermen. Here we should return to the topic of Picasso's references to previous art. It is

36

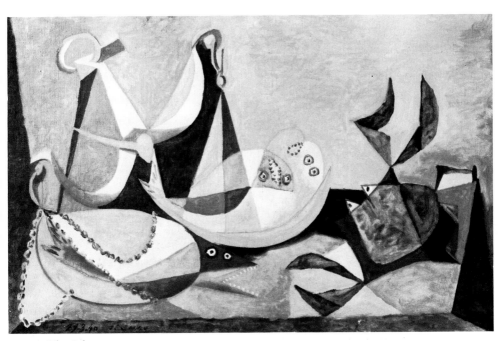

185 *The Soles* 1940

a truism that no great modern art has been made without as much absorption of the achievements of the preceding generation as ever was the case in Renaissance workshops and studios. Picasso is pre-eminently the modern master and innovative artist in whom we can see a massive shoring of previous art. Nobody can think about him for long without realizing how continuous, and crucial, was his interest in previous masters. One remembers that bright start to his career, with a capacity for pastiche so great as to lead to the outpainting of his admired models, this succeeded by a brilliant feeling for all pictorial culture, his liking for referential and paradoxical work, and the assumption that the whole of human artistic experience was his field. These attitudes had varying effects on his work. There was a juvenile sprightliness which one applauds as one applauds a performance. In Cubism he developed a profound sympathy with Cézanne. Then there is the dignity of the super-annuated artist which one finds in many works of the 1930s; and finally there are increasingly obtuse parallels between himself and favoured old masters. In the post-war years, just when the next great

253

186 *Jaime Sabartés* 1939

wave of major painting was coming to terms with new possibilities by a rejection of Picasso and what he had done, he, blind to contemporary art, painted ludicrous Picassian versions of Manet, Courbet, El Greco, Delacroix, Velázquez.

At its worst, this last tendency is embarrassing because the masquerading is so absurd, and obtuse; that happens later on. The first examples come when Picasso makes someone else masquerade (not that he had not done this before, in other circumstances); in 1939 he
186 painted the faithful Sabartés in a ruff, as a courtier of Philip II. Sabartés was of course a courtier himself, an ever-present favourite, always obedient, the butt of many a joke. He followed wherever Picasso went: from Antibes to Paris; from Paris to Royan, a town on the Atlantic coast above Bordeaux; and then back to Paris, where Picasso lived and worked throughout the years of the German occupation.

There is a way in which Picasso's war pictures, his war art, occur before and after Hitler's war rather than during it. One can easily draw parallels between the subjects and moods of his pictures during
187 the occupation – still-lifes of meagre meals and the gruesome *Woman Dressing her Hair* – and the political conditions. Yet the facts are that all his practical and overt political art was engendered either by the Spanish Republican movement in the late 1930s or the pro-

254

Communist and internationally minded *front populaire* of the late 1940s and early 1950s. When Picasso consciously and publicly allied himself to such causes, it had more direct effect on his art than had the presence of the SS around the corner. However, this said, *Woman Dressing her Hair* is likely to remain the great image of the pessimism which followed the affront of the first days of the occupation.

The picture was painted in Royan in June of 1940, after the Germans had taken over the town. There were restrictions on movement, travel, Nazi troops were everywhere, there was a curfew. None of these circumstances are present in this painting of a *coiffure*. What makes this picture different from the many other distortions of the female figure in previous years is that those exercises were primarily linear, as in the *Seated Woman* of 1927. In this case, 114 however, the figure is modelled in definite depth with reference to a traditional light source. Because the picture is tonal in this way, the metamorphoses are flabbier and give the image a fleshy aspect.

187 *Woman Dressing her Hair* 1940

Within the oppressive and cell-like interior the relationship of the body to the space it occupies is treated with aggressive, hyper-Baroque distortion, the monstrous feet extraordinarily foreshortened. It is a far more tactile image than had been the case with previous linear rearrangements of the body, and it is probably this aspect of the painting which saves it from being too pat, too usual within Picasso's terms. Other things give it a distinct quality: the contrast, for instance, between the crude drawing of the feet and the curves and crescents just where the woman braids her hair, which are as smoothly elegant as many passages in the biomorphic paintings inspired by Marie-Thérèse. In point of fact, this painting began with some portrait sketches of Dora Maar, and there is an oil painting of her which is remarkably similar, and must have been painted within a few days of the more generalized subject. This provokes the usual questions. First, does the image of the woman represent Fascism, or the ravages of Fascism? Second, if the picture is ambiguous in the answering of that question, does not that ambiguity indicate apoliticality rather than a *parti pris?*

For some months Picasso alternated between Paris and Royan, then finally settled in Paris, where he remained until the end of the war. Very many other artists, especially of course the Jewish ones, had left for America. Picasso refused all invitations to accept refuge in other countries, and his presence in Paris was certainly significant; it may even have actively helped the spirit of the Resistance. Attacked by collaborating painters such as Vlaminck, he was not greatly harassed by the Germans; not that the slightest interference by them was not greatly insulting, of course. On one occasion he distributed postcards of *Guernica* among them. In the winter of 1941 he wrote a short play, *Le Désir attrapé par la queue (Desire Caught by the Tail)*. Its absurdity and scatological humour owe a great deal to Jarry and to Apollinaire's *Les Mamelles de Tirésias*. Three years later a private reading of the play was organized by the poet Michel Leiris. On this famous occasion the piece was produced by Albert Camus and parts were taken by Jean-Paul Sartre, Raymond Queneau, Simone de Beauvoir and others. Mme de Beauvoir's memoirs give very faint praise to the play and, indeed, to the occasion, but other reminiscences accord it a symbolic value.

The war years saw some kind of recrudescence of Picasso's interest in sculpture, perhaps because of the fact that he had both a supply of

188 *Bull's Head*
1943

bronze and room to spare in the Rue des Grands-Augustins. He had produced little three-dimensional work in the last decade, but had often made adjustments to *objets trouvés*, pebbles or bones on which he then incised mythological references. He made toys for his daughter Maia. Some other three-dimensional pieces were fashioned from such fragile or transitory materials that they have now disappeared. Some of them were probably little more than jests or tricks; one often comes across stories of marvellous things being done with matchboxes and the like. A very well-known sculpture from the war period is the *Bull's Head*, which dates from 1943. Picasso, sorting 188 through a pile of jumble and miscellaneous effects in the flat in the Rue des Grands-Augustins, came across a narrow, springless bicycle saddle, the leather slightly sagging on the chassis, and a pair of handlebars in a shallow Maes bend. Placed together and soldered (the piece was later cast in bronze), these two elements form a convincing diagrammatic representation of a taurine head, if placed or hung in such a way that the piece is viewed frontally. That is, the

sculpture would not retain its illusionistic quality, and thus its point, were it free-standing or viewed in a three-dimensional manner. The *Bull's Head* is a pleasant *jeu d'esprit* born of a remarkable acuity of eye. But it does not come up for the count as a work of art. Its essential quality is rather the opposite of that 'radical unlikeness to nature', the facience of the best modern sculpture. One does not admire what has been made so much as the fact that it has been made from something else. There is such a stress on the nature and origin of the materials that only the fact of their transubstantiation is important; what strikes one is not aesthetic, but merely the quickness of Picasso's eye.

To a lesser extent, the same holds true of many other of Picasso's toy-like, small, malleable assemblage sculptures of the war years and thereafter. His liking for the playful was so much expressed by metamorphosis that this in itself tended to become the rationale for sculptural work; and the pieces would appear very ordinary were this not so. Things in the world that are not what they seem, or seem other than what they are: these always express, in the sculpture of this century, the failure of high intentions. Granted, Picasso himself probably did not think very highly of these works, did not take them seriously, these baboons made of toy cars, owls and goats modelled from wicker baskets and whatever else came to hand. He thought enough of them to keep them, but then he kept everything.

189

189 *Baboon with Young*
1951

190 *Man with a Lamb* 1944

A far more considered work of art was the *Man with a Lamb* of 190
1944. This very large work was the subject of much pondering, in a
different medium. Picasso seems to have made at least a hundred
drawings of the subject of the shepherd holding the frightened animal
before going on to the stage of modelling the clay figure. This was
done very rapidly, and the weight of all the clay caused the armature
to collapse. Picasso himself, as reported by Françoise Gilot, was not
clear how this came about: 'When I begin a series of drawings like
that, I don't know whether they're going to remain just drawings, or
become an etching or a lithograph, or even a sculpture. But when I
had finally isolated that figure of the man carrying the sheep in the
centre of the frieze, I saw it in relief and then in space, in the round.
Then I knew it couldn't be a painting; it *had* to be a sculpture.'

259

The first drawings for the sculpture show that the figure was originally conceived as having the faun-like, god-like, Grecian features familiar to us from the first appearance of Arcadian animals in the 1930s, and so we might be inclined to think of the sculpture itself as a development – replacement, even – of a rural and Hellenistic mode. For the work itself turned out to have more affinities with Rodin than with anyone else, and to be informed with clearly sentimental and Christian-humanitarian overtones.

Man with a Lamb, seven feet high, towered over Picasso's studio at the time of the Liberation in 1944. He had visitors in their thousands, old friends, exiles, new friends, British soldiers, GI's bringing cartons of cigarettes and black-market food. At about this time he began to think of joining the Communist Party. He was probably persuaded in this direction by the example of his friend Paul Eluard. But there were other real considerations; the extremely high standing of the party at the time of the Liberation, the great heroism of so many comrades in the Resistance, the necessity for a new order, and the still-present need for opposition to the Fascist régime in Spain. Picasso, in making the decision to *s'allier au parti*, did not do so with the thoughtful and honourable sense of commitment and responsibility, subjugation of personal interests and bourgeois habits, that troubled the conscience and intellects of so many French intellectuals who joined and left the party in the post-war years. He was totally simple about it, and employed a magnificently inappropriate pre-industrial metaphor to account for his decision: 'I joined the party as one goes to the fountain.'

In the Liberation and the months that followed there was political determination as well as a sense of relief; and there was room for much mourning. The last of Picasso's important pictures belongs to this period. It was entitled *The Charnel House*, in reference to practices in Nazi concentration camps now being revealed. The picture was initiated at the end of 1944 and was worked on for at least a year after that, with some subsequent changes and additions. It is not completed. There are many *pentimenti*, so many indeed that they constitute a good part of the picture. A large part of the canvas is unpainted. On the other hand, Picasso signed the painting and sent it for exhibition. Like *Guernica*, it is a black-and-white or grisaille painting, set in an indeterminate Cubist space and embodying a general symbolism of suffering. The complex interweaving of black

and white shapes, running patterns, interweavings of positive against negative areas, is more pronounced than in the earlier picture, though the palette is nearly identical and the iconography very similar. In some ways it is a more explicit political picture than *Guernica*. There are no animals in the painting (though there was at one stage a cock, subsequently suppressed); and the main theme is simply that of a pile of hideously broken bodies. One can say of it, as one cannot of *Guernica*, that it is a modern Massacre of the Innocents. It is obviously surprising that Picasso should have determined to combine this theme with such a different one as the still-life which occupies most of the top half of the canvas. It was not there at first, but was introduced in the third month of work on the painting. Since the still-life refers to – or is very similar to – the paintings of the occupation period which had most to do with the circumstances of the way Picasso lived under German rule, the pictures of meagre meals in darkened rooms, we may feel that some kind of contrast was intended: perhaps between these mundane privations and the unbelievably hideous sufferings endured by others. But that would hardly have been a viable theme. As one would expect, many individual motifs relate to recent work by Picasso himself. There is, for instance, a direct link between the figure of the dead man and certain of the studies for *Man with a Lamb*, where the lamb's legs are tied together; this was associated in Picasso's mind with its subsequent slaughter, whether ritual or otherwise.

Clearly, one cannot without much risk describe an unfinished and continually changing painting in terms of its iconographic programme. There was obviously some difficulty in finding the right set of motifs which would bring the painting together. But in any case the body of meaningful matter within the picture is not the most important thing about it. Picasso for once was extremely acute and to the point in a frank description of what was happening to *The Charnel House*. Progressive photographs were being taken by the 191 photographer Brassaï, who reports Picasso as follows: 'I'm treading lightly. I don't want to spoil the first freshness of my work . . . If it were possible, I would leave it as it is, while I began over again and carried it to a more advanced state on another canvas. There would never be a 'finished' canvas, but just different states of a single painting. . . . To finish, to execute – don't those words have a double meaning? To terminate, but also to finish off, to kill, to give the *coup de grâce*.'

191 *The Charnel House* 1944–45 (in progress)

The terminology is of course from the bullfight, but the thought behind these remarks may well have been prompted by his experience with *Guernica* and even with the very different experience of the *Demoiselles* years before. *Guernica*, as a painting, had been harmed by the way that it was brought to a conclusion. Picasso never finished *The Charnel House*. He probably worked on some parts of it until 1948, filling in certain sections with a blue-grey colour, thus altering the tonality, but within the scale established by the blacks and whites. Clement Greenberg has some important remarks on this: 'It seems to me that in *Charnel House* Picasso also makes a specific correction to the colour of the previous picture (*Guernica*) by introducing a pale blue-grey amid the blacks and greys and whites.

180
50

262

192 *The Charnel House* 1944–45

This works, along with the use of priming instead of applied white, to give the later painting more ease of space, more air.' Greenberg's major point, however, is in the question of the aesthetic value of leaving a painting in some sense unfinished as, in a literal way, *The Charnel House* so obviously is. This was a problem which had been in modern art since Cézanne (it is not the same problem as allowing a sketch an equal or superior value to a finished painting dependent on that sketch), but which was not seen in Picasso very much except in the Cubist period. The point about the *Charnel House* is that it was not exactly abandoned: Picasso saw that it could not be taken further without damage to its identity and quality. As Greenberg says, 'the picture was finished and brought off by being left unfinished'.

194 *William Shakespeare* 1964

193 *Don Quixote and Sancho Panza* 1955

WE SHOULD CONSIDER what differences were made to Picasso's work by the political affiliations of the last part of his artistic career. In 1946, Paul Eluard introduced him to Pierre Daix, who was later to become a most respected friend, and a devoted cataloguer of Picasso's *œuvre*. This was at the time when Picasso was thinking of sending *The Charnel House* to an exhibition in Paris of the art of the Resistance. Daix had been liberated from the concentration camp of Mauthausen, and he told Picasso how the thought of *Guernica* had helped him during the years of incarceration. (It is possible to be much moved by this and still have reservations about the painting.) He had the Communist qualities that Picasso admired.

Daix ran the magazine *Lettres françaises,* and in its pages Picasso enjoyed himself with graphic work. He contributed a famous
193 drawing of Don Quixote and Sancho Panza (perhaps thinking of Daumier), and made clever imaginary portraits of Racine,
194 Apollinaire, and Shakespeare (rendered oddly Gallic). The infamous
195 portrait of Stalin (seldom reproduced in general works on Picasso) is

264

another matter. This was done in 1953, when Stalin died, and was copied from an early photograph. It is surprisingly clumsy, even amateurish. It caused much scandal in the Communist Party, since some kind of idealization had been expected. Here the usual bourgeois accounts of the incident are led into misinterpretation. For Picasso was not at all averse to idealization; quite the contrary. He was not a realist painter. He had seriously thought of painting Stalin crowned with flowers, had thought of drawing a large heroic nude of him. There are those who will be amused by this; but in fact it exhibits two serious points, the reality of his devotion to Communism and the international peace movement, and the essentially *artistic* nature of his thinking. For the male nude, though it does not have a consistent or coherent history, is common and accepted at only one time in the history of art apart from classical antiquity and the Renaissance period between Donatello and Michelangelo: and that is in neo-classical battle paintings, in heroic subjects by David and Ingres – art instinctively brought to Picasso's mind when he thought of matters of global political import.

195 *Joseph Stalin* 1953

The circumstances of the Stalin portrait are perhaps not very important (the drawing itself is not at all important); but the lessons to be drawn from the episode are obvious. The brouhaha does not reflect badly on Picasso, though he produced a bad work of art, so much as on the politically minded people (not Daix) who surrounded him and condemned what he had done. For it is as misguided, and in this case heinous, to condemn a bad work of art for the wrong reasons as to applaud a good one for the wrong reasons. Communists are especially liable to make these mistakes when they interfere with art. Picasso's Stalin portrait was just a mistake, in the way that the *Guitar*

110 of 1926 was a mistake. In both cases Picasso simply took too much notice of those who surrounded him and were very vociferous. Whether they were Dadaists or Stalinists is not to the point.

It is not clear – it could not be so – to what extent the large political paintings of the late 1940s and early 1950s were the result of Picasso's membership of the Communist Party, and perhaps of the urging of friends more interested in political than in artistic matters. Their subjects certainly accord with Picasso's interests in big painting since the time of *Guernica*. But these political subjects conceived as murals,

202–4 *War*, *Peace*, and *Massacre in Korea*, are most unfortunate paintings. They were preceded by a mural just as disappointing, though in a

198 different way, the *Joie de Vivre* of 1946.

PICASSO'S CELEBRATION of the idea of a new dawn after the war seems to have been initially in portraits of his new mistress, Françoise Gilot,

196 and in the *Bacchanal* (1944), a free rearrangement of Poussin's painting

197 in the Louvre, *The Triumph of Pan*. He decreased the size, kept the general layout, and introduced a ribaldry not quite present in the seventeenth-century picture.

Picasso's last contribution to the community of modern art consisted of the *Joie de vivre* and the subsequent major-looking paintings. One cannot discuss them as a group, though, for they do not cohere as such; they are loosely related, casually undertaken, slackly executed. Picasso was now beginning his new career as the legend of Picasso. The works of art that he produced for the next twenty years or so are interesting primarily because it was Picasso who produced them.

In 1946 he was sixty-five. He had not been to the Mediterranean for six years, and when he returned to Antibes in 1946 he took Françoise

266

196 *Bacchanal* 1944

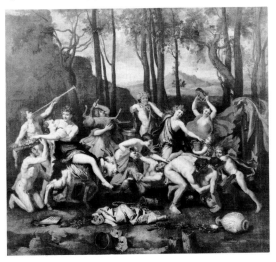

197 NICOLAS POUSSIN
The Triumph of Pan 1635

Gilot with him. There, an astute museum director offered him the use of the ancient palace of the Grimaldi to work in. Remembering the last painting he had done in the town, *Night Fishing*, Picasso painted a comparably-sized mural work on hardboard (canvas being difficult 198 to find at that time) which is entitled *Joie de vivre*. Described by Jean Sutherland Boggs as 'marvellously silly and unpretentious', it is, however, pretentious in an obvious way, immediately signalled by its 41 title. There is some sort of reply to Matisse in it. However flippant and ridiculous the piping fauns and dancing animals, this remains so; it is as if Matisse were now seen as a challenge that could be dismissed with a joke and a gesture. Picasso's flexible attitude towards the seriousness of what he was attempting, that long-managed variability of response, is here exposed. It is a dispiriting sight.

Other familiar Picassian motifs enter the art of the post-war Antibes period. There are many drawings and lithographs of 200 Françoise (her portrait as *The Flower Woman* had in fact been set off by a remark of Matisse's that he would like to paint her with green 201 hair); there are many fauns, now totally stripped of the cultural

198 *Joie de vivre* 1946

199 *Plate*

201 *Faun Piping* 1946

200 *The Flower-Woman* 1946

202 *Massacre in Korea* 1951

significance they had in the 1930s, and there are many animals, in
particular the owl. An absorbing new activity was found in the
making of ceramics. Before the war, Picasso had been to visit, in
Eluard's company, the pottery-making town of Vallauris. Returning
there subsequently, he made friends with a local ceramicist but found
that the little town – largely Communist – had suffered much of a
decline, there being little demand for the ancient craft practised there.
From 1947 Picasso took a serious interest in ceramics, in so far as a
great modern artist can be serious about such matters. He lived in a
199 villa above Vallauris for the next decade. Pots, jugs, pitchers, plates,
casseroles, were thrown, decorated with women, goddesses, fauns,
owls, bulls and the like, and then fired. His arcadian thematicism
thus came to its inglorious end.

The other side of Picasso's artistic imagination fared little better. In
202 1951 he painted the very large *Massacre in Korea*, which ploddingly
follows execution scenes by Goya and Manet. In this picture a group
of soldiers (all naked, but with guns and riot-control visors) shoot
down a group of seven or eight innocents. The painting is so bad as to
be embarrassing; and a reminder in the left-hand group of the way
36 that the family of *Saltimbanques* had once been posed makes it
poignantly and bitterly embarrassing. The same must be said of the
203-4 complementary murals *Peace* and *War*, which were painted in a

270

chapel in Vallauris. They were completed in 1952. Although Picasso had another twenty years to live, this was the termination of his career as the most important artist of the twentieth century.

The mastery did not just disappear, of course; and for a time there was still something of the old inventiveness. The ability to make something utterly his own, a picture that nobody else could have done, and yet still a surprise, is perhaps last seen in the popular work known as *The Kitchen*. Its springing lines, its consummate sense of design, its appearance of being even a little 'abstract', did not however appear in any other work. Picasso was still producing hundreds of paintings a year in his sixties and seventies, simply because he was

203–04 *Peace; War* 1952

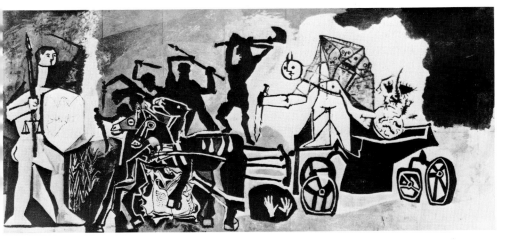

alive and could not live without painting. Perhaps it was the fact that his art had always had such conservative features that ensured the repetitiousness, the stasis of his last years. The urgency with which he always worked was not lost. It was simply transformed into a need to make more and more pictures, rather than new pictures whose characteristic would be that they contributed to the modern movement. No dialogue with the avant-garde had been possible to Picasso for years. Many paintings, and many records of his conversation, touchingly testify to his feeling in the last two decades of his long life that he belonged to the company of the Renaissance masters, that he belonged with his fellow-Spaniard Velázquez, and with Manet, the founder of the modern tradition that he himself so massively extended. The feeling was of course justified, and it is right that Picasso should have thought of those artists more than he considered the hundreds of younger and lesser painters whose entire careers were founded on what Picasso might have invented and played with for a year or two of his career. But his attention to old-master paintings, his obsession with Manet's *Lola de Valence* or his reworkings of Velázquez's *Las Meninas*, did not produce masterly paintings, only paintings in which the hand of a master was still visible. This does not matter. Picasso's stature as an artist is still, and will no doubt remain, unchallengeable.

206
207

206 *Jacqueline Roque as Lola de Valence* 1955

207 *Las Meninas* 1957

< 205 *The Kitchen* 1946

Bibliographical Note

The standard catalogue of Picasso's work is *Pablo Picasso: œuvres*, edited by Christian Zervos. It has been issued at intervals since 1932 by Editions Cahiers d'Art, Paris. At the time of Picasso's death in 1973 twenty-three volumes had been published. Picasso's juvenilia, together with a few later works, are assembled in *Picasso: Birth of a Genius*, ed. J. E. Cirlot, London and New York, 1972. Pierre Daix and Georges Boudaille published their devoted *Picasso: The Blue and Rose Periods. A Catalogue Raisonné, 1900–1906*, London and New York, in 1966. Werner Spies's *Picasso Sculpture*, London and New York, 1972, contains a comprehensive catalogue of the three-dimensional work. Picasso's graphic work, especially that of his later years, has not been fully catalogued. Bernhard Geiser's *Pablo Picasso: 55 Years of his Graphic Work*, London and New York, 1955, should be consulted, with the same author's *Picasso peintre-graveur*, 2nd edn, Berne, 1955. Hans Bolliger's *Picasso, Vollard Suite*, London, 1956, is an essential work of reference. The best single publication on Picasso is also a catalogue, *Picasso in the Collection of the Museum of Modern Art*, New York, 1972. This is very largely the work of Professor William S. Rubin. A number of entries are by curators in the museum's specialized departments, Riva Castleman and Elaine L. Johnson. Some entries in the catalogue are reprinted without amendment from Alfred H. Barr's *Picasso: Fifty Years of his Art*, New York, 1946.

The amplest biography of Picasso is by Sir Roland Penrose. His *Picasso* (1958; revised edition, Harmondsworth and New York,

1971) has many more of the virtues than the defects of a biography written by a friend within the artist's lifetime. One must also refer to Françoise Gilot's and Carlton Lake's fascinating, vulgar and brilliant *Life with Picasso*, London and New York, 1964. Fernande Olivier's *Picasso et ses amis*, Paris, 1933, is an affecting work. Most other specifically biographical books are far less richly informative than Sir Roland's and a great deal more reticent than Mlle Gilot's.

Apart from Professor Rubin's catalogue, the only general study of Picasso's art of any real interest to have appeared since Alfred H. Barr's book in 1946 is *Picasso 1881–1973*, ed. John Golding and Sir Roland Penrose, London and New York, 1973. This contains Professor Theodore Reff's account of some themes within the blue period, Dr Golding's study of Picasso's relationship with the Surrealist movement, Alan Bowness's examination of the sculpture and Jean Sutherland Boggs' description of the late (i.e. post-1945) work. These short essays will no doubt be the inspiration of future full-length books by other writers. There are few books on specialized topics within Picasso's work. The standard account of Cubism is John Golding's *Cubism: a History and an Analysis*, 2nd edn, London and New York, 1969. Edward F. Fry's *Cubism*, London and New York, 1966, is a most useful compilation of contemporary accounts of the movement, fully annotated. Douglas Cooper's *The Cubist Epoch*, London and New York, 1971, accompanied the largest exhibition of Cubist painting ever held, and is the most broadly based account of

274

the movement. The same author's *Picasso: Theatre*, London and New York, 1968, brings together all Picasso's work for the stage. Rudolf Arnheim's *Picasso's Guernica, the Genesis of a Painting*, Los Angeles and London, 1962, reproduces all the preparatory drawings and progressive photographs.

In the text of this book I have referred to Jean Cocteau's *Picasso*, Paris, 1923; Gertrude Stein's *The Autobiography of Alice B. Toklas*, New York, 1933; Jaime Sabartés's *Picasso, portraits et souvenirs*, Paris, 1946; Brassaï's *Picasso & Co.*, London and New York, 1967; Daniel-Henry Kahnweiler's *My Galleries and Painters*, London and New York, 1971; Leo Steinberg's *Other Criteria: Confrontations with*

Twentieth-Century Art, New York, 1972; and William Tucker's *The Language of Sculpture*, London and New York, 1974. Meyer Shapiro's comments are quoted from Professor Rubin's catalogue. Carla Gottlieb's analysis of the painting *Girl before a Mirror* (1932) is to be found in the *Journal of Aesthetics and Art Criticism*, New York, XXIV, 4, Summer 1966. Ruth Kaufmann's article on the *Crucifixion* of 1930 is in the *Burlington Magazine*, London, September 1969. Clement Greenberg's comments on *Guernica* (1937) are taken from his *Art and Culture*, 2nd edn, London and New York, 1973, and on the *Charnel House* (1944–5) from *Artforum*, Los Angeles, v, 2, October 1966.

List of Illustrations

Picasso hardly ever gave a title to one of his works; there is consequently often no agreed version, even in French. The titles given here are those preferred by the author, plus in many cases an alternative used by the owner or in one of the catalogues mentioned on p. 274. Unfortunately not all measurements, media or collections could be traced. Measurements are given in inches and centimetres, height before width.

16 *Nude from the Back*, Barcelona 1902. Oil on canvas, $18\frac{1}{8} \times 15\frac{3}{4}$ (46×40). Private collection, Paris. Photo Bulloz.

17 *Evocation* (*The Burial of Casagemas*), Paris 1901. Oil on canvas, $59 \times 35\frac{1}{2}$ (150×90). Musée National d'Art Moderne, Paris. Photo Bulloz.

18 *The Mourners* (*Le Mort*), Paris 1901. Oil on canvas, $39\frac{3}{8} \times 35\frac{1}{2}$ (100×90). Collection Edward G. Robinson, Beverly Hills, Calif.

19 *The Blind Guitarist* (*The Old Guitarist*), Barcelona 1903. Oil on panel, $47\frac{3}{4} \times 32\frac{1}{2}$ (121.3×82.5). Courtesy of the Art Institute of Chicago.

20 Study for *La Vie*, Barcelona 1903. Pencil on paper, $10\frac{1}{2} \times 7\frac{3}{4}$ (26.7×19.7). Collection Sir Roland Penrose, London. Photo John Webb, Brompton Studios, London.

21 *La Vie*, Barcelona 1903. Oil on canvas, $77\frac{1}{2} \times 50\frac{1}{8}$ (197×127.3). The Cleveland Museum of Art, Gift of Hanna Fund.

22 *The Frugal Meal* (*The Frugal Repast*), 1904. Etching, $18\frac{1}{8} \times 14\frac{1}{8}$ (46×36). Collection, The Museum of Modern Art, New York. Gift of Abby Aldrich Rockefeller.

23 *The Embrace*, Barcelona 1903. Pastel, $38 \times 22\frac{7}{16}$ (98×57). Collection Jean Walter–Paul Guillaume, Paris. Photo Giraudon.

24 *Brooding Woman*, Paris 1904–05. Watercolour, $10\frac{5}{8} \times 14\frac{1}{2}$ (27×37). Collection, The Museum of Modern Art, New York. Gift of Mr and Mrs Werner E. Josten.

25 *Woman's Head with Studies of Hands* (*A Mother Holding a Child and Four Studies of Her Right Hand*), 1904. Black crayon on cream coloured paper, $13\frac{1}{2} \times 10\frac{1}{2}$ (34.3×26.7). Courtesy of the Fogg Art Museum, Harvard University. Bequest of Meta and Paul J. Sachs. Photo James K. Ufford.

26 *Salome*, 1905. Drypoint, $15\frac{3}{4} \times 13\frac{3}{4}$ (40×35).

27 *Woman in a Chemise*, Paris 1905. Oil on canvas, $29\frac{5}{8} \times 17\frac{1}{8}$ (75×60). Tate Gallery, London.

28 *Meditation*, Paris 1904. Watercolour and pen, $14\frac{1}{2} \times 10\frac{1}{8}$ (36.8×27). Private collection. Photo The Museum of Modern Art, New York.

29 *Woman with a Helmet of Hair*, Paris 1904. Gouache on paper, $16\frac{7}{8} \times 12\frac{1}{4}$ (42.9×31.2). Courtesy of the Art Institute of Chicago.

30 *Harlequin's Family*, Paris 1905. Gouache and India ink on paper, $22\frac{7}{8} \times 17\frac{1}{8}$ (58×43.5). Collection Mr Julian Eisenstein, Washington, DC. Photo Henry B. Beville.

31 *The Acrobat's Family with a Monkey*, Paris 1905. Gouache, watercolour, pastel and India ink on cardboard, $41 \times 29\frac{1}{2}$ (104×75). Göteborgs Konstmuseum, Gothenburg.

32 *Mother Combing Her Hair*, 1905. Etching on zinc, $9\frac{1}{4} \times 7$ (23.5×17.8). Collection, The Museum of Modern Art, New York. Gift of Abby Aldrich Rockefeller.

33 *Two Acrobats with a Dog*, Paris 1905. Gouache on cardboard, $41\frac{1}{2} \times 29\frac{1}{2}$ (105.5×75). Collection Mr and Mrs William A.M. Burden, New York. Photo Sunami, The Museum of Modern Art, New York.

34 *The Dance*, 1905. Drypoint, $7\frac{1}{4} \times 9\frac{1}{8}$ (18.5×23).

35 *Young Acrobat on a Ball*, Paris 1905. Oil on canvas, $57\frac{7}{8} \times 37\frac{3}{8}$ (147×95). Pushkin Museum, Moscow.

36 *Saltimbanques* (*Family of Saltimbanques*), Paris 1905. Oil on canvas, $82\frac{3}{4} \times 90\frac{1}{2}$ (212.8×229.6). The National Gallery of Art, Washington, DC. Chester Dale Collection.

37 *The Circus Family* (*Les Saltimbanques*), Paris 1905. Drypoint, $11\frac{3}{4} \times 12\frac{7}{8}$ (30×32.7).

38 Study for the *Saltimbanques* (*Study for Family of Saltimbanques*), Paris 1905. Gouache on cardboard, $20\frac{1}{8} \times 24\frac{1}{8}$ (51.2×61.2). Pushkin Museum, Moscow.

39 *The King*, Paris 1905. Pastel, $21\frac{5}{8} \times 17\frac{3}{4}$ (55 × 45). Staatsgalerie, Stuttgart.

40 *The Two Brothers*, Gosol 1906. Oil on canvas, $55\frac{7}{8} \times 38\frac{1}{8}$ (142 × 97). Kunstmuseum, Basle.

41 HENRI MATISSE: *Joie de Vivre*, 1905–06. Oil on canvas, $68\frac{1}{2} \times 93\frac{3}{4}$ (174 × 238). Photograph copyright (1975) by The Barnes Foundation, Merion, Pa.

42 *The Watering Place*, Paris 1905. Drypoint.

43 *Boy with a Pipe*, Paris 1905. Oil on canvas, $39\frac{3}{8} \times 32$ (100 × 81.3). Collection Mr and Mrs John Hay Whitney, New York.

44 *Girl with a Fan (Lady with a Fan)*, Paris 1905. Oil on canvas, 39 × 32 (99 × 81.3). National Gallery of Art, Washington, DC. Gift of the W. Averell Harriman Foundation in memory of Marie N. Harriman.

45 *The Harem (Figures in Pink)*. Gosol 1906. Oil on canvas, $60\frac{3}{4} \times 43\frac{1}{8}$ (154.3 × 109.5). The Cleveland Museum of Art, Leonard C. Hanna Jr. Collection.

46 *Boy Leading a Horse*, Paris 1905–06. Oil on canvas, $87 \times 51\frac{1}{8}$ (221 × 130). Collection William S. Paley, New York. Photo The Museum of Modern Art, New York.

47 *The Toilette*, Gosol 1906. Oil on canvas, $59\frac{1}{2} \times 39$ (151 × 99). Albright-Knox Art Gallery, Buffalo, N.Y. Fellows for Life of 1926 Fund.

48 *Landscape at Gosol*, Gosol 1906. Oil on canvas, $27\frac{1}{2} \times 39$ (70 × 99). Private collection.

49 *The Peasants*, Paris 1906. Oil on canvas. 86 × 51 (218.5 × 129.5). Photograph copyright (1975) by The Barnes Foundation, Merion, Pa.

50 *Demoiselles d'Avignon*, 1906–07. Oil on canvas, 96 × 92 (244 × 233). Collection The Museum of Modern Art, New York. Acquired through the Lillie P. Bliss Bequest.

51 *Reclining Nude*, Gosol 1906. Gouache on paper, $18\frac{5}{8} \times 24\frac{1}{8}$ (47.3 × 61.3). The Cleveland Museum of Art, Gift of Mr and Mrs Michael Straight.

52 *Self-portrait*, Paris 1906. Oil on canvas, $36\frac{1}{4} \times 28\frac{3}{4}$ (92 × 73). Philadelphia Museum of Art. A. E. Gallatin Collection.

53 *Gertrude Stein*, Paris 1906. Oil on canvas, $39\frac{3}{8} \times 32$ (100 × 81.3). Metropolitan Museum of Art, New York. Bequest of Gertrude Stein, 1946.

54 *Two Nudes*, 1906. Oil on canvas, $59\frac{5}{8} \times 36\frac{5}{8}$ (151.5 × 93). Collection, The Museum of Modern Art, New York. Gift of G. David Thompson in honour of Alfred H. Barr, Jr.

55 PAUL CÉZANNE: *Three Bathers (Three Nudes; Three Women Bathers)*. Oil on canvas. Photograph copyright (1975) by The Barnes Foundation, Merion, Pa.

56 *Vase of Flowers*, 1907. Oil on canvas, $36\frac{1}{4} \times 28\frac{3}{4}$ (92 × 73). Collection of Mr and Mrs Ralph F. Colin, New York. Photo The Museum of Modern Art, New York.

57 GEORGES BRAQUE: *Large Nude*, 1907–08. Oil on canvas, $56\frac{5}{8} \times 40\frac{1}{8}$ (144 × 102). Galerie Alex Maguy, Paris.

58 *Nude with Draperies*, Paris 1907. Oil on canvas, $59\frac{7}{8} \times 39\frac{3}{4}$ (152 × 101). Museum of Modern Art, Moscow.

59 *Large Dryad (Nude in a Forest)*, Paris 1908. Oil on canvas, $73\frac{1}{4} \times 42\frac{1}{8}$ (186 × 107). Museum of Modern Art, Moscow.

60 *Three Women*, Paris 1908. Oil on canvas, $78\frac{3}{4} \times 70\frac{1}{2}$ (200 × 179). Museum of Modern Art, Moscow.

61 *Bather*, Paris 1908. Oil on canvas, Private collection.

62 *Bowl of Fruit (Fruit Dish)*, 1909. Oil on canvas, $29\frac{1}{4} \times 24$ (74 × 61). Collection, The Museum of Modern Art, New York. Acquired through the Lillie P. Bliss Bequest.

63 *The Reservoir* (*The Reservoir at Horta de Ebro*), 1909. Oil on canvas, $23\frac{3}{4} \times 19\frac{3}{4}$ (60.5 × 50). Collection of Mr and Mrs David Rockefeller, New York.

64 *Two Heads*, 1909. Oil on canvas, $13\frac{3}{4} \times 13\frac{1}{4}$ (35 × 33.7). Collection, The Museum of Modern Art, New York. A. Conger Goodyear Fund.

65 *Woman with Pears*, 1909. Oil on canvas, $36\frac{1}{4} \times 28\frac{7}{8}$ (92 × 73.3). Private collection. Photo The Museum of Modern Art, New York.

66 *The Botijo* (*Still-life with Liqueur Bottle*), 1909. Oil on canvas, $32\frac{1}{8} \times 25\frac{3}{4}$ (81.5 × 65.5). Collection, The Museum of Modern Art, New York. Mrs Simon Guggenheim Fund.

67 *Girl with a Mandolin*, 1910. Oil on canvas, $39\frac{3}{8} \times 28\frac{3}{4}$ (100 × 73). Collection of Nelson A. Rockefeller, photo Charles Uht.

68 *Wilhelm Uhde*, 1910. Oil on canvas, $31\frac{7}{8} \times 23\frac{5}{8}$ (81 × 60). Collection of Mr and Mrs Joseph Pulitzer, Jr.

69 GEORGES BRAQUE: *Violin with Pitcher*, 1910. Oil on canvas, $45\frac{5}{8} \times 29$ (115.8 × 73.7). Kunstmuseum, Basle.

70 *Ambroise Vollard*, 1910. Oil on canvas, $36\frac{1}{4} \times 25\frac{1}{2}$ (92 × 64.9). Pushkin Museum, Moscow.

71 *Drawing* (*Nude*), 1910. Charcoal, $19 \times 12\frac{1}{4}$ (48.3 × 31.2). The Metropolitan Museum of Art, New York, The Alfred Stieglitz Collection, 1949.

72 *Nude*, Cadaquès 1910. Oil on canvas, 74×24 (188 × 61). Private collection.

73 *Nude* (*Nude Figure*), 1910. Oil on canvas, $38\frac{1}{2} \times 30$ (97.8 × 76.2). Albright-Knox Art Gallery, Buffalo, N.Y. Consolidated Purchase Fund.

74 *Daniel-Henry Kahnweiler*, 1910. Oil on canvas, $39\frac{5}{8} \times 28\frac{5}{8}$ (100.5 × 72.6). Courtesy of The Art Institute of Chicago.

75 *Fruit and Wineglass* (*Fruit and Glass*), 1908. Tempera on wood panel, $10\frac{5}{8} \times 8\frac{3}{8}$ (27 × 21.3). Collection, Mr and Mrs John Hay Whitney, New York. Photo The Museum of Modern Art, New York.

76 *Ma Jolie* (*Woman with a Zither or Guitar*), 1911–12. Oil on canvas, $39\frac{3}{8} \times 25\frac{3}{4}$ (100 × 65.5). Collection, The Museum of Modern Art, New York. Acquired through the Lillie P. Bliss Bequest.

77 *Absinthe Glass, Bottle, Pipe and Musical Instrument on a Piano*, 1910–11. Oil on canvas, $19\frac{3}{4} \times 51\frac{1}{4}$ (50 × 130). Collection Heinz Berggruen.

78 *The Guitar*, 1912. Sheet metal and wire, $30\frac{1}{2} \times 13\frac{7}{8} \times 7\frac{5}{8}$ (77.5 × 35.2 × 19.4). Collection, The Museum of Modern Art, New York. Gift of the artist.

79 *Pointe de la Cité*, 1912. Oil on canvas, $35\frac{1}{2} \times 28$ (90 × 71). Norton Simon, Inc., Museum of Art.

80 *The Architect's Table*, 1912. Oil on canvas, oval, $28\frac{5}{8} \times 23\frac{1}{2}$ (72.7 × 59.7). Collection, The Museum of Modern Art, New York. Gift of Mr and Mrs William S. Paley.

81 *Man Smoking a Pipe* (*Man with a Pipe*), 1911–12. Oil on canvas, oval, $35 \times 27\frac{7}{8}$ (89 × 71). Kimbell Art Museum, Fort Worth, Texas.

82 *Still-life* (*Still-life with Chair Caning*), 1912. Oil, oilcloth and paper on canvas with rope surround, oval, $10\frac{5}{8} \times 13\frac{3}{4}$ (27 × 35). Owned by the artist. Photo Giraudon.

83 *Man with a Hat*, 1912. Charcoal, ink, pasted paper, $24\frac{1}{2} \times 18\frac{5}{8}$ (62.3 × 47.3). Collection, The Museum of Modern Art, New York. Purchase.

84 *Coup de thé* (*Bottle and Newspaper on Table*), 1912. Collage with charcoal, $24\frac{3}{4} \times 18\frac{7}{8}$ (63 × 48). Musée National d'Art Moderne, Paris.

85 *Student with a Newspaper*, 1913–14. Oil on canvas. Private collection, Paris.

86 *Guitar*, Paris 1913. Charcoal, wax crayon, ink and pasted paper, $26\frac{1}{8} \times 19\frac{1}{2}$ (66.4 × 49.5). Collection of Nelson A. Rockefeller.

87 *Still-life in a Landscape*, Paris 1915. Oil on canvas, $24\frac{1}{2} \times 20\frac{1}{2}$ (62.3 × 52).

88 *Glass of Absinthe*, 1914. Painted bronze with silver sugar strainer, $8\frac{1}{2} \times 6\frac{1}{2}$ (21.6 × 15.5). Collection, The Museum of Modern Art, New York. Gift of Mrs Bertram Smith.

89 *Still-life*, 1914. Painted wood with upholstery fringe, l. 18 (46). The Tate Gallery, London.

90 *The Harlequin*, 1915. Oil on canvas, $72\frac{1}{4} \times 41\frac{3}{8}$ (183.5 × 105). Collection, The Museum of Modern Art, New York. Acquired through the Lillie P. Bliss Bequest.

91 *Man Leaning on a Table*, 1915–16. Oil on canvas, $78\frac{3}{4} \times 52$ (200 × 132). Private collection.

92 *Still-life with Wafer*, 1914. Pencil.

93 *Max Jacob*, 1917. Pencil on paper, $13 \times 9\frac{3}{4}$ (33 × 25). Private collection. Photo Giraudon.

94 *Ambroise Vollard*, 1915. Pencil on paper, $18\frac{3}{8} \times 12\frac{1}{2}$ (46.7 × 32). The Metropolitan Museum of Art, Elisha Whittelsey Collection, 1947.

95 *American Manager* (*Parade*), 1917. Costume made for the London Festival Ballet, 1973. Photo Alan Cunliffe.

96 *French Manager* (*Parade*), 1917. Costume made for the London Festival Ballet, 1973. Photo Alan Cunliffe.

97 *Pierrot*, 1918. Oil on canvas, $36\frac{1}{2} \times 28\frac{3}{4}$ (92.7 × 73). Collection, The Museum of Modern Art, New York. Sam A. Lewisohn Bequest.

98 *Sleeping Peasants*, 1919. Tempera, $12\frac{1}{4} \times 19\frac{1}{4}$ (31 × 49). Collection, The Museum of Modern Art, New York. Abby Aldrich Rockefeller Fund.

99 *Three Women at a Fountain* (*Three Women at the Spring*), 1921. Oil on canvas, $80\frac{1}{4} \times 68\frac{1}{2}$ (204 × 174). Collection, The Museum of Modern Art, New York. Gift of Mr and Mrs Alan D. Emil.

100 *Drop Curtain* (*Parade*), 1917. Glue tempera on canvas, 394 × 630 (10 × 16 m).

101 *Studio with Plaster Head*, 1925. Oil on canvas, $38\frac{5}{8} \times 51\frac{5}{8}$ (98 × 131). Collection, The Museum of Modern Art, New York. Purchase.

102 *Three Musicians*, 1924 (1921). Oil on canvas, 80×74 (203 × 188). Philadelphia Museum of Art, Collection A. E. Gallatin.

103 *Three Dancers*, 1925. Oil on canvas, $84 \times 56\frac{1}{4}$ (215 × 140). Tate Gallery, London.

104 *Nessus and Deianeira*, 1920. Pencil, $8\frac{1}{4} \times 10\frac{1}{4}$ (21 × 26). Collection, The Museum of Modern Art, New York. Acquired through the Lillie P. Bliss Bequest.

105 *The Rape*, 1920. Tempera on wood, $9\frac{3}{8} \times 12\frac{7}{8}$ (23.8 × 32.7). Collection, The Museum of Modern Art, New York. The Philip L. Goodwin Collection.

106 *The Studio*, 1927–28. Oil on canvas, 59×91 (150 × 231). Collection, The Museum of Modern Art, New York. Gift of Walter P. Chrysler, Jr.

107 *Crucifixion*, 1930. Oil on wood, $19\frac{3}{4} \times 26$ (50 × 66). Owned by the artist.

108 CHARLES-EDOUARD JEANNERET (LE CORBUSIER): *Still-life with Many Objects*, 1923. $45 \times 57\frac{1}{2}$ (114 × 146). Fondation Le Corbusier, Paris.

109 *Still-life with Ram's Head*, 1925. Oil on canvas.

110 *Guitar*, 1926. Nails, cord, newspaper and cloth on painted canvas, $38\frac{1}{8} \times 51\frac{1}{8}$ (97 × 130). Owned by the artist.

111 *Construction with Glove (by the Sea)*, Juan-les-Pins 1930. Cardboard, plaster and wood on canvas, coated with sand, $10\frac{5}{8} \times 14$ (27×35.5). Owned by the artist.

112 *Playing Ball (Bathers with a Ball)*, 1928. Oil on canvas.

113 *Woman in a Hat*, 1935. Oil on canvas, $22 \times 18\frac{3}{8}$ (55.9×46.7). Private collection, Paris. Photo Musées Nationaux.

114 *Seated Woman*, 1927. Oil on wood, $51\frac{1}{8} \times 38\frac{1}{4}$ (130×97). Collection, The Museum of Modern Art, New York. Fractional Gift of James Thrall Soby.

115 *Woman in an Armchair*, 1927. Oil on canvas, $51\frac{1}{8} \times 38\frac{1}{4}$ (130.5×97). Owned by the artist.

116 *Artist and Model*, 1927. Oil on canvas, $84\frac{1}{4} \times 78\frac{3}{4}$ (214×200). Private collection.

117 *The Acrobat*, 1930. Oil on canvas, $63\frac{3}{4} \times 51\frac{1}{8}$ (162×130). Owned by the artist.

118 *The Dressmaker's Workshop*, 1926. Oil on canvas, 68×101 (172×256). Musée National d'Art Moderne, Paris. Photo Giraudon.

119 *Painter and Model*, 1926. Oil on canvas, 68×101 (172×156). Owned by the artist.

120 Illustration for *Le Chef d'œuvre inconnu*, (*Painter and Knitting Model*), 1927. Etching, $7\frac{1}{2} \times 11$ (19×28).

121 *Woman in an Armchair*, 1929. Oil on canvas, $76\frac{3}{4} \times 51\frac{1}{8}$ (195×130). Owned by the artist.

122 *Head*, Paris 1928. Painted metal, h. 10 (25.5). Owned by the artist.

123 *Two Women at a Window (Two Women by a Window)*, 1927. Oil on canvas, $38\frac{1}{2} \times 51\frac{1}{2}$ (98×131). The Museum of Fine Arts, Houston. Gift of Mr and Mrs Theodore N. Law.

124 *Painter and Model*, 1928. Oil on canvas, $51\frac{1}{8} \times 64\frac{1}{4}$ (130×163). The Sidney and Harriet Jan Collection. Gift to The Museum of Modern Art, New York.

125 *Pitcher and Bowl of Fruit*, 1931. Oil on canvas, $51\frac{1}{2} \times 64$ (131×162.5). Collection Nelson A. Rockefeller, New York.

126 *Vollard Suite* No. 63 (*Sculptor and Reclining Model by a Window Viewing a Sculptured Head*; from the *Sculptor's Studio Suite*). Paris, 1933. Etching, $7\frac{5}{8} \times 10\frac{1}{2}$ (19.4×26.7).

127 *Paulo Picasso (Paulo as Harlequin)*, 1924. Oil on canvas, $51\frac{1}{8} \times 38\frac{1}{8}$ (130×97). Owned by the artist.

128 *Olga Picasso (Portrait of Olga Picasso in an armchair)*, 1917. Oil on canvas. Owned by the artist.

129 *Figure*, 1907. Painted wood, $32\frac{1}{4} \times 9\frac{1}{2} \times 8\frac{1}{2}$ ($82 \times 24 \times 21.5$). Owned by the artist.

130 *Woman by the Sea*, 1929. Oil on canvas, $51\frac{1}{8} \times 38\frac{1}{8}$ (130×97). Private collection. Photo The Museum of Modern Art, New York.

131 *Seated Bather*, 1930. Oil on canvas, $64\frac{1}{4} \times 51$ (163×129.5). Collection, The Museum of Modern Art, New York. Mrs Simon Guggenheim Fund.

132 *Vollard Suite* No. 66 (*Model Kneeling by a Window Viewing a Sculpture of Nude Figures and a Rearing Horse*; from the *Sculptor's Studio Suite*), Paris 1933. Etching, $11\frac{5}{8} \times 14\frac{1}{2}$ (29.7×36.7).

133 *An Anatomy*, 1932. Pencil on paper. Reproduced in *Minotaure*, No. 1, 1933.

134 Illustration for *Le Chef d'œuvre inconnu* (*Musical Instrument*), 1926. Drawing, India ink on paper, $12\frac{3}{4} \times 9\frac{3}{4}$ (32.5×24.7).

135 *Wire Construction*, Paris 1928–29. Wire, $19\frac{5}{8} \times 16\frac{1}{8} \times 6\frac{3}{4}$ ($50 \times 41 \times 17$). Owned by the artist.

136 *Vollard Suite* No. 74 (*Model and Surrealist Sculpture*; from the *Sculptor's Studio Suite*), Paris 1933. Etching, $10\frac{5}{8} \times 7\frac{5}{8}$ (27 × 19.5).

137 *Figure of a Woman*, Paris 1930. Iron, with iron last and ball, toys and string, $31\frac{7}{8} \times 9\frac{7}{8} \times 12\frac{5}{8}$ (81 × 25 × 32). Owned by the artist.

138 *Woman in a Garden*, 1929–30. Bronze (original in iron), $82\frac{3}{4} \times 46 \times 32\frac{1}{4}$ (210 × 117 × 82). Owned by the artist.

139 *Woman's Head*, 1931. Bronze (original in white painted iron with two colanders), $39\frac{3}{8} \times 14\frac{1}{2} \times 24$ (100 × 37 × 61). Owned by the artist.

140 *Figurine*, 1931. Iron and iron wire, h. 11 (28). Owned by the artist.

141 *Wooden Figure* (*Woman*), Boisgeloup 1931. Wood, h. $12\frac{3}{8}$ (31.5). Owned by the artist.

142 *Wooden Figure* (*Woman*), Boisgeloup 1931. Wood, h. $18\frac{7}{8}$ (48). Owned by the artist.

143 *Wooden Figure* (*Woman*), Boisgeloup 1931. Wood, h. $7\frac{3}{4}$ (19.5). Owned by the artist.

144 *Head* (*Head of a Woman*), Boisgeloup 1932. Bronze, $19\frac{5}{8} \times 12\frac{1}{4} \times 10\frac{5}{8}$ (50 × 31 × 27). Owned by the artist.

145 *Head* (*Bust of a Woman*), Boisgeloup 1932. Bronze, $30\frac{3}{4} \times 18\frac{1}{8} \times 18\frac{7}{8}$ (78 × 46 × 48). Owned by the artist.

146 *Head* (*Bust of a Woman*), Boisgeloup 1932. Bronze, $50\frac{3}{8} \times 22\frac{7}{8} \times 26$ (128 × 58 × 66). Owned by the artist.

147 *Head* (*Head of a Woman*), Boisgeloup 1932. Bronze, $33\frac{1}{2} \times 14\frac{1}{2} \times 17\frac{7}{8}$ (85 × 37 × 45.5). Owned by the artist.

148 *Vollard Suite* No. 38 (*Seated Model and Sculptor Studying Sculptured Head*; from the *Sculptor's Studio Suite*), c. 1933. Etching, $10\frac{1}{2} \times 7\frac{5}{8}$ (26.7 × 19.5).

149 *Vollard Suite* No. 8 (*Seated Nude*), 1931. Etching, $12\frac{1}{4} \times 8\frac{3}{4}$ (31 × 22).

150 *Vollard Suite* No. 9 (*The Rape*), 1931. Etching, $8\frac{3}{4} \times 12\frac{1}{4}$ (22 × 31).

151 *Vollard Suite* No. 34 (*Head of Rembrandt and Various Studies*; from the *Rembrandt Suite*), 1934. Combined technique, $11 \times 7\frac{7}{8}$ (28 × 20).

152 *Vollard Suite* No. 59 (*Sculptor Seated by a Window, Working from Model*; from the *Sculptor's Studio Suite*), 1933. Etching, $7\frac{5}{8} \times 10\frac{1}{2}$ (19.5 × 26.7).

153 *Vollard Suite* No. 82 (*Four Models and a Sculptured Head*; from the *Sculptor's Studio Suite*), 1934. Combined technique, $8\frac{1}{2} \times 12\frac{1}{4}$ (21.7 × 31).

154 *Vollard Suite* No. 37 (*Sculptor seated, Reclining Model and Statue of Man*; from the *Sculptor's Studio Suite*), c. 1933. Etching, $10\frac{1}{2} \times 7\frac{5}{8}$ (26.7 × 19.5).

155 *Vollard Suite* No. 1 (*Seated nude crowned with Flowers*), 1930. Etching, $12\frac{3}{8} \times 8\frac{3}{4}$ (31.5 × 22).

156 *Vollard Suite* No. 87 (*Minotaur assaulting Girl*; from the *Minotaur Suite*), 1933. Combined technique, $7\frac{5}{8} \times 10\frac{5}{8}$ (19.5 × 27).

157 *Vollard Suite* No. 27 (*Faun and Sleeping Woman*), 1936. Etching and aquatint, $12\frac{1}{2} \times 16\frac{1}{2}$ (32 × 42). Collection, The Museum of Modern Art, New York. Purchase.

158 *Vollard Suite* No. 85 (*Drinking Minotaur and Sculptor with Two Models*; from the *Minotaur Suite*), 1933. Combined technique, $11\frac{5}{8} \times 14\frac{3}{8}$ (29.5 × 36.5).

159 *Vollard Suite* No. 94 (*Blind Minotaur Led by Girl with Bouquet of Wild Flowers*; from the *Blind Minotaur Suite*), 1934. Combined Technique, $10 \times 13\frac{5}{8}$ (25.3 × 34.6).

160 Drawing for *Crucifixion*, 1929. Pencil on paper, $13\frac{5}{8} \times 19\frac{7}{8}$ (34.5 × 50.5). Owned by the artist. (See ill. 107.)

161 Picasso 1931, standing in front of a painting of Marie-Thérèse Walter. Photo Cecil Beaton.

162 *Still-life on a Table*, 1931. Oil on canvas, $76\frac{3}{4} \times 51\frac{1}{8}$ (195 × 130). Owned by the artist.

163 *Reclining Nude*, 1932. Oil on canvas, $40 \times 36\frac{1}{2}$ (101.6 × 92.7). Collection Mr and Mrs Peter A. Rubel, New York.

164 *The Mirror*, 1932. Oil on canvas, $51\frac{1}{2} \times 38\frac{1}{4}$ (131 × 97). Art Gallery, University of Notre Dame. On loan from the Gustav Stern Foundation.

165 *Girl in Front of a Mirror* (*Girl Before a Mirror*), 1932. Oil on canvas, $64 \times 51\frac{1}{4}$ (162.5 × 130). Collection, The Museum of Modern Art, New York. Gift of Mrs Simon Guggenheim.

166 *Minotauromachie*, 1935. Etching and scraper, $19\frac{1}{2} \times 27\frac{3}{8}$ (49.5 × 69.5). Collection, The Museum of Modern Art, New York. Purchase.

167 *The Dream and Lie of Franco I*, 1937. Etching and aquatint, $12\frac{3}{8} \times 15\frac{5}{8}$ (31.5 × 39.5). Collection Sir Roland Penrose.

168 *The Dream and Lie of Franco II*, 1937. Etching and aquatint, $12\frac{3}{8} \times 15\frac{5}{8}$ (31.5 × 39.5). Collection, The Museum of Modern Art, New York.

169 *Ubu*, 1937 (drawing printed in the notebook published to mark the performance of Alfred Jarry's *Ubu enchaîné* by the Comédie des Champs-Elysées in September 1937). Ink on paper. Private collection.

170 Drawing for *Guernica* (*Composition Study for Guernica*), 1 May 1937. Pencil on blue paper, $8\frac{1}{4} \times 10\frac{5}{8}$ (21 × 27). On extended loan to The Museum of Modern Art, New York, from the artist.

171 Drawing for *Guernica* (*Composition Study for Guernica*), 1 May 1937. Pencil on blue paper, $8\frac{1}{4} \times 10\frac{5}{8}$ (21 × 27). On extended loan to The Museum of Modern Art, New York, from the artist.

172 Drawing for *Guernica* (*Composition Study for Guernica*), 1 May 1937. Pencil on blue paper, $8\frac{1}{4} \times 10\frac{5}{8}$ (21 × 27). On extended loan to The Museum of Modern Art, New York, from the artist.

173 Drawing for *Guernica* (*Guernica Studies and 'Postscripts'*, 1 May 1937: *Composition Study*), 1937. Pencil on gesso, on wood, $21\frac{1}{8} \times 25\frac{1}{2}$ (53.6 × 65). On extended loan to The Museum of Modern Art, New York, from the artist.

174 *Horse's Head* (*Guernica Studies and 'Postscripts'*, May 2, 1937: *Horse's Head*), 1937. Oil on canvas, $25\frac{1}{2} \times 36\frac{1}{4}$ (65 × 92). On extended loan to The Museum of Modern Art, New York, from the artist.

175 Drawing for *Guernica* (*Guernica Studies and 'Postscripts'*, May 2, 1937: *Composition Study*), 1937. Pencil on gesso, on wood, $23\frac{5}{8} \times 28\frac{3}{4}$ (60 × 73). On extended loan to The Museum of Modern Art, New York, from the artist.

176 Drawing for *Guernica* (*Guernica Studies and 'Postscripts'*, May 8, 1937: *Composition Study*), 1937. Pencil on white paper, $9\frac{1}{2} \times 17\frac{7}{8}$ (24 × 45.5).

177 Drawing for *Guernica* (*Guernica Studies and 'Postscripts'*, May 9, 1937: *Composition Study*), 1937. Pencil on white paper, $9\frac{1}{2} \times 17\frac{7}{8}$ (24 × 45.5). On extended loan to The Museum of Modern Art, New York, from the artist.

178 Drawing for *Guernica* (*Guernica Studies and 'Postscripts'*, May 10, 1937: *Bull's Head with Human Face*). Pencil on white paper, $17\frac{7}{8} \times 9\frac{1}{2}$ (45.5 × 24). On extended loan to The Museum of Modern Art, New York, from the artist.

179 *Guernica*, 1937 (in progress). Progressive photograph No. 1 by Dora Maar.

180 *Guernica*, 1937. Oil on canvas, 138 × 308 (350.5 × 782.3). On extended loan to The Museum of Modern Art, New York, from the artist.

283

181 *Weeping Woman*, 1937. Oil on canvas, $21\frac{1}{4} \times 17\frac{1}{2}$ (54 × 44.5). Collection Anthony Penrose.

182 *Still-life with Bull's Head* (*Still-life with Red Bull's Head*), 1938. Oil on canvas, $38\frac{1}{8} \times 51$ (97 × 129.5). Collection Mr and Mrs William A. M. Burden, New York.

183 *Cat* (*Cat Eating Bird*), 1939. Oil on canvas, $38\frac{1}{8} \times 51\frac{1}{4}$ (97 × 130). From the collection of Mr and Mrs Victor W. Ganz. Photo courtesy Perls Gallery, New York.

184 *Night Fishing at Antibes*, 1939. Oil on canvas, 81×136 (206 × 345.5). Collection, The Museum of Modern Art, New York. Mrs Simon Guggenheim Fund.

185 *The Soles*, 1940. Oil on canvas. Scottish National Gallery of Modern Art, Edinburgh.

186 *Jaime Sabartés*, 1939. Oil on canvas. Private collection. Photo Giraudon.

187 *Woman Dressing Her Hair*, 1940. Oil on canvas, $51\frac{1}{4} \times 38\frac{1}{4}$ (130 × 97). Private collection. Photo The Museum of Modern Art, New York.

188 *Bull's Head*, 1943. Bronze (from assemblage of bicycle saddle and handlebars), $16\frac{1}{2} \times 16\frac{1}{8} \times 5\frac{7}{8}$ (42 × 41 × 15). Owned by the artist.

189 *Baboon with Young*, 1951. Bronze, $21 \times 13\frac{1}{4} \times 20\frac{3}{4}$ (53.4 × 33.7 × 52.7). Collection, The Museum of Modern Art, New York. Mrs Simon Guggenheim Fund.

190 *Man with a Lamb* (*Man with Sheep*), 1944. Bronze, $86\frac{1}{2} \times 30\frac{3}{4} \times 28\frac{3}{8}$ (220 × 78 × 72). Owned by the artist.

191 *The Charnel House*, 1944–45 (in progress). Progressive photograph No. 2 by Brassaï, April 1945.

192 *The Charnel House*, 1944–45. Oil on canvas, $78\frac{3}{4} \times 98\frac{1}{2}$ (200 × 250). Collection, The Museum of Modern Art, New York. Mrs Sam A. Lewisohn Bequest (by exchange) and Purchase.

193 *Don Quixote and Sancho Panza*, 1955. Poster.

194 *William Shakespeare*, 1964. Pen and ink, $10\frac{5}{8} \times 8\frac{1}{4}$ (27 × 21). Private collection.

195 *Joseph Stalin*, 1953. Pen and ink. Photo Keystone Press Agency Ltd.

196 *Bacchanal*, 1944. Watercolour and gouache on paper, $12\frac{1}{4} \times 16\frac{1}{4}$ (31 × 41). Owned by the artist.

197 NICOLAS POUSSIN: *The Triumph of Pan*, 1935. Oil on canvas, $54\frac{3}{4} \times 61\frac{3}{4}$ (139 × 157). Musée du Louvre, Paris. Photo Giraudon.

198 *Joie de vivre*, 1946. Oil on fibreboard, 47×98 (120 × 250). Musée Grimaldi, Antibes. Photo Giraudon.

199 *Plate* (*Plate with Head of a Goat*). Ceramic. Galerie Louise Leiris, Paris. Photo Giraudon.

200 *The Flower-Woman*, 1946. $57\frac{1}{2} \times 34\frac{1}{2}$ (146 × 89). Collection Mrs Jonas Salk.

201 *Faun Piping* (*Faun playing the Diaulos*), 1946. Oil. Château Picasso, Antibes. Photo Lauros-Giraudon.

202 *Massacre in Korea*, 1951. Oil on plywood, $43 \times 78\frac{3}{4}$ (110 × 200). Owned by the artist.

203 *Peace*, 1953. Oil on isorel, 185×403 (4.7 × 10.24 m). Chapel, Vallauris.

204 *War*, 1953. Oil on isorel, 185×403 (4.7 × 10.24 m). Chapel, Vallauris.

205 *The Kitchen*, 1946. Oil on canvas. Private collection.

206 *Jacqueline Roque as Lola de Valence*, 1955. Ink on paper, $12\frac{5}{8} \times 10\frac{1}{4}$ (32 × 26). Owned by the artist.

207 *Las Meninas*, 1957. Oil on canvas, $63\frac{3}{8} \times 50\frac{3}{4}$ (161 × 129). Owned by the artist.

Index